Past Times
of
Macclesfield

Volume IV

Dorothy Bentley Smith

AMBERLEY

To my three children: Victoria, Nicholas and Alexandra

First published 2017

Amberley Publishing, The Hill, Stroud
Gloucestershire GL5 4EP

www.amberley-books.com

British Library Cataloguing in Publication Data.
A catalogue record for this book is available from the British Library.

ISBN 978 1 4456 6704 1 (print)
ISBN 978 1 4456 6705 8 (ebook)

Origination by Amberley Publishing.
Printed in Great Britain.

Contents

Foreword

This particular volume, No. IV, completes two decades of local history research begun initially in 1994 at the behest of Granville Sellars, editor of the then *Community News*, for a series of articles in that newspaper.

It was essential to ensure accuracy as far as possible, and to that end I began to transcribe the wealth of property deeds extant for Macclesfield and its environs before they became targets of antique fairs, auctions and the like, or even framing to embellish living room walls and those of public houses etc. I was fortunate to discover many had been submitted to record offices, libraries and university archives. Others, of which copies have been made, arrived via people who were genuinely interested in the town's history, or the history of their particular premises.

Property deeds can be easily misinterpreted, often names of individuals appear, particularly in earlier centuries, who never lived nor carried on business in the property, but had loaned the occupant money as a way of investment. I also learnt the necessity of first looking for title deeds, and obtaining sight of as many deeds as possible for a particular area. This helped in identifying properties in two extant eighteenth-century land tax returns before subsequent numbering of properties took place. Unfortunately what is often not recorded with earlier deeds is the modern address, which would make the task of identification so much easier.

Although much of the information, amplified from other authentic sources such as wills, letters, personal documents, contemporary publications and newspaper reports, was included in my local history articles, it brought additional important details to light from correspondents, and the occasional correction. The additions have been included in the text, and alterations made where necessary.

I am extremely grateful to my late husband for his insistence that two large volumes of *The Illustrated London News*, January to June 1881 and July to December 1891, have remained in our possession through three household removals, despite the logistics of storage. With great pleasure, I can now appreciate their contents and have found articles and wonderful engravings that complement many of my writings, and therefore have been used as appropriate.

This particular volume comprises articles that were wholly or partially published in the *Macclesfield Express* from March 2010 to mid-2012, those that have been created for exhibition purposes, and miscellaneous articles that are appearing for the first time. It has been a fascinating and rewarding journey, and one that still continues.

Macclesfield has a rich and varied history, spanning at least 1,000 years. During that time there have been periods of progression and retrogression, some well documented, others yet to be revealed. My sincere hope is that my contributions have helped bring to life events and characters long forgotten, yet, in many instances, deserve their place, not only in local history but also in national history. What must never be forgotten is that without local history there would be no national history; everything, however large or small, begins somewhere.

Dorothy Bentley Smith

Acknowledgements

As always, my thanks go to all those who have helped provide information in one form or another, invariably from authentic sources such as original documents, illustrations or property deeds; they are appropriately mentioned in the text. Another valuable source of information is the facsimile of the *Encyclopaedia Britannica* originally published by A. Bell and C. Macfarquhar (Edinburgh, 1771).

Particularly helpful has been the availability of copies of original local newspapers, either in the Heritage Museum library, the Chester City & Cheshire County Record Office, and, most conveniently, on microfilm in Macclesfield public library. With reference to the latter I am greatly indebted to the excellent staff, especially those providing duties in the local history section who have unstintingly helped in so many ways and made my efforts so much easier and more enjoyable.

Thanks must also be given to those who have welcomed me into their homes and properties, many of whom have made arrangements over the years to provide access to those buildings not often open to the public.

A special thank you is due to Phillip Oliver, who has offered invaluable items from his local history collection for publication, the most important being the sale catalogue of the Smale household contents. Also, thanks go to Matt and Joe of the Ollier Studio, who have determinedly sought out and provided extra excellent illustrations of old Macclesfield.

Others, who must not be forgotten, are those working on industrial or development sites who have been fascinated by their findings within the town's older properties or areas, and from whom I have obtained maps, plans and permission to take photographs. These have helped me locate the extant of John of Macclesfield's medieval wall surrounding his small castellated home, his subterranean cellars in the Market Place with a passage (now blocked off) under the top of Mill Street, and a further middingstead close by. Others, working on Waters Green, helped established that the depth of the land build up above the original medieval boggy area has grown at least 4 to 5 feet since the eighteenth century.

I am also extremely grateful for information supplied over the years by the legal department and the planning department of the old Macclesfield Borough Council, and to what was the North West Water Board for copious details of the drainage areas etc. around the town. It is imperative when studying history also to have a good knowledge of geography, otherwise many questions remain unanswered or lead to misinterpretation of facts. Unfortunately geography appears to be something of a neglected subject at present, so I am fortunate to have received a good all round education at the high school I attended.

Last, but by no means least, my family, close friends and colleagues, who have made light of all my idiosyncrasies over the years, deserve to know how much I value their constant support and forgiveness in my endeavours to seek out and establish as much truth as possible, and to argue and debate a point which I consider imperative.

Barnaby

Barnaby holidays have been part of Macclesfield life, 'time out of mind', but are now simply referred to as Barnaby; it commemorates the feast of St Barnabas, whose saint day is 11 June. Few facts remain, yet strong indications point to a very early origin in the town.

Ranulf de Blunderville (1172–1232), 6th Earl of Chester, traditionally created a Macclesfield guild in around 1220, and there is little doubt that he holds the key to the mystery as to why St Barnabas became Macclesfield's patron saint.

He was a strong administrator, much involved in the Barons' Wars with King John, whom he supported. As an elder statesman with great power as Earl of Chester, he granted land near Leek in Staffordshire on 22 April 1214 to the Cistercian abbey at Poulton on the River Dee, 5 miles south of Chester.

With the refounding of the abbey known as Dieulacres near Leek, he also gave lands in Chelford and Withington as income, and the friars built a chapel to the Blessed Virgin Mary. From Macclesfield, a thriving market town, he also gave the rents of a Chestergate property to the friars, to support the chapel. Such was his love for the abbey, when he died in 1232 his heart was buried there.

Having no chapel, the people of Macclesfield worshipped at St Peter's, Prestbury, which, through tythes etc., supplied part of the income of the abbot of St Werburgh's Abbey in Chester. When Queen Eleanor was able to provide a chapel for the town in 1278, it was dedicated to All Saints and All Hallows, not St Barnabas. So why should the patron saint of Cyprus (and not, as erroneously assumed, the patron saint of silk workers) be chosen by a Macclesfield guild?

The site of Dieulacres Abbey on the outskirts of Leek.

Barnabas

Born Joses, a Jewish Cypriot, he had with others sold his land and possessions in Jerusalem and given the money to the original apostles of Jesus to send out missionaries for spreading Christianity. In partnership with St Paul, who in some ways was initially the weaker of the two, a church was founded at Antioch; Cyprus was converted to Christianity, and the impetus to spread the faith had begun.

At some point the surname 'Barnabas' was given to Joses by the other apostles, meaning 'son of consolation'.

After many years he and Paul separated. Paul continued to Ephesus, and Barnabas returned with his nephew to Cyprus, where he was martyred at Salamis in AD 61, having made enemies in the hierarchy of the Jewish Church.

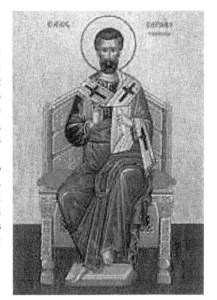

St Barnabas icon.

Crusade

Cyprus was vital to the English and other crusaders.
Captured by Richard I in 1191, he sold it to the Templars the following year, and it was a haven for supplies both to and from the Holy Land, and for those returning injured.

In 1218, Ranulf de Blundeville left with a large contingent to join the Fourth Crusade, gathering archers and bowmen from the Cheshire forests, and would have particularly included those skilled men from Macclesfield. In later centuries their successors would prove so crucial to the victories at Crécy, Poitiers and Agincourt. Ranulf had given his commitment by oath some three years earlier, having heard the Archbishop of Canterbury preach from the High Cross in Chester for support.

His great successes in Egypt made him a popular hero, and his adventures inspired many ballads. He left Egypt late in September 1220, disappointed at the failure of political negotiations with regard to Jerusalem. There is little doubt that the remaining contingent would have visited Cyprus on the return journey for stores and recuperation, especially allowing time for the injured to recover sufficiently in order to cope with the arduous travelling ahead.

On their return to England, as a gesture of goodwill to the Macclesfield men, Ranulf appears to have granted a charter, with the guild likely to have been established early in 1221; the guild being a Christian establishment would have had a saint, and Barnabas seems to have been an obvious choice.

Payment for the charter would have allowed privileges in Chester. Members looked after their widows and orphans, trained apprentices, usually for seven years in the 'Art and Mystery' of their trade and in absolute secrecy; the knowledge gained to learn their skills was vital to the success of their particular trade, and they were proud of it.

The trade of the Macclesfield guild is unknown – no records remain. The logical answer, however, would be that it was related to supplying the necessary equipment for the bowmen and archers of the forest, such as fletchers who made the arrows. Young apprentices would have been trained in making the arrows, longbows and other associated accoutrements until the position of journeyman was achieved. This demanded utmost loyalty and suggests that the guild would have been one for the foresters. Whether or not those in the wool and leather trades were included is contentious, but they were vital to the 'production line'.

Guild members and their Grand Master would walk in procession each year, carrying an effigy of their saint to Prestbury church on the designated feast day, and celebrate from the previous evening with feasting and a fair.

Kolossi Castle near Limassol, Cyprus, built by the Knights Hospitaller.

In the mid-thirteenth century, the Black Prince, as lord of the manor, visited Macclesfield and decided to re-establish a stud and also a cattle farm in the park belonging to his manor. Within ten years the herd numbered over 700, and cattle are recorded as being sold at the Barnaby Fair, so it is apparent that the fair was well established by then.

The guild would no doubt appear to be a privileged affair among many of the townspeople and created jealousies among other artisans in the town. There are records of the men from the forest making merry in the town and causing problems, from drunkenness to squabbling, with the townsfolk. This is probably the reason why, forty years later (1261), Prince Edward, as Earl of Chester (later to become Edward I), granted a Corporation charter, effectively creating the 'Mayor, Aldermen and Burgesses of Macclesfield', as the council would be known for many centuries. This allowed for greater privileges among all who held burgage plots in the town and was a fairer distribution of authority.

With the guild eclipsed, it would quietly fade away as members jostled for power in the Corporation. Since the St Barnabas festivities had been enjoyed for forty years, the Corporation would have been ill advised not to continue the festival. Barnaby was here to stay.

The longbowmen and archers of Macclesfield did not disperse either, but remained vital to the campaigns on the Continent; so much so that in the battles of Crécy (1346) and Poitiers (1356) in support of the Black Prince, they were each paid 6*d* per day because of their skill, instead of the 3*d* paid to the Welsh contingent.

It is interesting to note that Barnabas, although not originally one of the twelve disciples of Christ, was one of the first 120 apostles after the Crucifixion to go out into the world and begin the spread of Christianity. Was it just coincidence that it was said the burgesses of Macclesfield numbered 120 when organising the original borough boundary and council (although an agreed number is not specified in Prince Edward's charter of 1261)?

Georgian Celebrations

No Fireworks

November is the time of year when fireworks are traditionally in vogue, reflecting one of England's most celebrated national events, the foiling of the Gunpowder Plot. While throughout history, since their invention in China, fireworks have been popularly used on thousands of other occasions, it was not the case on one very important occasion in Macclesfield.

After Napoleon's retreat from Moscow in the bitter winter of 1812, his continental supremacy deteriorated during the following two years. On 31 January 1814, the allies were able to enter Paris having offered him conditions for peace, and he accepted these by a treaty signed at Fontainebleau.

On 29 April, preparations were completed for his departure to Elba in exile. At last Europe felt able to celebrate, although it was somewhat prematurely, as history would later reveal.

Throughout the country festivities began with parades and fireworks on 18 June. The mayor and Corporation of Macclesfield announced a 'General Illumination' for the following Monday. Ever vigilant and fearful of fires and disorder, certain specific instructions were also issued.

To avoid annoying women and children there was to be no firing of guns or pistols, or selling of squid, crackers and other fireworks. The houses that were on the outskirts of the town, or where there was sickness, and even those where Quakers lived, were not expected to be illuminated.

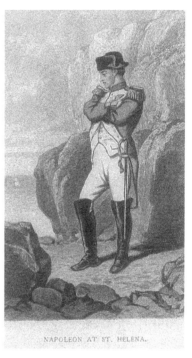

NAPOLEON AT ST. HELENA.

Rare print of Napoleon Bonaparte at St Helena, his final place of exile. (Possession of the author)

Illuminations

On a Monday morning, on 20 June 1814, the Macclesfield festivities began, with flags flying above several factories and the two churches, Christ Church and St Michael's. Many 'opulent' townsmen decorated their houses with a variety of emblems and historic designs, including wreaths and garlands of flowers.

When evening came, the whole town was illuminated with candles and lamp lights as people paraded the streets to see the brilliance of the displays. The new town hall was yet to be built, so it was the old guildhall, which was 'modernised' in 1678 with steps built up to the first floor, that sported a large golden crown formed with coloured lights. Beneath it was the Corporation Arms of the lion and wheat sheaf with a border of green lamps, while other lamps formed a letter 'G' on one side, 'R' on the other, and the word 'PEACE'.

The house of the chief magistrate, George Pearson, was a blaze of lights surrounding a figure of Peace complete with an olive branch in her hand and accompanied by the borough coat of arms and an insignia of Neptune and Mars.

Site of the former Root Market on the south side of the Market Place. Critchley & Turner's bank occupied the left or east end of the row of buildings (2002).

The façade of Critchley & Turner's bank on the southern side of the market square, adjacent to the graveyard of St Michael's, together with their neighbour's building, shared a 'superb transparency' of Atlas and the globe, which had been created by a Mr Woodford of the Royal Academy in London.

The office of the local newspaper, the *Macclesfield Courier*, on the corner of what was then Goose Lane, though often referred to as 'The Gutters' (now Brunswick Street), and Jordangate (now part of Market Place) displayed a half-length portrait of William Pitt the younger. He was encircled by a wreath of oak leaves and acorns, entwined with roses and lilies and various other devices. This was a great tribute because he had died in 1806 at the 'old' age of just forty-six years, said to have been due to being worn out by an astonishing workload and his overwhelming desire to bring about peace.

Decorations

Not only was the town incredibly illuminated around the market square to celebrate peace with France, but many ordinary people had made a great effort to decorate the windows of their houses. Every inn (and there were plenty of them as Macclesfield was a well-known market town) had also made their façades attractive by using all sorts of royal or patriotic emblems to hang wherever possible.

Various other town houses around the Market Place were also enthusiastically decorated, and King Edward Street, then known as Back Street, was also mentioned. On entering the street from Jordangate, on the left-hand side was a building 'one part occupied by Messrs. Brocklehurst & Bagshaw and the other by Mr J. Brocklehurst Junior silk merchant', which had the 'appropriate inscription 'LAW AND COMMERCE' along the front.

At that time the Brocklehursts were dissenters and, as the law then stood, unable to hold public office, as such, theirs was a bold statement without acknowledging any royal connection.

Further along the street on the right-hand side stood the grammar school. As a sign of academia it displayed two poems, one in each window on either side of the front door. The one on the left began:

> Now the tyrant reigns no more,
> Save on Elba's distant shore.

The one on the right concluded:

> Hail with loud and ceaseless cheer,
> Cotton, Lord of Combermere.

This was Sir Stapleton Combermere (1773–1865), whose father represented Cheshire as a Member of Parliament for forty years. Educated first at Audlem Grammar School and then Westminster School, he joined the Welsh Fusiliers as a second lieutenant in 1790, becoming first lieutenant a little more than one year later.

He proved to be a superb soldier, advancing through the ranks after a successful career in South Africa and India. Through the latter he met

Brocklehurst premises King Edward Street. On the left of the white portico was the bank and solicitors' office; on the right, the commercial offices. The white portico leads to the Dissenting Chapel behind the buildings.

Sir Arthur Wellesley, later to become Lord Wellington, whom he eventually joined in the battles against Napoleon (first in Portugal, then Spain, where he won the Battle of Salamanca against considerable odds, and eventually France). Wellington thought highly of him, stating that if he gave Cotton an order he knew it would be 'carried out with discretion as well as zeal'. Hence the poetry.

Park Green, then known as Parsonage Green, was also elaborately presented, particularly as Daintry and Ryle had ensured that their splendid factory façade was embellished with over 1,000 lamps and a variety of emblems.

Some of their long-serving employees were treated to a dinner, while 500 employees assembled on Parsonage Green outside the factory and walked in procession to 'Byron's', the home of Mrs Daintry in Sutton. They continued up the lane to Foden Bank, home of J. S. Daintry and finally to Park House, the mansion of John Ryle Esq. in South Park.

On returning to the factory, an exceptional dinner was provided for them comprising 1,000 lbs of prime beef; 300 lbs of plum puddings; 360 fruit and meat pies; 2 cwt of bread and 220 gallons of ale.

The employees also enjoyed hot pies, cold meat and ale on the Wednesday, with the leftovers given to the poor. There were many other 'deeds of generosity' made by employers and others throughout the town, many in the form of monetary gifts.

Macclesfield Fairs, Markets and Carnivals

Puppet.

The earliest fair accounts for Macclesfield only survive from 1619, but there are frequent references in the medieval court rolls of the borough that help bring the story to light.

The granting of fairs was a royal prerogative, with the mayor, aldermen and burgesses petitioning for them, having decided what the relevant feast days were. Fairs were held annually and complemented the local market, suggesting they were held in the Market Place.

Originally they were part of religious festivals when visiting troupes of jugglers, musicians, acrobats etc. performed, and itinerant 'salesmen' brought goods from long distances to sell, such as furnishings, toys, haberdashery and so forth. There would also be much ale drinking and feasting.

For centuries, official events, such as court sessions and feast days, were dated with reference to saints' days. People knew their calendars by this method, and it can be confusing at times.

For instance, in 1376 one man was accused of attacking another with a pitchfork on the Sunday before the feast of St Gregory. At the same court session, William, son of John del Whyk, together with two maidservants, was fined the very large sum of 40*d* for collecting turf (peat), burning it and selling it to Roger de Fallibroome for his use at the feast of St Barnabas. The first example is clearly used only as a date, but the second one additionally indicates the use of the peat, presumably for a fire, in the celebrations on St Barnabas's feast day.

Charters

The earliest extant town charter of 1261, granted by Prince Edward, later crowned Edward I, gives no specific reference to fairs. Its main purpose was to grant a merchant guild with a leader. This had the effect of creating a body operating as a Corporation, as mentioned previously, which formed a borough on the western side of the Market Place and upper part of Mill Street.

Two further surviving charters, from Edward III in 1334 and Edward IV in 1465, simply confirm the charter of 1261. Unfortunately, those relating to the subsequent monarchs granting privileges at the start of their new reigns, for a price of course, are no longer extant until that of Elizabeth I in 1595.

By this, Elizabeth granted three Macclesfield fairs: the May fair, Barnaby in June, and the Wakes fair in October, which seems to indicate Barnaby as an addition but it was merely confirming its existence. One thing previously overlooked is that these fairs were Roman Catholic in origin and, during the turbulent times of Henry VIII's Dissolution of the Monasteries, effigies of saints and other religious objects were destroyed by the thousands, and references to the adoration of saints were suppressed as much as possible.

Elizabeth, by being specific about the Macclesfield fairs, appears to be ensuring that Macclesfield could once more acknowledge its earliest saint without molestation.

By 1619 the fair accounts show people travelling great distances to buy and sell horses. Cows, oxen and pigs were bought and sold within the area and the trade in wool was extremely important, but then the Civil War intervened.

In 1684, James II's charter declared that two fairs could be held on 25 April and 23 September. The April date coincided with the day on which Parliament met in 1660 to declare his brother Charles II as restored to the English throne. Ironically it was also the date of Oliver Cromwell's birthday, so everyone should have been satisfied!

This charter, however, meant that the Wakes had been moved from Halloween, so Barnaby was disassociated. By then the fairs reveal items of silk appearing for sale, whereas previously the trade was in the hands of only two or three local merchants.

In 1752, with the alteration of the British calendar to align us with the Continent, the dates became 5 May and 3 October.

The fairs were then visited by quack doctors, performers and even a Punch and Judy show, which travelled to and fro along the River Weaver, attending fairs in different places. One fair was held in the Market Place, but the October fair, which had been moved to 11 November, took place on the Roe family land close to Christ Church. William Roe, who had inherited his father's estate on Chestergate in 1781, wished to develop the area and requested that the fair be moved. The Corporation agreed and it took place for many years on Waters Green, becoming famous for its cattle and sheep sales. Yet again, however, the date had been altered.

Circuses

Following the feast days and fairs of earlier centuries, the nineteenth century also witnessed the arrival of circuses. In Macclesfield they became very popular from the 1820s and were invited to the town, being sponsored either by the mayor or other prominent citizens.

The first to appear was Polito's Circus, which saw the town's people and those from the surrounding areas become fascinated by their arrival. With the increase in overseas trade since the seventeenth century, more exotic creatures were being imported into the British Isles, some of which could be trained to perform tricks to draw large crowds.

The Polito family circus was one of the most famous ones, so much so that it inspired one Staffordshire pottery to produce a mantelpiece in its honour. Stefano Polito, Italian by birth, was well known in England by the end of the eighteenth century for his travelling menagerie.

After his death in 1814, the circus was continued for a while by his brother John, and in December 1818 it made its appearance on Waters Green in Macclesfield.

The advertisement of the 12th caused great excitement. It was to be held the following Saturday, Monday and Tuesday, and 'not to be equalled in the world'. The animals were considered to be 'the most grand rich and complete collection … that had ever crossed the ocean.' Some of the creatures had not been seen before in Britain, such as the 'Giant Serpent' or boa constrictor, newly arrived from India, which was billed as formidable and of tremendous size. Previously no one had attempted to keep one because of the difficulty of their

Circus clowns.

survival in the English climate; it was emphasised that this could be the only opportunity to view 'so curious and magnificent a spectacle'.

The Egyptian camel, the only one to be imported for twenty-five years, was also known as the horned horse or Nilghau. It had actually come from Hindustan and was 14 hands high, of excellent appearance and elegant shape. With its two horns growing above the eyes, the name of 'horned horse' seemed appropriate (its anatomy was considered to be a combination of the horse, the cow and the antelope).

The zebra had the 'graceful figure of the horse with the fleetness of the stag'. Its black and white stripes were described as beautiful and in regular lines. Words could not express the reverence felt for the male elephant, 'the most scientific of its race', which would prove its intelligence by performing amazing tricks under the command of its keeper. These were guaranteed to astound the audience. The list was endless, including a giant porcupine, a jackal, a lynx and a water buffalo. There was even a kangaroo, a silver vulture from Brazil, eagles and a magnificent crane. Last, but by no means least, were the cat family, comprising three lions, 'the most superior ever imported', a Bengal tiger, several panthers, leopards and a jaguar. The admission fee was 1s, a day's wage for many, but it was a Christmas treat for dozens of households.

The interest in Polito's menagerie never faded, and from time to time reports appeared in the newspaper, such as the one on 15 March 1823. The circus had arrived in the Isle of Man when some of the caravans got stuck in deep snow on the road between Douglas and Ramsey. Because of the incline, the beasts were forced to one side of the vehicles, the boards gave way and out poured tigers, bears, hyenas and other terrified animals. Due to the cold, or the surprise of being surrounded by snow, they all seemed 'paralyzed', and were soon once more secured. The poor creatures were probably also still recovering from sea sickness.

Another, known as the Olympic Circus, provided incredible artists on horseback, especially famous was the 'Yorkshire Jumper'. For their performances, a small arena was created behind the Bate Hall Inn on Chestergate. Their first was in February 1822, and by the 1840s great circuses were visiting the town. They still featured jugglers and acrobats but, apart from exotic creatures, the superb performances on horseback were still the main attraction. And where better to accommodate them than on Waters Green, for their cattle, horse and other livestock fairs that regularly took place. It would also allow people to see the animals before attending the performances at the Bate Hall's small arena.

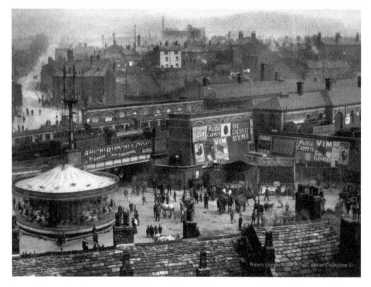

Late Victorian horse sale, Waters Green. (Courtesy of the Ollier Studio)

Complaints

Such had been the controversy down the centuries with regard to Macclesfield's fairs and markets, that a considerable amount of legislation was the consequence. In earlier centuries it was the hawkers and pedlars who caused problems but the nineteenth century, with its incredible increase in population, was to create many more.

In February 1820, the mayor, Samuel Pearson, had no alternative but to issue an order with regard to the sale of animals. It had been the custom to show horses, cows and other animals intended for sale in the Market Place, in the streets of the town. From 7 March this was forbidden because of the 'danger and inconvenience' to the public. They were to be sold at The Waters only, where the fairs were usually held, and anyone ignoring the order would be fined and penalties given.

Two years later, in July 1822, the roles were reversed as the 'Butter women' and other market traders complained to the council. They had to stand, but seats were provided and kept in a yard close by. Because the market people were standing on the flags they were causing an obstruction; a man was paid to prevent this and also carry out the chairs. The women felt that it was the duty of the magistrates and constables to make sure the regulations were carried out.

This by-law, with regard to obstruction of the pavement, was enforced by the council on many occasions over the years, as an amusing incident in 1857 proves – or perhaps in this instance disproves. On 21 February, the editor of the *Macclesfield Courier* published a letter from an irate reader under the pseudonym 'Passer Bye'. On walking along Mill Street the previous night, he had been 'astonished' to see a large crowd of boys and 'children of larger growth' staring wide-eyed and 'gaping with open mouths'. The object of their attention was a scantily clad female performing feats of juggling in a doorway. The pavement was so obstructed that those wanting to pass by had to cross to the other side of the street.

'Now Sir … where were the police and why are such nuisances tolerated?' wrote the angry correspondent. He had waited for an officer to appear, without success, and continued that tradesman and such, displaying goods, had been fined for partial, let alone complete, blockage, and this performance had continued night after night. 'What with Theatre nuisances, gin shop nuisances, nuisances from itinerant impostors whose cleverest feats consist in cajoling a half-witted populace out of their cash', he wanted to know which other town in England would tolerate such a nuisance for a single hour.

New Fairs

In the middle of November 1826, a meeting of townsmen was held in the Golden Lion at the top of Mill Street, close to what is now the mall of the Indoor Market. It was suggested that two new fairs should be organised and the dates of other fairs altered.

The burgesses, on hearing this, had written to the paper stating it could only be done by Act of Parliament, which had not been sanctioned. The mayor, William Johnson, an auctioneer of Chestergate, had actually sanctioned the meeting. He had also agreed that the dates of the present three fairs would be altered if the additional fairs were considered necessary. For some reason, perhaps because of pressure from certain individuals, the mayor went ahead and agreed to their request and authorised two new fairs. The announcement was made on the following 10 February, the first of which was to be held on the 21st of the month followed by another on 24 March.

Of the five established fairs, including the June fair of Barnaby and the Wakes fair (which by then was held on 11 November), only the one in August was to be altered to the 11th of the month.

The newspaper report on 24 February, relating to the new fair held the previous Wednesday, was not particularly good. The supply of horses and horned cattle had been 'scanty', and the pigs even more so. The cattle were mostly considered to be of an inferior sort, except for one cow that 'excited considerable curiosity'.

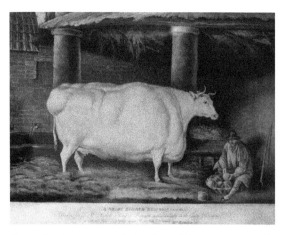

Engraving from 1811 of the Short Horn seven-year-old heifer, the first to be specially bred for beef.

The show judges declared her to be the finest beast (both in symmetry and colour) that had been exhibited at the town's show for many years. She had been bred near Oswestry, Shropshire, by a Mr Phillips, tenant of Lord Bridgewater, and fed at Royle near Nantwich on land belonging to the vicar. She weighed 72 score i.e. 1,440 lbs; today an average large, mature beef cow weighs from 1,250 to 1,470 lbs. When slaughtered, the rough fat was found to be 202 lbs.

The prize for the best fat pig went to John Ryle, one of the town's leading silk manufacturers and a future Macclesfield MP. Aside from his Park House estate on Park Lane, he had also bought a farm at Henbury.

Opposition

With the newspaper report of the unsuccessful new fair in February 1827, the complaints became public. Many residents had been opposed to the idea from the outset. One irate inhabitant soon put pen to paper, – 'Why do we need additional fairs in February and March?' – and signed his 'epistle' with the name 'Fairplay'. His objections continued, emphasising in particular the following problems. Farmers had the opportunity to sell young stock for their spring rent at the March fair in Stockport, and at the May fairs of Congleton, Stockport and Macclesfield. He could not believe that having seven fairs a year was to the town's advantage. Extra fairs could only reduce prices, which was no advantage to the farmer nor to the manufacturing class. Cattle at this early season were not exactly suitable for butcher's meat.

Shopkeepers in the town occupied the most expensive sites and paid the heaviest rents. Any extra fairs would be to the disadvantage of the shops. Fairs ensured that the cheap goods 'hawked for sale' were often damaged or refused goods, acquired by the 'boothmen' because they were not of a reasonable quality. They would not stand up to scrutiny from a decent retailer because his reputation was made by the standard of his stock.

The 'cheap pennyworth' of the streets was sold by salesmen who were 'here today and gone tomorrow'. Main streets and shops were the best properties of a trading town, and at that time the population had decreased by 5,000, leaving almost 1,000 dwellings empty.

No doubt the mayor saw it as his prerogative to grant fairs, but surely this was a trespass? He pointed out that the original fairs were Barnabas and All Souls, i.e. June and the end of October, from the thirteenth century. Over time, three more fairs were added, but he suspected that as the mayor was empowered to issue by-laws, he had used this to provide the two extra fairs. Many people were upset and determined to refer the issue to the quarter sessions, where the magistrates would be bound to show how they had come to make the decision.

It was better to reduce or abolish the tolls, otherwise many would leave. The vegetable and pitcher stalls (stalls set up at a definite place) were once temporary, but had become permanent. The roots and fruits were sent into The Waters with the excuse that it would allow the new town hall to be built, yet there they had remained. This had meant that the large population in the lower part of town were no longer shopping in the Market Place, and the main shops near the town hall were suffering. The correspondent did agree, however, that it had improved the properties in the Sunderland Street area of the town but he asked the mayor to reconsider his decision.

At the next meeting of the Corporation, which took place on Monday 2 April, the councillors took the decision that the chief magistrate, in other words the mayor, had 'exceeded his powers', and under the circumstances considered it wiser to abandon the two new fairs.

Drinking Problems

William Johnson, when acting in his capacity as an auctioneer, would have use of the public house

Victorian 'fairings' for sale at fairs and markets.

facilities in the town when his auctions took place. The fact that the original meeting had taken place in the Golden Lion does suggest that it was more than likely the idea of some of the town's landlords to increase the number of fairs.

Although the auction of animals took place in The Waters, a poor fair meant a shorter auction time, and everyone crowded into the inns and public houses. This had happened on more than one occasion, resulting in problems for the magistrates as a result of drunkenness and bad behaviour in the streets.

Stallage

While the mayor, aldermen and burgesses had managed not to be involved in a court action with regard to the two new fairs of 1827, it was an entirely different matter in August 1831. On the previous occasion the mayor had realised his mistake, but this time a source of revenue for the Corporation was the issue. As the council were the plaintiffs, under law it was the mayor, as representative of the council, whose name had to be used to instigate the proceedings. The case had arisen to prove the right of the Corporation to charge stallage on the butchers who refused to take stalls in the market but instead sold meat from their houses on market days.

Obviously the case could not be heard in the local magistrates' court, and instead took place at the Chester assizes. A lawyer called Lloyd opened the case for the council, while his legal assistant, Mr Jervis, next presented the facts. The Corporation had the right by charter to all the tolls and stallage for the Macclesfield market. Around twenty years previously the butchers began to 'infringe' this right and, although the charter from James I was since lost, he could produce all those granted from Charles II onwards. This would satisfy the judges as to the legal entitlement of the Corporation.

Market Lookers

Jervis was also able to show from the market books that the council had proved their possession of the market by appointing market lookers and other inspectors. They examined the meat that was brought for sale and ensured that it was fit for public consumption.

The butchers might have argued that the market had been moved from one site to another, but this still did not entitle them to open up shops in their own houses and sell the meat. It was an established fact that the owner, who had the grant of a market, could move it to any place within the same jurisdiction, and it was a more convenient way of protecting the public from 'unwholesome meat'.

Mr Thomas Parrott, the town clerk of Macclesfield, was present with the Corporation muniment box. He opened it up and produced the enormous Charles II charter, which comprised five membranes. He then began to recite the oath that the market officers were sworn in by. It was objected to by the defence lawyer, however the judge overruled and Mr Parrott completed his recitation. He also stated that the market lookers went through the Shambles every market day and inspected the meat.

The Shambles

At this point in the story an explanation is necessary. A shamble was simply a table or a stall on which meat was laid out for sale.

On 13 May 1809, Mr Deane had offered to erect eighty butchers' stalls, or shambles, each 14 feet long and 5 feet wide (almost 14 by 4.7 meters) on a piece of land he owned near the Market Place. They would have slate roofs, which Mr Deane committed himself to repair, and the lease to the Corporation was agreed as £200 each year.

Thomas Parrott, town clerk, the portrait unfortunately in poor condition.

There was a right inserted, however, that within the next twenty years, on a payment of 20 guineas (£21) for rent, the Corporation had the option of purchase.

The Shambles were constructed on a site that today would occupy the central part of the town hall car park. While the town hall, with its modern extension, now lies in a south to north direction, the Shambles was laid out west to east, and access was gained through the passageway of the Union Gateway, a public house that stood at the entrance to it and was situated in the Market Place almost alongside the town hall.

Evidence

The town clerk, Thomas Parrott, continued presenting his evidence in the court case in Chester, brought about by the Corporation challenge against the Macclesfield butchers. He related that in 1814 a Police Act for the borough changed the market days from Saturday and Monday to Saturday and Tuesday, and Ralph Deane, a member of the Corporation had built the Shambles, which provided eighty very 'commodious and convenient stalls'. Before their completion in 1810 on Mr Deane's private land, the butchers were in the Old Market, which was still in use, and their stalls were opposite from where they now stand.

The town clerk did not recall the meat being sold in their own houses before the Shambles were built, but they began to do so shortly afterwards. John Chapman was the first to do so, then it was his brother, and finally twenty-one others followed.

Mr Chapman had been in business as a butcher on Mill Street for seventeen years and Mr Parrott had been a customer at the shop for five or six years – he paid his bills there. He said that 'a great many of the aristocracy' dealt with him, and even Mr Dickinson (the surgeon) when he was mayor. Dickinson's answer brought laughter to the courtroom when he said, 'I liked his meat so well, although I did not acknowledge his right'.

The Old Market could not accommodate eighty butchers, but another witness recalled that the butchers' stalls were dismantled at the close of the market and kept in the 'Meal House'. At that time George Oldfield had collected the tolls and made sure that the market lookers burnt the 'unwholesome meat opposite the town hall'.

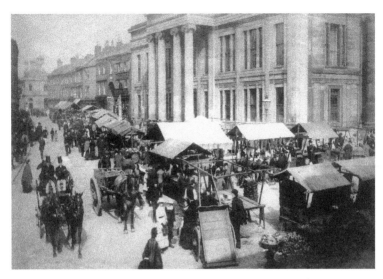

Late Victorian market outside the town hall. (Courtesy of the Cheshire Archives Service)

The Butchers

The evidence continued. Tolls were collected from the butchers who were not freemen. Of recent years, butchers' meat not sold in the Shambles was hawked around the town. This was confirmed by a Mr Hardern, who had been a huckster (i.e. a retailer of small or petty goods) on Chestergate. Around twenty years previously he had sold beef, mutton and veal on Saturday nights, which he had bought from the butcher at the close of the market.

The present collector, Peter Wally, was called to give evidence and said Chapman had a stall in the Shambles but since 18 March, although one had been kept for him, he had not attended. In 1813, the alderman, Mr Deane, had sent a message to Chapman stating that he would have to pay stallage if he took one of Deane's new stalls. Chapman's reply could not be remembered, but he did take the stall for a short while yet at the same time kept his shop open.

The defending solicitor, Mr Temple, created a long discussion as to whether or not Mr Parrott's evidence was admissible as he was a freeman of the borough. Although he was town clerk, he could give evidence in producing books and documents, but the judge agreed that all the other evidence given by him had to be 'struck out'. Temple then argued that the Corporation books confirmed no right existed before 1748; this was within the time of legal memory. There had been long and continued opposition to the Corporation's claim and many witnesses were called to give evidence in support. Originally there had been fifty outside stalls, but now the Shambles had created a very crowded area that was not popular with the butchers.

Benjamin Bullock said he opened a butcher's shop in the Root Market and never paid stallage, then he moved opposite the Angel Inn for three or four years. Francis Chapman, who had moved to Hyde, still had two shops on Mill Street but had never paid stallage. He had been told he could have a new stall and pay for it, but he refused, so his licence was stopped.

The judge summed up all the 'pros and cons' for the jury, who were out for 3 hours. On their return the verdict was for the plaintiffs, so the Corporation won the day.

By the mid-nineteenth century the Victorians were so confused about the date of the Wakes holiday that the local newspaper insisted and proved it was the Festival of St Michael on 29 September, which had become the name of Macclesfield's chapel, today our parish church. As a consequence, and after consultation with the town clerk, in August 1850 Mayor Barnett

declared a ruling. As 29 September would not fall on a Sunday until 1861, the Wakes Sunday would be celebrated each year on the first Sunday after the 29th.

The last time it had fallen on a Sunday, people arrived from different towns on different days, finding only around four shops open and hardly anywhere to eat.

The Victorians are not the only ones to be confused, yet despite the changes of dates over the centuries, Barnaby and the Wakes have always been there from the beginning of the borough.

The Carnival

It was not until 14 August 1926 that the first carnival made its appearance. Known as 'King Carnival' it set a precedent for future carnivals. Firstly it was for charity and secondly it was established with a South Park connection.

A grand effort was made to overcome the gloom of a depression and the General Strike. It was felt it would lift everyone's spirits, give a boost to the silk trade and, most important of all,

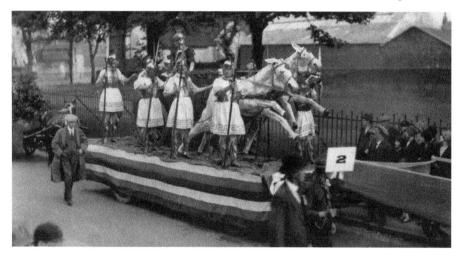

Above and below: These two photographs appear to relate to the King Carnival of 1926. (Courtesy of Julie Vohra and the Ollier Studio)

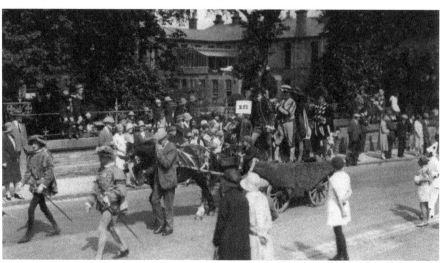

provide desperately needed funds for the infirmary. It was mostly the inspiration of Councillor William Frost, who had donated 45 acres to create South Park in 1922. An ardent bowler and member of the Infirmary Committee, he had encouraged the Macclesfield Bowling Association to organise the event. It was a tremendous success, donating over £500 to the infirmary fund.

The considerable and colourful procession wound its way around streets decorated with buntings and flags, which were also displayed on public buildings. Beginning at Victoria Road, it progressed via Chestergate and Jordangate to Waters Green then Park Green. Next it turned south around Coronation Street and High Street and made its way back to Mill Street.

Still undeterred, it once more moved along Chestergate to Catherine Street, eventually arriving in South Park having passed along Crossall and Browne Streets. With unabated exhilaration, the fun continued in the park, with prizes given to the best floats; finally, the accompanying bands 'crashed out the National Anthem' and everyone dispersed.

The pre-war carnivals continued until 1935 on behalf of infirmary funds, and in 1930 it was a joint venture between the Bowling Association and Carnival Committee. A July mass meeting at the Opera House was told: 'Tonight we are making history.'

Silk Queen

It had been decided that selecting a 'silk princess' for each silk firm, with a grand final in July to decide who would be silk queen, would be the first 'big push' in reviving the industry. Photos of the girls appeared in the newspaper and votes were submitted. On this evening was the final ceremony at the opera house.

Miss Lilian Jervis, eighteen years old, was chosen and with suitable pomp and ceremony the chairman of the Carnival Committee, Fred Beard, continued his speech: 'This ceremony will be recorded in the annals of the history of Macclesfield and thousands yet unborn will one day read of what we are doing tonight.'

Despite the fact the carnivals were well supported, the death knell tolled in 1935 due to a controversy. That year Miss Iris Barnes had been chosen, but by January 1936 it was reported that she was 'tired of her job' as silk queen. Her complaint, that her speeches had not been written for her, and a further report that silk princesses from other mills considered it a waste of time, hit the headlines. Another girl, who had been unsuccessful in the final, said the other candidates had been treated 'shabbily'!

Councillor Abraham's speech, in counteracting the accusations, did not help the situation. His unfortunate choice of words, suggesting that the girls were not professional enough to take part in other events, such as in Olympia, London, did not go down well. Miss Barnes denied the report and he tried to talk his way out of the situation, but the damage had been done. The council, realising that the expense was growing each year, and things were taking a difficult turn, decided to abandon the project. Coronation activities soon took over, and then the Second World War intervened.

Revival

In 1969, Mrs Lister, trainer of the Morris troupe called 'Macclesfield Silkies', formed a committee with parents; the spring bank holiday of 1971 saw the first carnival since 1935.

The crowning of a silk queen was still considered part of the event, although the silk industry had virtually disappeared. The competition was thrown open to any young lady in Macclesfield who wished to take part, and the tradition of the South Park connection remained.

Until 2002 a carnival was organised in alternate years and again, although successful, with the retirement of the organiser, Mrs Ann Marsh, in that year, attempts in the following two years to try to co-ordinate the event failed. Over the years it was proudly recorded that more than £15,000 had been given 'to many deserving causes'.

Jenny Lind

Living close to the Staffordshire border, and the area known as 'The Potteries' in and around Stoke-on-Trent, pottery and porcelain have become a part of my life. While appreciating the finest that those Staffordshire factories could offer, especially in the eighteenth and nineteenth centuries, an introduction to Staffordshire figures, and their importance from an historical point of view, was quite a revelation.

Many represent famous people, such as politicians, army and navy heroes, artists and singers, and occasionally present a fascinating challenge in identification, if not already known. They are depictions of British 'entertainment', whether or not satire or admiration, and are a wonderful facet of social history.

A recent purchase from one of the local Macclesfield Friday market stalls in the centre of town was intriguing and begged further research. Although broken at one time and stuck together, which for this type of figure is not all that important, it is a nice crisply moulded one, being earlier out of the mould. When moulds had been used for a long period, the figures began to lose definition, so those of early production were the best. This one is earthenware, made for a more general market, but having studied the very large-looking bird next to the young lady, on what appeared to be a sort of stool, a personality came to mind. Having discovered illustrations of several beautiful porcellanous figures of that particular personality, my conclusion was proved correct. The figure would have been produced in around 1850. It is of the famous singer Jenny Lind (1820–87), otherwise known as 'The Swedish Nightingale'.

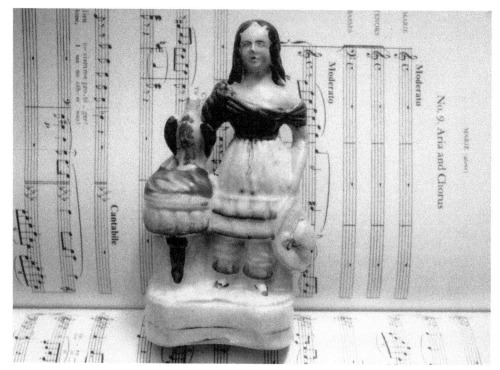

Unusual Staffordshire figure of Jenny Lind in the role as 'The Daughter of the Regiment'.

The figure represents her role in the comedy, *Daughter of the Regiment*, and although the bird resembles an eagle in proportion to Jenny's figure, it is surely meant to be a nightingale. The potters of Staffordshire had their own way of representing their favourite personalities; perhaps the one who created this figure was trying to say that, although she sang like a nightingale, her reputation was such that it was more akin to the king among birds, the eagle.

I first learnt of Jenny Lind from my father, who told me that when he was a schoolboy in the early twentieth century, she was still remembered and talked about with great affection and admiration. Her high notes were phenomenal, but she did strain her voice at one period and had to be retrained.

The local *Macclesfield Courier* newspaper wrote of her many successes, too numerous to count, for she particularly endeared herself to the British public by her more than generous contributions to charity.

Performances

Late in 1848 she gave two performances in Manchester, which resulted in a sum of just over £2,500 being given towards the building of an additional wing at the Manchester Royal Infirmary; there is no doubt that one or two of the wealthy Macclesfield gentry, who had connections through business in Manchester, would have been there. Another local connection was with the Stanley family of Alderley Edge.

Revd Edward Stanley, brother of Sir John Stanley, 7th Baronet, was rector of Alderley for thity-two years. He, and also his brother, had always involved themselves in Macclesfield affairs and were highly thought of. On 29 April 1837, it was announced that the minister had become Bishop of Norwich, much to everyone's delight in the area.

In 1847, the bishop and his wife invited Jenny Lind to the bishop's palace, where she had given a performance for charity and had made a promise to return. However, due to an extensive tour in America, scheduled to end in 1849, she refused many engagements in England, but with persuasion from the bishop she performed once more in Norwich.

After her gruelling American engagements, when she gave ninety-three performances in a little less than two years, she severed her connections with the organiser and decided to retire. It was at this period that she took time to recover and retrain her voice; in January 1850 she was reported as being in Switzerland and once more singing. She had returned to Europe with her new husband and accompanist, Otto Goldschmidt, and they eventually settled in England. Otto formed the Bach choir in 1875, with Jenny training the soprano choristers, and in 1882 she was appointed professor of the newly founded Royal College of Music in London, but finally retired from singing a year later.

Pickford Hall

Today, leather is immediately associated with the fashion industry in the form of shoes and handbags. A second thought would be furniture and saddles. Until the twentieth century, leather was important for so many other things; for instance, the mining industry made good use of leather hats and buckets, and alehouses often used leather jugs. It should be no surprise therefore to discover that in earlier centuries, instead of wallpaper, tapestries were the choice of the wealthy, followed by silk, which adorned the walls of grand mansions in the eighteenth century, but in-between times leather was used, either embossed or gilded, as in the case of John Pickford's Old Hall at Ashton in Lancashire.

In Macclesfield, the Pickford family also owned a hall, known as Pickford Hall, which stood somewhere on the site of the present-day United Reformed Church. The site of this hall is confirmed by title deeds, which I was kindly given permission to see by the Church Elders in co-operation with their solicitor.

The first deed referred to in the document is that of 11 June 1767, and related back to previous buildings on the Pickford plot of land in that area, which at that time actually occupied both sides of the Dams Brook. This indicates that the stream dissected the plot into more or less two equal halves, across which a bridge had been built, appropriately named Pickford Bridge.

A deed of 3 December 1783, relating to the half-plot on which the church now stands, clearly stated that a house called Pickford Hall had previously occupied the site, together with cottages, outbuildings and a large barn. There had also been a tan yard, but that had been converted into a garden later for the house. James Pickford the Elder is recorded as a tanner on a separate deed

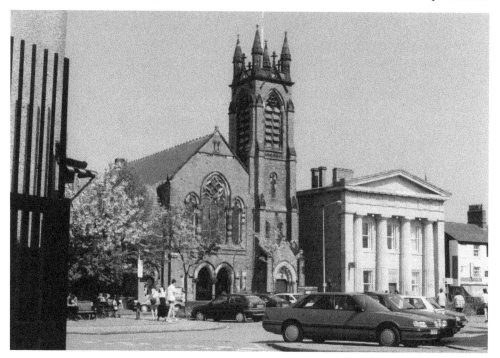

The United Reformed Church, Park Green, which now occupies the site of the former Pickford Hall.

of 10 October 1623 in a family collection of documents, when he purchased some land in Sutton from a William Swettenham.

From entries in the Prestbury parish registers there is evidence that one or two members of the family were already in the area during the reign of Elizabeth I. However, a century later it was the grandson of James, called Jonathan, who would establish his branch of the family at Ashton-under-Lyne.

The tanning business appears to have been an important and lucrative one, which suggests that business connections in that area resulted in the marriage of Jonathan and Alice Lees at Ashton on 15 June 1669. Through their marriage settlement, property belonging to the Lees family at Altehill, 3 miles from Ashton, was included for the benefit of their heirs.

In all, they had five children: two sons and three daughters. John was the elder son and James the younger one but, by a quirk of fate, although John was heir, he and his wife would have no children, so on his death the inheritance left by their father passed to James, including the Macclesfield holdings.

Their father Jonathan died in 1690 and by his will Alice, as widow, received income from several Macclesfield properties for the remainder of her life, and apparently took up residence in Pickford Hall.

The eldest son, John, lived in the Old Hall of Ashton after his marriage. Although he inherited all the properties from his father, Jonathan had ensured that £1,000 was given to trustees for the education of younger son, James and his three sisters.

A description of the Old Hall, Ashton, in 1842 paints a rather gloomy picture. The hall was regarded as having a somewhat severe appearance, surrounded by stately gateways, courtyards, moats and drawbridges, and was reported to have been at least 400 or 500 years old. It had been 'modernised' from time to time, but there was one important feature that was well remembered: at one time the large room had been hung with gilded leather. This would have been extremely expensive to create and begs the question whether or not the Pickford tanning business in Macclesfield had played a part in its creation.

Tanning was a difficult and dirty business needing plenty of water, so John's grandfather, James the Elder, had wisely acquired a plot of land in Macclesfield through which the Dams Brook flowed, almost at the end of its journey to join the River Bollin close by.

On the site, partly occupied today by the United Reformed Church on Park Green, as already stated, the tanner James the Elder had created his business complex comprising a house with outbuildings, a large barn and tan yard behind. On the other side of the stream at some point a dye house was built, probably in connection with the tanning business.

By 1728 the dye house was very old and permission was given to John Pickering to convert it into a 'twisting house' to twist yarn for the button industry, which had rapidly advanced during the latter part of the seventeenth century. This part of the site was later developed by Charles Roe, beginning with a small silk-twisting mill in 1743–44; it expanded considerably during the following years and finally reached Waters Green.

Processing

Tanning was the art of preparing raw hides or skins received from butchers for use in the leather industry. The demand for 'heavy' leather was considerable, however, in Macclesfield there was an affluent glover named John Norbury (d. 1678) who would have needed 'light' leather for making gloves.

The tanning process was in three parts. First the horns and tails were cut off the hides and washed in water to get rid of the 'blood and gore' and then placed in a stone pit, full of a weak lime solution. This was strengthened as the process continued over at least ten to fourteen days. The hides were periodically taken out of the mix at first, but then left longer. Great care was taken to check when the hairs were ready for scraping off, so as not to 'burn' the skins.

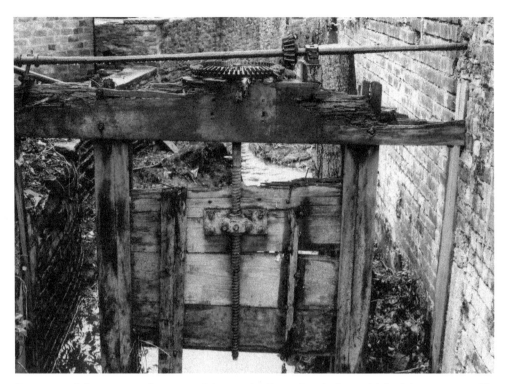

Remnants of the seventeenth-century sluice on the Dams Brook from Pickford Street presumably created to redirect water to and from the tan yard originally sited to the left of the photo, and the dye house to the right.

The next stage, lasting four to eight days and called 'baiting' ('to bait' meant 'to beat'), rid the skins of the fatty tissue adhering to the flesh side. The most effective method was by submergence in a mixture of hen or pigeon dung and water, appropriately called a bait. This reduced the leather to a softer and mellower state, which was then worked on a bench with a tanner's knife with frequent washings in clean water.

The final process was that of oozing, for which tree bark, the most favoured being oak, was pounded and mixed with water. The skins were then submerged to allow penetration of the liquid, which was checked by cutting off a small piece of hide.

After this the hides were dried, and presumably James Pickford had built the large barn for this purpose. At this stage they were stiff and too hard for use, so it was the turn of the currier to perfect them as required. This is probably when the Pickford hides were taken to be treated in the dye house on the other side of the stream across Pickford Bridge.

The leather was either left in its natural colour or otherwise almost invariably dyed black by using copperas and a little logwood. The currier then oiled and shaved the skins on the underside to acquire the correct thickness required for making saddles, shoes, and so forth.

There was no shortage of cordwainers (shoe makers) in seventeenth-century Macclesfield, and although many shoes were created out of different materials, some of silk, the soles were all made from good strong leather.

By the time the widow, Alice Pickford, took up residence in Pickford Hall in 1690, it would seem that the tanning business was at an end, and created the opportunity to replace the tan yard with a garden.

Park Green House

There are two properties in Macclesfield that are unique to the area and, although they are listed properties, it is essential to stress just how important they are to the conservation of the town's history.

The Pickford family have been extensively written about in previous articles, and it is appropriate to write about these two particular properties 'in tandem' because, like Pickford Hall, they were both built on land previously belonging to the Pickfords.

The first property is Park Green House, the Flemish-style gabled-ended house with its main entrance on Sunderland Street, and reminiscent of the reign of William and Mary (1689–1702). With their arrival from the Netherlands, many artistic styles came with them and became popular, first in London and then in the provinces, but their greatest achievement was encouraging the founding of the Bank of England in 1694. Surprisingly this gave the impetus to the already advancing Industrial Revolution, the seeds of which had been sown with the Restoration of the Monarchy in 1660, and, as elsewhere, this had a considerable effect on Macclesfield trade.

The Pickfords from King Sterndale near Buxton, just over the Derbyshire border, had settled in Macclesfield by the mid-seventeenth century. They soon held important civic positions, in particular that of mayor and town clerk, especially during the Commonwealth period. At the same time they acquired large areas of land, both within and on the outskirts of the small borough.

One of these encompassed what is today Sunderland Street, leading from Park Green to Waters Green, and known by the medieval name of 'Eyes', meaning 'enclosures'. It soon acquired the name of Pickford Eyes, part of which was leased out by the family as a form of investment.

 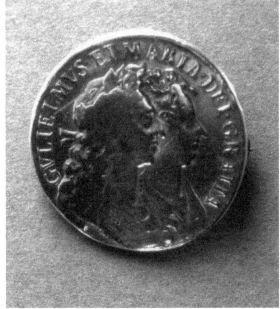

Above left: Park Green House, built *c.* 1720, with its original interior now excellently restored.

Above right: The Flemish style attributed to the reign of William and Mary (1698–1702); images on their coinage courtesy of John Bentley.

On 6 March 1713, John Pickford, the then owner, leased 12 acres in Cheshire to a Manchester mercer Thomas Bradshaw, which, since acreage in the United Kingdom became standardised, is now equal to approximately 25.25 acres. This was done by the creation of a loan, and then Bradshaw subleased to a Robert Nixon.

By 1722 Nixon (spelt on one deed as Nickson) had created a separate plot of land out of the acreage, which measured 22 yards by 34 yards, then built a house on the plot, today's Park Green House, and added a barn. This property was subleased for a short period to a Henry Orme, who was possibly of French descent. William Moreton took over the lease, but died leaving his son, Christopher to take over the premises.

Finally, on 18 February 1726, the house, barn and plot of land were leased to a cooper called Urian Whilton, who appears to have been a Quaker. Quakerism came early to Macclesfield via one of the Pickfords who had business dealings in Derby.

George Fox, founder of the Quakers, had begun his work in 1646, then, dragged to court in Derby in 1650 by the Parliamentarians, had warned those present that they should 'tremble at the voice of God'. This created the name of Quakers for those who followed Fox's teachings.

Meanwhile Joseph Pickford, brother of John, having moved to Ashton-under-Lyne, had a flourishing business in cotton manufacture and he directly leased the land to Whilton.

On 27 May 1744, Urian's daughter married a dyer, Thomas Royle, whose surname became Ryle. After Martha's father had died, Thomas leased the property with an increased area of land. By May 1768 he had built a dye house, predominantly for silk, alongside the River Bollin and renewed the lease for 999 years; the land became known as 'Lower Eyes'. This was the beginning of a very lucrative business. From its very creation, the house was a merchant's house, and restoration by its present owners, including removal of partitioned walls, has surprisingly uncovered many of its original architectural features.

The Architecture

The architectural characteristics of Park Green House are certainly unusual today. To date it has been impossible to find another extant town house in England of around the same time that also has the same combination of features.

The Gable

In the years 1605, 1606 and 1607, James I issued royal proclamations to ensure that the fronts of all new buildings were to be completed in brick, stone or both. However, town houses on the outskirts of London, and in the provinces, tended to continue using timber.

In 1619, John Smythson, on his visit to the capital, saw and drew a new style of building, that of Lady Cooke's house in Holborn, the area of London accommodating the inns of court. He discovered two more houses close by with brick fronts surmounted by curved gables with scrolls, and topped with pediments. This style was in vogue during the 1630s and 1640s until the innovations of Indigo Jones took over. It has been suggested that Jones could have created this Holborn gable.

For some considerable time the architectural label given to this feature has been accepted as 'Dutch-gable', however, at this early seventeenth-century period no such gables were to be found in Holland. In 1980, W. Kuyper of Delft University wrote: 'There is every indication that this Holborn gable is an independent English contribution to the development of the old gable.'

In 1645, a house development in Leiden, Holland, does show a 'Holborn' design without scrolls, cornicing or a string course between the upper and lower stones. Kuyper also mentions that a Flemish refugee adorned Leiden town hall with 'Protestant style' gables. It was only in the 1660s that gables with large concave sides began to appear in Amsterdam, on the ridges of which garlands of fruit were hung.

A more recent essay (2009) on the subject by Hentie Louw of Newcastle University also reiterates that 'the so-called Dutch gable in England is not really Dutch in origin'. It is now considered to be Flemish in style, which had been adopted by the Dutch and originally seen in Antwerp.

As Park Green House was built in around 1720, it must have been inspired by the Dutch, or to use another alternative, have had the Netherlandish influence of William III and Mary (1689–1702), particularly as fashion in the provinces always took much longer to establish itself than in London, and the renaissance of this particular style in England had certainly been influenced by the two sovereigns.

It is a well-known fact that styles have usually come back into fashion around every 100 years. However, if one is going to use the expression 'Flemish' rather than 'Dutch', is this still correct for the house on Park Green in Macclesfield?

The Italian Connection

Sebastiano Serlio began his career as a painter and lived in Rome from 1514 to 1527, at which time Rome was sacked. He then moved to Venice and remained there until the early 1540s. During this period he wrote *On Five Styles of Buildings,* published in 1537, in which he acknowledged his mentor, Baldassare Peruzzi, who had left him his drawings and whom he regarded as his 'guiding spirit' for the detailing and study of the remains of antiquity. He was the first to incorporate drawings into his handbook on architecture, using Peruzzi's and Bramante's drawings in addition to his own. In this work he reproduced his model for a church façade, which clearly shows the idea of a curved gable.

After the initial publication, Serlio published four more books during his lifetime, while a further three were published posthumously. The seven handbooks, published as one treatise under the heading of *Tutte l'opere d'architettura et prospetura,* were translated into English as the *Complete Works on Architecture and Perspective (1537–75)*, and other European languages in 1611. The early publications had already attracted the attention of Francis I of France, who had recaptured the French possession of Milan in northern Italy in 1515. This resulted in Serlio leaving Venice to settle in Lyon, where he died in 1554, having taken part in the building of the Palace of Fontainebleau. Not only did this treatise inspire Francis I of France, but it must surely have inspired both Lady Cooke and her architect when considering her new house in Holborn.

The Attic Window

The half-moon attic window, set in the gable, was a feature first discovered by the Roman architect Andreas Palladio (1508–80) in Emperor Diocletian's baths in Rome, and is consequently also known as a 'Diocletian or thermal window'. Palladio used this design extensively in his buildings, together with other ideas gathered from the ancient ruins in the city; his style became known as Palladian or Italian Renaissance.

Diocletian (244–311) born in Dalmatia, modern-day Croatia, was Emperor of Rome for twenty years to 305; he then returned to live in his villa in Split until he died. During his time in Rome he was responsible for the creation of the largest Roman bath complex in the city, which could accommodate 2,500 people at the same time. The half-moon windows featured throughout, yet the central opening, with its arched top, was not a Roman original but Etruscan by design.

The Etruscans, who were an earlier civilisation than the Romans, lived in the part of Italy mostly occupied by Tuscany today. Originally they lived in caves from around 800 BC and buried their dead in beehive-shaped graves created in small hillocks. They invented the arch in which the central key stone disseminates the weight of the building above, down through the semicircle of stones of which it is the apex. A possible idea suggested by the natural curves with which the Etruscans had been used to living.

Etruscan ruined arches exhibit columns of large stones down either side of the archways, a feature that in many Roman buildings was replaced with round columns or square pilasters. Both

the Etruscans and the Romans adopted their main ideas from Greek architecture, and it has been suggested that, when tracing the roots of the Indo-European language unique to Etruscan society, they may have settled on the Italian coast from their original home of Troy. Hemmed in on all sides, Etruria, which had grown into a highly specialised society famed for its high quality metal work, was eventually absorbed into the Roman state and had disappeared as an independent confederation by around 200 BC.

The Venetian Window

The alternative name for this feature is the Serliana window, named after Serlio. It has three panes, the centre one of which is arched at the top and wider than the two accompanying ones placed one on each side of it.

Robert Nixon, who was responsible for the building of Park Green House, must have seen the design somewhere. The artist, William Halfpenny, produced an illustration of it as an example of the Palladium style in his publication *Practical Architecture,* published in London two years later.

Halfpenny, an English architectural designer and carpenter, wrote a series of books in which he examined the five orders of architecture, and illustrated a large number of windows and doors from the work of Indigo Jones. This provided a guide to the proportions of the composite parts. It was a popular aid to builders who used it to create a range of ideas for including in their projects throughout the country.

In Macclesfield, the Venetian window in Park Green House inspired two of the most important townsmen to follow suit some time later viz. John Stafford in modernising his Jordangate residence, which became known as Cumberland House, and Charles Roe, for his Chestergate house. Later versions of the nineteenth and twentieth centuries are somewhat superficial when compared with their eighteenth-century counterparts.

Original Chinoiserie tiles.

The Sash Windows

Before becoming King of England, William of Orange had visited London in 1677 for his marriage to Mary. His accommodation was an apartment in Whitehall palace, which had been newly furnished with sash windows. On returning to Holland it was he who had possibly inspired the adoption of English sash windows in preference to the Dutch style. The fully developed English style was of a typical hollow box-like construction, although from the outside the two styles appeared identical. The English sash windows are well represented in Park Green House.

Building Materials

In 1696, one of the Macclesfield burgesses, Nicholas Thornley, asked permission to build a brickworks on Macclesfield Common; the latter an area rising steeply on the eastern side of the town. Although there was a little resistance, the acceptance was won and the mayor and committee agreed the area in which it could be established. Thornley built his kilns and

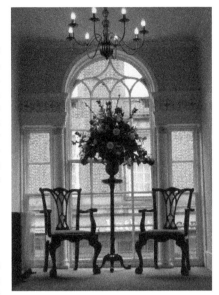

Beautiful Venetian window overlooking what is today Sunderland Street, formally eighteenth-century Pickford Street.

surrounded the works with walls, but one year later rioters, assisted by a minority of burgesses, tore down the walls and dismantled the kilns.

Twenty men were apprehended, charged and sentenced at the assizes, Thornley was compensated and his entitlement to the brickworks was confirmed. There is little doubt that the bricks used in the building of Park Green House came from this works nearby on the Common.

Stone was also available from the quarries on Macclesfield Common. Its content was gritstone with variable amounts of sand, which was easily worked although somewhat rough and liable to discolouration and soiling.

From the mid-seventeenth century, despite restrictions due to the Navigation Act of 1651, Britain continued to acquire, via the important port of Amsterdam, basic building materials and luxury goods such as Italian marble and the Dutch or Delft decorative tiles and pan tiles. Clay products were a Dutch speciality, in fact clay was their only available raw material and as a consequence they had perfected the production of bricks, so much so that many thousands were imported along the eastern seaboard of England.

In the early 1670s, Roger Coke wrote a treatise on trade, and highlighted the important position that Dutch clay imports had attained in the English economy, and suggested that local manufacture should be improved instead. Perhaps this had been the inspiration for Nicholas Thornley in his attempt to set a fashion for a new style of building in the town, rather than the stone buildings that had begun to replace the old timber Tudor houses during the early part of the century.

The front façade of Park Green House, built at a time when the rough track of what would later become Sunderland Street, led to a small bridge at the far end across the Dams Brook just before it entered the River Bollin. However, there is another question to be answered: why would such an elaborately designed frontage have such a plain gable above?

If it is to be regarded as truly Palladian in style, then it would have had at least finials of some design on the lower cornerstones on either side of the curved gable ends. Whether or not it possessed a pediment of some description may never be known, but perhaps a clue to finials lies in the fact that when the building on its eastern side was adjoined to it (apparently at some time in the late eighteenth century), the corner stone on that side, together with the corner brickwork, disappeared.

It is known that at some point in the early twentieth century a large urn could still be seen on the right-hand side of the curved gable-end cornerstone. In all probability, although the left-hand urn was disposed of, that on the right-hand side had remained in situ for some time. This could have left an overly elaborate-looking pediment, which, for safety reasons, was removed at the same time as the urn on the right.

Italian Renaissance features were very much considered a Roman Catholic tradition, hence the reformation of Dutch architecture after they had won their independence from Spain.

(I am extremely grateful to the staff of the Kantorowich Library in the Humanities Department of Manchester University for helping me track down the architectural information for this article.)

The Dye House

Along with its important silk industry, Macclesfield had also developed an important companion dyeing industry, possibly inspired initially by the leather dyers with their use of the abundant supply of water flowing through the town. The Pickford's leather-dyeing industry of the seventeenth century, which seems to have been one of the most substantial, was replaced in prominence by the Ryle's silk-dyeing industry of the eighteenth century.

The silk mills of Macclesfield in the eighteenth century were predominantly spinning mills. They supplied the local button trade with silk thread and also sent yarn to other areas for sewing, embroidery and weaving etc.

Charles Roe, having built the first mill in 1743–44 on Parsonage Green and a large mill housing Lombe (Italian) machinery in 1748 on Waters Green, became associated with the Ryles, whose premises were close by the original smaller mill.

The former Ryle dye house, as indicated in the deeds, appears to have initially stood behind the house in the form of a barn. Its replacement, however, was a far more substantial building next to the River Bollin on the southern side of what is today the Memorial Park, at the southern end of Park Green (then named Parsonage Green) and alongside London Road. Even so, it could easily be viewed from the house, and was only a three-minute walk away.

The Dyeing Process

Initially Thomas Ryle would use wooden vats for dyeing the hanks of spun silk thread. In shape the vats were similar to half barrels, or square-shaped and presumably made by Ryle's father-in-law, Urian Whilton. They were known as dye-becks (a beck being a tub or vessel) but the Macclesfield dyers called them balks or balques (possibly a French or Huguenot term).

The hanks or skeins arrived after spinning with the gum from the silkworms, known as sericin, still holding the fibres together, and this had to be thoroughly but carefully washed out before dyeing could take place.

Each hank was looped separately onto a long pole of green wood or ebony and allowed to hang down over the dye-beck containing boiled water, to which pure olive oil soap had been added. By means of a winch, the pole was lowered, allowing the silk to enter the liquid. Another wheel rotated the hanks on the pole and they were also gently moved to and fro around the beck until devoid of sericin. After this process a weight loss of 20–25 per cent had occurred; the liquid was then retained, so that part of it could be added to the dye mix in order to keep the silk 'oiled'.

By the time Thomas, who no doubt began by working in his shed, had 'modernised' by building the substantial dye house in 1768, Charles Roe, having left the silk trade, had established an important copper works on Macclesfield Common. This suggests that Thomas Ryle would have bought large coppers for his new premises, which would have been installed in a stone slab over brick-built ovens. Surprisingly, this method was still used in Macclesfield until fairly recent times.

Stoves.

It had taken centuries to perfect the different colours from natural dyes and to try to prevent the bleeding of one colour into another when the silk was subsequently washed after purchase. Recipes were jealously guarded, although some secrets had travelled from East to West along the Silk Road.

Early Dyes

The first evidence of silk dyeing must, of course, be in China, where the production of silk originated. Initially it was the Imperial families who sponsored their own silk-producing establishments as a demonstration of their wealth and superiority. Soon court and government officials were included in the wearing of silk, and in time it spread among the wealthier classes and literati. The finest silks were kept for the emperor and his family, while the cheaper and plain silks were those offered in exchange for other goods or services, especially in the remote area around the Taklamakan Desert in north-west China.

There two principal trade routes around the desert, on which merchants travelled, converged to allow entry into the mysterious land of myths and legends through an area called the Gansu corridor.

Emperors considered bright yellow as the Imperial colour, and red was also a favourite, so these dyes were the first to be perfected, then, as later with pottery decorations, others followed.

Today in Uzbekistan, the revival of creating hand-woven silk carpets has also meant using ancient recipes of natural dyes. Using flowers, leaves, stems and roots of plants, together with minerals and insects, a variety of colours are produced:

Madder: beige and brown.
Cochineal: red.
Pomegranate: pink and red.
Saffron: yellow and gold.
Isparak flowers: yellow and orange flowers (mixed with madder).
Indigo: dark blue, light blue and green (mixed with Isparak).

Silk Button and Twist Warehouse

Above left: Former Cheshire Curtains premises outside.

Above right: Rear view with upper door to original warehousing.

From approximately the same period as the property on Park (Parsonage) Green, the same branch of the Pickford family also owned property in the centre of town.

The upper part of Churchill Way, from Chestergate down to the remnant of Exchange Street behind the supermarket store, was originally known as Barn Street, and curved to enter Millgate, now Mill Street. The reason for the name was because a very large tithe barn, known as 'The Great Barne', stood on the street just behind what is now the Indoor Market. The barn, together with buildings, a house and malthouse situated between the northern end of the barn and Chestergate, appear on a deed from 1662. They were owned by the Pickford family, who were rapidly becoming the entrepreneurs of seventeenth-century Macclesfield.

They monopolised the important beer-brewing industry of the town, and also the important leather industry. The site of their tannery, known to all as Pickford Hall, is now occupied by the United Reformed Church building on Park Green.

Barn Street was subsequently given the name of Derby Street, in remembrance of the Earl of Derby, who had owned land in the area but who was beheaded by the Parliamentarians. The young earl, unable to pay the large fine demanded by Parliament in order to recover his father's estates, saw his holdings in the Macclesfield area seized, the official expression being 'sequestrated'. It would appear that the Pickfords had purchased some of the earl's former properties.

Stanley Street

A deed from September 1711 refers to the house, which already existed on the Pickford site adjoining Barn Street and was in the area of where the Royal Bank of Scotland now stands on the corner of Chestergate and Churchill Way. By November 1711 another house and further buildings had been erected and were in possession of John Pickford of Ashton-under-Lyne.

The property, which is of particular interest, is that until recently occupied by Cheshire Curtains on what is now called Stanley Street, though a more appropriate name would be Stanley Square.

The original Stanley Street, known for centuries by its medieval name of Dog Lane, was renamed in 1827 and actually ran from what had been the market square (now part of Market Place), where the entrance to the Indoor Market is located, continued through the Mall and market area to the rear exit, which is nearest to the overhead car park entrance.

In order to create the Indoor Market in the late 1960s, a whole row of buildings was demolished between the property and the market, and the car park entrance was actually a square courtyard, part of a silk mill complex. This has caused confusion because it has been assumed that the previous Cheshire Curtains building was in fact one of the silk mills that stood on the original Stanley Street, and has therefore been given the name Stanley Street Mill. This is definitely a misnomer because the silk mills, which stood on the original street, were demolished with the rest of the street.

The Warehouse

The building itself was obviously a warehouse, having virtually no windows on the south-facing side, which were essential in a silk mill. Also, over the Stanley Street entrance a door high up in the building indicates it was a loading bay, which would have had a pulley to lift up goods to the first floor.

The first-floor windows are on the northern side, away from bright sunlight, which could easily have faded the colours. It would have also ensured that the building was more secure.

Although there are many silk mill buildings still standing in Macclesfield, the uniqueness of this building is that it is the only silk button and twist warehouse remaining in the town, and the original interior remains virtually untouched from when it was first built.

The Development

At the end of the Napoleonic Wars, the silk trade experienced one of its periodic depressions, but by the early 1820s it was thriving again and so encouraged the building of further factories. At this period, and earlier, mill premises were often shared by different manufacturers; in fact the word 'mill' originally referred to a loom as it was a mechanical object. Eventually it was adopted to mean the building into which a loom or several looms were placed.

Advertisements began to appear at this time in relation to silk mills built on Dog Lane. The silk mills were variously occupied and a silk mill complex developed around a courtyard at the western end of the street.

A stone building stood at the rear of the silk mills across the other side of the courtyard, evidently part of the property referred to on a deed from 1662, which dated from the time of the Pickford ownership in the seventeenth century. This would probably have been a one- or two-storey cottage building.

Many of the smaller stone buildings and cottages that remain in Macclesfield are of seventeenth-century construction. When the brickworks on Macclesfield Common began to flourish at the end of the seventeenth century, more and more of these stone buildings were replaced by higher brick buildings.

As the silk mill complex on Dog Lane developed further in the early 1820s, the two silk mills fronting Dog Lane required enlarged warehouse facilities. One mill was four storeys high, and the other three. The intention must have been to demolish the stone building at the rear across the far side of the courtyard and rebuild in brick to create a larger building. Instead it appears that having mostly removed three of the walls, part of the remaining wall was left in situ, then extended to a height of three storeys. This is clearly visible, especially from the outside of the building; from the inside, the entire ground floor inadvertently suggests that the whole building is stone built.

Interior wall built of stone in the seventeenth century.

Moss Family

Around this time it became a button and twist warehouse tenanted by a George Johnson Moss, who also leased two floors in one of the silk mills for his silk twist and silk manufacture.

The silk mill contained machinery turned by a powerful steam engine, and an advertisement from 8 March 1817 had declared that it was 'well worth the attention of silk throwsters.' There were three rooms almost entirely filled with machinery. Despite the fact it was meant to appeal to silk twisters, there was also a quantity of silk looms on the premises.

By April 1821 the complex was described as occupying 'an extensive and most convenient Ground plot' and situated 'in the centre of the town of Macclesfield'. It had reservoirs, which would have been quite small compared with what we are used to today, an engine house, gearing, and other features.

George Johnson Moss had been born in Stockport to Isaac and Martha Moss, and baptised in the parish church of St Mary's in Stockport on 6 March 1803. Only brief records of him exist, yet he and his family allow a glimpse back in time to the days of George IV (1820–30) and his brother William IV, just before their niece, Princess Victoria ascended the throne.

George Johnson Moss, although born in Stockport, moved to Macclesfield where other family members were in business as silk weavers. He would have served his apprenticeship until twenty-one years old, but whether or not this was in Stockport or Macclesfield is not known. He first appears in partnership with Abraham Moss in Sutton, where they are described as button makers in 1828–29.

Unfortunately his life was short, dying at the age of twenty-six years; he was buried on 2 April 1829 at the impressive Stockport Circuit Tabor Methodist Chapel. However, the 1830 Directory shows George, Isaac and Abraham Moss as button makers at the Stanley Street premises, but county directories at this time are quite often notoriously out of date by two or three years.

The other alternative could have been the retention of George's name in recognition of his founding of this part of the business.

The Will

His will, dated 23 March 1829, was obviously prepared just a few days before George died on the 29th, and he is described as a 'Button and Silk manufacturer' of Macclesfield.

His estate was less than £1,000, which does indicate a consequential business. He had two brothers who were presumably his partners, Abraham and Isaac; three sisters, all unmarried, Martha, Mary Ann and Eleanor; and also a daughter, Mary Drury, whose mother, a widow, had died.

It was not uncommon at this period for fathers of natural offspring to be concerned about their welfare and to leave provision in their wills. In this instance George asked his father to be the child's guardian and invested £200 at interest to be used for her maintenance and education. If for some reason the father was 'prevented' from acting as guardian then the interest had to be retained and, together with the capital, given to Mary when she was twenty-one years old. If she died before that age, it was to be divided among his sisters.

Apart from this he did leave money to his sisters and two friends, and after payment of debts etc. the remainder of his estate was to be divided between his two brothers. As his daughter lived in Liverpool, this indicates business connections in the port, and Liverpool, having shaken off restrictions to its import trade, which had allowed London to dominate for long enough, was now poised for even further expansion.

It would seem that after George's death his two brothers continued the business on Stanley Street. The last mention of their connection with the premises is an advertisement of August 1835, announcing a sale by auction of two silk mills, part occupied by Messrs Moss.

The Layout

Also listed in the advertisement is a substantial building 19 yards by 6.5 yards used as a button and twist warehouse, with a cross building adapted for three dwellings or 'warehousings'. This detail is far more specific than earlier advertisements and is the exact description for what remains on site today, i.e. the former Cheshire Curtains building with its internal size of 19 yards by 6.5 yards, and the three adjoining cottage properties, now occupied by other businesses. These together form an L-shaped group.

Properties that had adjoined the original silk mill on Dog Lane had been used as warehousing, but in 1821 the second silk mill had been built, so it is evident that a more substantial warehouse was necessary, hence the alteration to the stone building at the rear of the courtyard to create a substitute warehouse.

The description included the additional information that there was 'a good spring of water and plenty of hands in the neighbourhood'. The dwelling today known as Stanley Mews and situated close by the warehouse, although described as a cottage at that time, was adapted for use as stables, with six further cottages completing the surrounding enclosure of the courtyard.

By a quirk of fate in 1848, 'Messrs. Moss' were operating as 'Fancy Trimming manufacturers' on Pickford Street on the opposite side of town.

Until recent years the whole of the premises on the corner block of Chestergate, and what is now Churchill Way, were under the same ownership as investment properties.

Poetic Amusements

After the death of Lord Byron on 19 April 1824, there was virtually a stampede of poets rushing to have their own works published. Everyone seemed to be writing or discussing poetry, and the *Macclesfield Courier* also began to select and print, sometimes one, sometimes two, poems. Some were very entertaining, written by unknowns, and yet well worth the space in the paper. One such poem, which appeared in an October edition of 1824, could almost have been written a hundred years later. It was a catalogue of articles found in the kitchen drawer and stated to be 'A Fact'. It was addressed to the 'inattention of a modern housewife to the cleanliness of her cook'.

Three aprons, two dusters, the face of a pig;
A dirty jack-towel, a dish clout[h] and wig;
A foot of a stocking, three caps and a frill'
A brush and six buttons, a mousetrap and quill;
A comb and a thimble with Madona bands;
A box of specific for chaps in the hands;
Some mace and some cloves tied up in a rag,
An empty thread-paper and blue in a bag;
Short pieces of ribbon, both greasy and black;
A grater and nutmeg, the key of a jack;
An inch of wax candle, a steel and a flint;
A bundle of matches, a parcel of mint;
A lump of old suet, a crimp for the paste,
A pair of red garters, a belt for the waist.
A rusty bent skewer, a broken brass cock.
Some onions and tinder, and the draw'r lock;
A bag for the pudding, a whetstone and string,
A penny cross-bun and a new curtain ring;
A print for the butter, a dirty chemise,
Two pieces of soap and a large slice of cheese;
Five teaspoons of tin, a large lump of rosin,
The feet of a hare, and corks by the dozen;
A card to tell fortunes, a sponge and a can;
A pen without ink and a small patty-pan;
A rolling pin pasted, and Common Pray'r book.
Are the things which I found in the draw'r of the cook.

Macclesfield Courier Tips

Rice Pudding

From its earliest days as the *Macclesfield Courier*, the newspaper provided many useful tips to its readers, like the one during the crisis of 1812, when there was a shortage of wheat. Evidently this gave rise to the birth of good old English rice pudding.

The idea was to use rice as a substitute for flour. There was a particular scarcity in July of that year, and a resourceful matron of a foundling hospital produced some new recipes. The first was to use rice in puddings, which had been previously made with flour; this she fed to the children twice a week.

She discovered that in a baked pudding made with milk, 1 lb of rice would go almost as far as 8 lbs of flour. So delighted was she, that she had continued the rice puddings ever since. For her to cook one serving, however, the quantities required were considerable, because she was feeding 170 individuals. She used 24 lbs of rice, 9 parts of treacle and 18 gallons of milk.

She continued experimenting and recommended further recipes, which included stewing it with bacon and seasoning, meat, or with cheese. She also found that it was a good ingredient for bread.

To produce a very good white loaf of 1lb 14 oz., first 4oz. of rice had to be boiled until quite soft. When drained it was mixed with a teacupful of yeast, a teacupful of milk and a small

Rice and potatoes.

tablespoonful of salt and left to stand for three hours. It was then kneaded, rolled about in a handful of flour and put in the oven. After baking for about one and a quarter hours it would produce the white bread, but it should not be eaten until it was two days old.

Useful Potatoes

Next, a new method for cleaning silks, woollens and cottons was found to be successful and therefore recommended. The idea was to grate raw potatoes to a fine pulp in clean water, then pass the liquid through a coarse sieve and into another vessel containing water. This had to be left standing until the fine white particles of the potatoes had settled. The liquid was then kept until needed, and two middle-sized pots were said to be sufficient for 1 pint of liquid.

Taking the article that needed to be cleaned, it was laid out on a linen cloth and then a sponge, dipped into one of the pots of liquid, was 'applied' to it. This was done until all the dirt was removed, after which the article was rinsed in clean water several times. This method was further recommended for all sorts of materials and guaranteed not to spoil the colours.

By April 1816, Butler's Chemical Scouring Drops had appeared 'for effectually taking grease out of silks, stuffs, woollen clothes' etc. at 1s per bottle. It was sold by Butler & Sons, No. 4 Cheapside at the corner of St Paul's in London, and by perfumers in Macclesfield, Stockport, Chester, Northwich and other towns in Cheshire and elsewhere. The instructions were hopefully on the label, so we can only assume how it was used by customers.

At the same time a very interesting item called 'Vegetable tooth powder' also found its way into the column of advertisements. 'It will preserve teeth in a sound state even to "old age" if used constantly'. This was bought in boxes at 2s 9d each (14p). Although this sounds very cheap by today's prices, when considering that the most a skilled silk weaver could earn was 14s per week (70p), it was actually very expensive.

The Great Storm

On 5 January 1839, a freak snowstorm hit Ireland, something that had never before been heard of. The next day temperatures rose sharply to well above the average for that time of year, melting the snow. However, on the 7th a bitter cold stream of air brought hurricane conditions with winds up to 100 mph.

The storm hit the English coast with enormous ferocity and Liverpool suffered a devastating night, after which people ventured out to see piles of bricks and rubble piled in the streets – the result of chimneys, walls and parts of buildings hurled to the ground. The death toll was large, and there were many injured.

As it arrived in east Cheshire, one of the pinnacles on St Peter's Church in Prestbury, together with the weathercock, crashed to the ground. Worse was to follow in Macclesfield.

The lead off one building was blown off, followed by several chimney stacks around the town, but unbelievably the most terrible damage occurred in Sutton, just over the border with Macclesfield and around the High Street and Cross Street area.

The Wood family, cotton and silk manufacturers, had taken over the remains of the Old King's medieval corn mills, which were situated opposite the Three Crowns Inn on Cross Street at the corner of Mill Green. These they had converted into a mill, which was leased to a partnership.

In 1810, Charles, Richard and Samuel Wood had created a reservoir to supply their mills in Sutton. It was fed by a large reservoir on the other side of London Road, today a large field opposite the football ground. The watercourse crossed the road and the remains of the channel can still be seen running along in front of St Edward's Church; it then deviated along the eastern boundary of South Park to enter the reservoir known as Wood's Pool by means of a sluice.

The top of Hobson Street, with the path into South Park. Behind the retaining wall on the right was the area where Wood's Pool was created. (see *Past Times of Macclesfield*, Vol I., p. 53).

Inset: Details of the boundary stone of 1822; this marks the boundary between Macclesfield Town and the parish of Sutton.

Wood's Pool

At that time Wood's Pool was a rectangular basin fed by a shallow pool of the same width, but when both were full there seemed to be just one reservoir. The descent from the reservoir down to the factory was very steep, but the Woods had engaged Mr Webb of Derby under the supervision of Mr Hughes of Manchester to construct the system – both were eminent men.

A Mr Podmore and his son had rented fishing rights in July 1836 and constantly visited the reservoir to stop poaching but had never noticed any defect. The mound holding back the water was considered sound and well constructed.

Early during Monday morning the storm arrived in full force; the details of that awful night were later revealed at an inquest held in The Flying Horse on London Road. Mrs Milner told of her terrifying ordeal when she heard a dreadful noise around 2 a.m., which sounded like the steam going off at the Wood's factory. She looked out of her back window and saw what looked like the sea. Some time later her husband went downstairs and tried to clear out some of the water but went back to bed not realising that the tragedy was not over. It would have been dark and he probably thought it better to wait for daylight. However, a little later he went down again and saw the water still rising; rescuing the family Bible and *The Life of Christ* he returned upstairs and told his wife to get dressed.

The water in the reservoir was already full when the wind blew with great force against the bank. Some of the water was forced out, and the pressure of the gale impacted on this weakest point; then slowly but surely the whole bank gave way, allowing the huge volume of water finally to come rushing down the hill towards Cross Street and Mill Green.

The surgeon, James Milner, had built three houses on High Street parallel to the eastern end of the embankment, one occupied by his brother. Other houses had been built in the area, some on the lower side of High Street. Fortunately there were spaces between and some had stone walls adjoining.

As the water rushed down it demolished parts of Mr Milner's uninhabited houses and part of a wall at the rear of Manifold Buildings, which fronted Pitt Street. Close to the buildings was an irregular open space with a passage leading out at the bottom end into Cross Street.

The corner of Pitt Street and Mill Road. Before High Street was extended, this corner caught the full impact of the flood. On the extreme left at the bottom of Mill Road, on the opposite side of Cross Street The Three Crowns Inn can be seen (now renamed The Macc).

The Flood

As the events of the terrible storm of 7 January 1839 were recounted by several witnesses before the coroner's jury, several tragic stories were revealed.

Manifold Buildings, which fronted Pitt Street, were secured by wide double doors and there was a wall at the rear. At first only part of the wall was washed down as the water poured across the open space, through the entry at the bottom and into Cross Street. But later, as the whole of the embankment gave way, the full force hit and demolished the remainder of the wall, and burst open the doors of Manifold Buildings. A young boy who lived in the entry was swept away, and the body had still not been found at the time of the inquest.

The water reached 4 feet in the Cross Street houses, with one filled to a height of 5.5 feet, and there a Mr Armitt drowned. Furniture, possessions and clothes were swept away in the 'extremely rapid' current and the floor of the cellar in the Traveller's Rest was 'torn away'.

William Royle, brother of the landlord of the Travellers Rest, who lived there with his wife and baby, reported that he heard a great noise. He immediately went to the window from where he saw the street flooded. Making his way downstairs, he waded through the kitchen, afraid that they all might drown. He tried to open the back door but it was impossible because of the force of the water. Thinking the best idea was to smash open a window, he did so with his foot, but unfortunately gashed his leg on the remaining jagged edge of the panes. He must have bled badly because in one place it was cut through to the bone. Undeterred, he managed to wade through the adjacent entry into Cross Street, although he was only wearing his shirt and nightcap. He eventually reached a house near to the Three Crowns and sat there, bleeding for two hours, until the water went down. Eventually he managed to send a message for some clothes to his brother at the Travellers Rest, and having got dressed returned to his family.

His wife said that as soon as he had got out of the kitchen the floor gave way, and he had been very lucky. She was left in a terrified state with the baby, and decided to try to follow him, but was unable to get through the window holding the child. She remained at the bottom of the stairs, and then heard the floor give way in the kitchen. Peering round the corner, she saw all the barrels floating on the water in the cellar below.

The Travellers Rest, Cross Street – now converted to a convenience store.

As the flood water began to subside, scavengers with lanterns were soon eagerly collecting whatever they could, and the residents had a difficult time trying to prevent their furniture being stolen.

Devastation

As the water finally reached the River Bollin across Mill Green, it carried many of the residents' possessions with it, and some were even found floating through Prestbury village. The volume of water in Cross Street, having created a tributary, swept as far as Park Green and continued along Sunderland Street, where many businesses suffered damage.

Poor Thomas Armitt, the man who had drowned, had been hit with such force as the water entered his house that he was found with his legs pushed through a panel in his front door. When the door was finally broken down, his dead body was found with all his furniture, pitchers and other belongings piled on top of him.

Two sisters who worked at the Wood's factory heard the factory bell ringing at 5.15 a.m. They evidently lived close by, but not near enough to appreciate what was happening. Ten minutes later, making their way down to the factory, they saw water pouring down one of the streets. Changing direction they decided to head for Mill Lane, but when they turned the corner found that it was just impossible to go any further. At the same time a man with a wagon and three horses was coming along, wading through water up to his middle.

The Damage

The bursting of the reservoir in Sutton, used to supply Wood's large cotton mill, will be remembered for a very long time. It must have seemed incredible that what looked like a comparatively small reservoir of water could do such colossal damage.

As the water had descended on the few newly built houses on High Street, it gushed down Mill Green Street (now Mill Road) and down into Mill Green, soon to be swelled by that pouring along the remainder of the street, which concentrated its main force in the middle area.

Fortunately only three people were killed: Ruth Oakes, an old lady who lived in Slack's buildings, which were close to the Manifold Buildings; the ten-year old boy who had been swept out of the entry between the buildings; and, of course, Thomas Armitt, who was fifty-eight years old.

The ten-year-old boy was Joseph Higginbotham, who had been getting dressed with his brother. They had both put on their shirts and rushed out of the room, while the rest of the family had quickly climbed onto the furniture. Thinking the boys were safe, the family had no idea they had been swept outside. Joseph was lost, but James was seen floating along by a neighbour 'like a boy of wood' and in a very bad state; the man grabbed him and pulled him to safety.

Everyone else in town had survived the night of 'The Great Storm', as it came to be known, although several were injured, and as the evidence at the inquest continued with regard to Sutton, some miraculous escapes came to light.

Survivors

Some people lived in the cellars on Cross Street and had been lucky to survive. A few, not realising the force of the water, had opened their doors and inadvertently let in the floodwater.

Many residents had been in bed when the flood hit and, on getting out of bed, found that they could not go down the stairs. One woman had actually been 'washed out of bed' and was carried down the entry into Cross Street then across Mill Green to Poole Street, where she managed to catch hold of a door latch of a house and pull herself inside. The young man living there found her some clothes, but she was dreadfully hurt and all her legs were raw. When dressed, she was eventually taken to the Poor House.

A man and boy, on leaving their house, were carried down into Cross Street, where the man caught hold of a drainpipe. The water forced open the door of the house and they were swept in. The female occupant pulled the boy to the bottom of the stairs, wrapped him in a blanket and took him up to bed, he too had badly hurt his leg.

William Cockson, who was a butcher, waded up to his neck in water to save a horse.

Work as Usual

Two young girls who were on their way to one of the Brocklehurst factories met the flood as they approached the dye house bridge. They pushed up against Rowland Gould's door, and one of them managed to knock on the door while the other clung to her. Mr Gould, an important council member and former mayor of Macclesfield, immediately got out of bed, took them in and afterwards sent one of his men to carry them to the factory.

Another little girl who worked at Bullock's factory saw Peter Warren, who lived near the boarding school in Byrons Lane. The time was between 6 and 7 a.m. when she told him about the great flood in Mill Lane, and that she had seen men with lanterns collecting things. He told her to go another way to work and went down to see the devastation for himself.

One of the Wood family sent relief and calico clothes to the workers involved in the tragedy and a collection was made in town.

The storm had caused chaos everywhere throughout the country. It brought down large trees in Hyde Park and St James's Park. One Liverpool resident had been particularly fortunate: asleep in his garret when the chimney fell through the roof, he awoke when a policeman called his name. 'I'm here in the top room' he shouted, but he was actually under a huge pile of rubble in the cellar and still in bed. He was soon rescued, and must have been one of very few who had managed to sleep that night.

The southern end of Pitt Street. On the right is the former button and trimmings mill, built shortly after the devastating flood of 1839, on land drained of an original medieval pool that fed the king's corn mills for centuries.

Astronomy in Macclesfield

The earl of Rosse, an Irish nobleman, built his first large telescope in 1848 and his observations were recorded in the *Macclesfield Courier* in 1852.

On Saturday 22 May 2010, the Macclesfield Astronomical Society celebrated its twentieth birthday, which was important enough to be included in the August issue of the national magazine, *Astronomy Now*. Many founding members were present at the celebrations, including the president, the 13th Astronomer Royal Sir Francis Graham Smith, Vice; President and former director of Jodrell Bank, Professor Emeritus Rod Davies; and the Gresham Professor of Astronomy, Ian Morison. Apart from a talk by Professor Morison, an entertaining address was given by Dr Allan Chapman – 'Aliens: From Selenites to E.T.'.

However, Macclesfield's connections with astronomy did not begin with the creation of Jodrell Bank after the Second World War, but much earlier.

Lectures

The first record of astronomical lectures in Macclesfield was on 31 March 1838 but unfortunately it did not inspire much enthusiasm, as this somewhat intriguing incident indicates:

> We are sorry to report that the Philosophical Society and their friends have suffered disappointment and annoyance in the course of Astronomical lectures by Mr Dewhurst. We regret to add that the lecturer presented himself last evening before his audience in a state which compelled the assembly to retire from the room!

It was almost a decade before an H. Connell from the Edinburgh Observatory appeared to entertain the town, for at that period men of science were very much entertainers. The announcement was for two lectures, Monday and Tuesday evenings, 22 and 23 February 1847 in The Theatre, Macclesfield. This was the most convenient building for displaying the extensive illustrations, which included a considerable variety of 'Splendid Transparent Scenery of the Heavens', also models in motion with a 'Vertical Orrery'. Following the lecture was a display of 'Dissolving views' and a colourful finale with the use of a chromatrope. This latter item was essentially a kaleidoscope, from which the colours and patterns could be projected around the theatre by use of a lamp, and by turning the handle of the machine.

Little more is known at present about Connell, who was possibly related to a wealthy Glasgow merchant; nor even how the lectures were received, which seemed to be organised as an individual event.

John Wallis

The next character to appear, this time on behalf of the Useful Knowledge Society, can claim some important recognition. His name was John Wallis, resident of London. In the 1820s and 1830s he was so popular that, when the Royal Institution began its Christmas lectures in 1825, he presented the second one in 1826 and later in 1838.

With relatively modest fees compared with other lecturers, but colourful and spectacular lectures, he was in great demand. He came into the provinces, first to the Co-operative Institute in Manchester, and was re-engaged twice, then to Macclesfield in May 1848. He arrived with literally a ton of equipment and a great variety of transparent scenery with which to illustrate his subject. His London fees were 24 guineas in 1830 for a series of six lectures, later rising to 27 guineas, but the London Institution paid him 40gn. (i.e. £42). For the series of seven lectures in Macclesfield he was paid £29 9s.

Wallis was a great friend of the Congregational minister Robert S. McAll, who had been chaplain of the Roe Street Sunday School in Macclesfield from 1814 to 1823. McAll then moved to St George's Chapel, Sutton, and in 1827 to Manchester, but his early death in 1838 meant that at the time of Wallis's lectures in the town, McAll was gone.

Wallis undoubtedly came from a fascinating family. A likely ancestor was John Wallis (1616–1703) a genius in his lifetime; a brilliant mathematician highly regarded by Cromwell, who, because of his astronomical interests, had the asteroid Johnwallis named after him. He was also considered the best codebreaker, and by the interception of a French dispatch to Poland in 1689, sent to England for his attention, he prevented havoc in northern Europe.

By the late eighteenth century, a John Wallis was the largest producer of board games. These were used to educate people; they were colourful and highly popular. John and Edward Wallis joined their father in the lucrative London business; one of the popular games was that of 'Astronomy'.

As interest progressed rapidly during the second half of the century, more and more articles on astronomical discoveries from various parts of the world appeared in the local newspaper, many of which, surprisingly, were very much scientific in character.

The London Institution: engraving of 1827 by William Dreeble; the building was demolished in 1906.

Dr Sainter's Scandal

Portrait of Dr John Sainter 1878.

Of recent years, Dr Joseph Denby Sainter, a physician and surgeon of Macclesfield who was born in Snaith, Yorkshire *c.* 1806, has been lauded as someone who made an important contribution by recording prehistoric remains in the Macclesfield area. His discoveries culminated in *Scientific Rambles Round Macclesfield* (1878).

Arrival

Sainter's arrival in town was announced on 7 May 1836 when Mr James Cockson, a surgeon from Chestergate, Macclesfield, placed a notice in the newspaper.

Cockson had taken up residence at the 'Rookery just inside Bollington', but still attended his 'Old Surgery' from 9 a.m. to noon. His partner, Sainter, who lived on the premises, would send messages to him as necessary.

Anxious to assure everyone of Sainter's professionalism, details of his partner's medical training were included. Sainter was a former pupil of the late John Dow MD of Barnsley, Yorkshire, and had then gained experience in London hospitals. He had returned north to Sheffield General Infirmary to act as a dresser to W. Overden, a surgeon, as an accoucher (a man who helped women in childbirth). His education had been completed in London and he was fully competent to discharge his duties 'in all branches' of his vocation. This was most unusual: never before had a surgeon in Macclesfield given a published reference in respect of a new partner or successor. The residents of Macclesfield must have been extremely impressed by Cockson's words, for he was a well-respected doctor.

Later, when Sainter became an ardent member of the Macclesfield Scientific Society, submitting articles, sketches of prehistoric remains, and finally producing his book, nothing less than a glowing, or even a small, obituary would have been expected after his demise in 1885. Yet, there was none – why?

Court Case

Incredibly, what has never come to light during recent years is a scandal of his own making, which took place little more than a decade after his arrival in town. The story was thrust into public view at Macclesfield Town Hall on 30 June 1849 when the magistrates' court was in session; the public gallery was crowded to capacity and the story began to unfold.

Sainter had engaged a William Edward Fergusson as his assistant; a salary was agreed and a written document was signed by Fergusson stating that he agreed not to practise within 7 miles

of Macclesfield while the contract was operative. Again, this was unusual, because if Fergusson was qualified to practise medicine he should have expected a full partnership. Otherwise if he was not qualified he could not practise anyway without a licence.

Sainter had discharged Fergusson and initially the Macclesfield 'audience' was not given the reason for this. Fergusson had set up in practice in the forbidden area and, in order to stop him, legally Sainter had to apply to the Court of Chancery for an injunction, which he did. Having succeeded, he discovered that Fergusson had continued in practice. This was despite the fact that Fergusson was under threat of being taken into custody and thrown into prison for contempt of court. However, when applying for an injunction, the injured party had to prove that he had fulfilled his part of the contract, otherwise the court could not intervene. Fergusson had at once set out his defence and ardently denied the accusations made. The case was about to create a sensation, revealing details Sainter had tried hard to hide.

Evidence

The case of Sainter versus Fergusson began in earnest, with Thomas Parrott, solicitor and town clerk, defending Fergusson. An objection by the prosecuting council, Mr Monk of Manchester, saw Parrott relinquish his civic position during the trial, which was taken by his deputy.

Sainter had dismissed Fergusson without notice, accusing him of taking 'liberties with his wife'. Fergusson had refuted this in a statement witnessed by Parrott and another Macclesfield attorney, which had been sent securely bound with red tape and sealed to the Court of Chancery in London. This was produced by a Chancery Clerk who had brought it from London that day, and with further technicalities resolved, the case, by which Sainter accused Fergusson of perjury, was now underway.

Monk, Sainter's solicitor, started with a great flourish and, looking round the courtroom, declared that he was appalled at the publicity the case had received.

The first prosecuting witness, William M. Wilkinson of Lincoln's Inn Fields, Middlesex, had been attorney for Sainter in the Chancery Court case. He stated that he had known Mrs Sainter for over twenty years, since her childhood, and also knew her brother 'intimately'; the latter, a legal clerk in London, had recently died.

Having received a letter from Sainter, he had hurried to Macclesfield the same day, heard the story, visited Fergusson and told him Mrs Sainter wanted him to leave town. A stunned Fergusson accused the doctor of having 'a resentful disposition', he was an old man and she, just a young woman. At the time Sainter was aged forty-three and his wife was ten years younger.

Monk next called two witnesses, despite having initially pronounced that this case had nothing to do with what had happened between Fergusson and Mrs Sainter and was not to be mentioned. The first, Joseph Cookson, was a gardener whose parents lived and worked at the Westbrook House estate, later to become part of West Park. He saw Fergusson and Mrs Sainter meet on the road near the house and followed them through the town field, where they sat on the grass for a while. The court reporter was compelled to write that the evidence at that point had become 'unfit for publication' – a delightful phrase typifying Victorian sensibility.

Cookson accused them of trespassing, but they walked to and fro on Whalley Heyes Lane, trying to 'shake him off'. Having separated near Chestergate, Cookson was grabbed by Fergusson, who asked the night watchman from Woodward's factory to hold him while he went for a policeman, but Fergusson never returned.

Next, George Sidebotham, an artist, gave his account of seeing the couple in the dining room of the house when he called one Sunday. Days later, in the afternoon, he saw Mrs Sainter leave the house and surgery on Chestergate and followed her to Bowfield Lane (now Victoria Road), where she met Fergusson in a field. Cookson's description of what happened next, and the editorial comment, were repeated with added elaboration. Cookson had actually hidden himself behind a bush and, lying flat, had carefully taken off his cap and placed it on the ground. In cross-examining both witnesses, Parrott brought some discrepancies to light, for instance Cookson

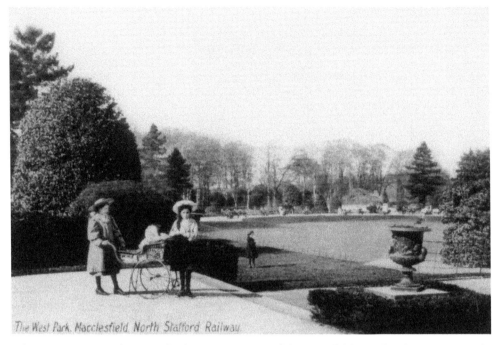

The West Park, Macclesfield, North Stafford Railway

Edwardian postcard of West Park, the area once part of the town field. Westbrook House is on the right beyond the sunken bowling green, with its much reduced area of land due to the creation of the park (see *Past Times of Macclesfield*, Vol. III, pp. 5, 7 and 120). (Courtesy of Julie Vohra and the Ollier Studio)

had noticed neither the gulley nor the stream where he said he had settled to observe the couple. And Parrott stressed that the two statements of the witnesses were totally uncorroborated.

Verdict

The magistrates left the courtroom to make their decision on the evidence given, but were only absent for fifteen minutes. They returned, saying it was 'their painful duty to commit the prisoner to Chester Assizes for Trial'.

There is no doubt that before sunset that day, the full details of the two witnesses would be known in virtually every household in the town, but this was far from the end of the story. It seemed as though the Macclesfield magistrates had made the most convenient decision. Now more expense would be heaped on the pair, with Sainter in a far better position than Fergusson to deal with it. Parrott said that unless adultery was believed to have taken place then he wished for Fergusson's acquittal, so a decision had to be made on the matter.

The judge concurred with Parrott's summing up that Mr Wilkinson's evidence had to be treated with caution. Despite the fact he had wanted to shield Mrs Sainter's character, by his actions the reverse was the effect and it had been 'broadcast to the world'. The conduct of the two principal witnesses had been 'most disgraceful'. Also, apart from Sainter, no one from his household had been brought to court to give evidence.

The jury had hardly retired before they returned with a verdict of 'not guilty'. Having made that decision, Fergusson was also found not guilty of perjury. However, before he left the dock the unfortunate man was taken into custody by the sheriff's officer for non-payment of £500 damages originally awarded against him in the first trial for setting up in practice with a specified area of the town, contrary to his agreement with Sainter. This was what he was appealing against.

Mystery

What happened to Fergusson is unknown, but there is a mystery surrounding the whole episode. Margaret, the former Miss Dow, daughter of Dr Dow of Barnsley, disappeared, leaving Sainter with his housekeeper and son James; in the 1850s Sainter moved from the Chestergate surgery to one in King Edward Street.

Dr Dow had died in 1832 when Margaret was seventeen years old. There is no trace of her marriage to Sainter, but a Margaret Dow married James Fenton on 17 June 1832 in Westminster, London. Had she joined her brother in London after her father's death? Also at that time, Sainter himself was supposed to be completing his education there. Her son, James Thomas Stevenson Fenton, was baptised January 1835 in Westminster.

Later, Margaret's son James finished his education at Macclesfield Free Grammar School, suggesting that he was not here during his early years. The 1851 census records the boy as fifteen years old and born in Macclesfield in 1836, the year of Sainter's arrival in town, but there is no trace of the boy's baptism in the area.

Upon leaving school, James Dow Sainter studied for the medical profession at Manchester Royal Infirmary and, in 1869, entered the army as a medical officer. He led a distinguished career, serving first in the North China War in 1859–61 and was decorated with a war medal. He then served in India and Arabia in 1862–77, and after retiring from India as a Lieutenant Colonel he was posted back to England. For two years he was in charge of the military hospital in Salford and Manchester, and was complimented at the headquarters for the excellent condition of the hospital.

After retiring from the army, he settled in Scotland and died at Caraigellachie in 1905. Interestingly, his obituary stated that he was born in 1835 at Prestbury and not in 1836, the year in which Sainter arrived from London.

In Sainter's will, dated 1879, he appointed James Hooley, a spice and tea dealer and William T. Hardern, a surgeon dentist, as executors. He left several bequests to charities out of a value of £2,897, and for some years had declared himself a widower. He left his servant Margaret Barrow any household effects that the trustees thought would furnish a small house, and sufficient money was invested to pay the rent of the small house out of the interest. She was fifty-three years old, and after her death any residue from the estate was to go to James Dow Sainter. Exactly what the relationships and circumstances were may never be known, although all sorts of possibilities come to mind; it is therefore better to leave the readers of this story to be their own judge and jury.

Camera Obscura

One unusual Macclesfield court case would have been quite sufficient for the town in 1849, however, they were 'treated' to another just before Christmas. It was a smaller affair and took place on 13 December, not in the town hall as Sainter v. Fergusson, but in the county court on King Edward Street. This building is now erroneously named 'The Guildhall', but it never was. The original guildhall was in the centre of the medieval market square, but in Elizabethan times was moved slightly to the north-east, to occupy part of the site on which the 'Old Town Hall' building stands today.

The saga began on 4 August 1849 when a 'Great Attraction' was advertised. Surprisingly, it was a camera obscura on a 'large and magnificent scale'. It had been commissioned at 'considerable expense' by James Frost of the Bowling Green Inn on Cock-stool-pit Hill above the River Bollin

Early railway engines. The *Rocket* came into use for passengers in 1830, but the engine most likely viewed with the Macclesfield camera obscura was the First Locomotive Engine. In time it was followed by the *Royal George. Illustrated London News*, 1881.

and Sunderland Street, and intended both as a tourist and local attraction. It was mounted so that a complete panoramic view of the town and surrounding hills could be seen, together with a good view of the North Staffordshire railway just below, 'making a most delightful picture', especially when the trains passed along the line. The best views were said to be between 10 a.m. and 4 p.m. at a charge of 3*d* each; children with adults were admitted free. The mayor and several 'gentry' had visited, expressing 'great satisfaction' with the contraption.

It had been constructed by an eminent optician, J. M. Bowen of No. 27 Market Place in Manchester, and he was suing Frost for £20 as part of the balance still owing to him.

Once again Thomas Parrott (town clerk) of Macclesfield was acting for the defence and, coincidently, Mr Norris, the Manchester attorney, for Mr Bowen as he had for Sainter.

Norris began by explaining that Frost occupied a tavern attached to a bowling green, and had decided that a camera obscura would increase his custom. He asked Mr Bowen to come from Manchester and begin the work.

1871 OS map shows the position of the Bowling Green Inn and the Bowling Green Tavern in relation to the railway line and public baths.

Construction

Bowen came and Frost indicated that he would spare no expense because he wanted a first-rate article. Initially Frost had the building constructed too high, creating extra visits for Bowen. When completed the cost was £104. Frost only paid £16 on account and then refused to pay the balance of £88. Bowen took advice and, as he explained, a county court case in Chester would have been too great an expense, so instead he chose to sue for £20 – the maximum allowed in the local county court.

The pariscopic lens and speculum, i.e. parts of the mirror, were expensive to produce and several were made before it was correct. The first one split, the second was made 'useless' by Frost, who had again ruined the present one.

Four journeys were charged and several workmen were employed for two to three days. Parrott pointed out the excessive costs of the journeys, which Frost had not been told about beforehand.

Norris called Marla Creda, an optician from Dollond's in London, who valued the camera obscura at £180 to £200, which he would not have made for less. Parrott had two valuations: one from John Gregan, who made several, saying too much had already been paid; the other from a local optician, Mr Brown, who stated his valuation to be 'less than £10'.

Norris cross-examined; Gregan was in fact a joiner not an optician, and Brown had been a barber by trade until recently. Norris laughingly ridiculed their estimates. The judge decided for Mr Bowen, commenting:

> A camera was something like a hat; they might have one for four [shillings] and ninepence or forty shillings. If parties call in men of skill; they must pay for the experience which is brought to bear on the matter, and this is one of those cases.

The outcome meant that neither man had a very merry Christmas. Frost had ruined his camera obscura and Bowen, after much trouble, had made little or nothing out of it, except, of course, his reputation had remained intact.

Another Season

However, this was not the end of the project so far as James Frost was concerned. On 27 April 1850, an insert on page 4 of the local newspaper informed everyone that the bowling green of Bowling Green House would open the following Monday, 29 April, and that, 'James Frost wishes to draw attention to his camera obscura and magic lanterns…'

The following year, 1851, but slightly later than usual on 10 May, Frost informed the public that the Corporation Bowling Green was open for the season and being 'considerably improved, is in excellent order'. The subscriptions for the season were 10*s* (50p). On Tuesdays, Thursdays and Fridays from 5 p.m. non-subscribers could pay 3*d* each for the hire of the bowls and use of the green.

The camera obscura had also undergone 'great improvements' and was open to visitors from 9 a.m. to 4 p.m. daily. This seems to indicate that there had obviously still been problems with Frost's 'Great Attraction' and, while bowling has remained a particularly favourite game in and around the town, and avidly played, the whereabouts of the camera obscura after 1851 remains a mystery, for no further mention of it has been found. It suggests that, despite Frost's endeavours, the building of the Corporation baths close by diverting attention from the trains passing along the railway line at the bottom of the hill, thus causing the contraption to lose appeal.

Victorian Baths

The newly extended baths of 1924 on Macclesfield Common.

The original Victorian baths and washhouses from 1849 were the brainchild of John May, clerk to the Board of Guardians. He had given two lectures on public health and was no doubt inspired by the first Public Health Act (1848), which focused minds more and more on the subject. The statistics had drawn attention to the disparity between the mortality rates of towns and country, and also the age at death between the 'leisured and working classes'.

Macclesfield had always been at the forefront of modern innovations and, in July of 1848, even Manchester, which had mushroomed beyond recognition since the turn of the century, although having public baths and washtubs, did not have a public swimming bath. At that time Macclesfield was already grappling with the expense of an entirely new water supply, as the population of just under 9,000 in 1801 had doubled by 1821 and was set to double again by 1851. John May, however, was determined and with persistence his campaign resulted in the formation of a committee to see the project through.

Swimming Baths

On 29 December 1849, the welcome news was given that on New Year's Day the new baths and washhouses would be open to the Macclesfield public. It had only been eighteen months since the first meeting when, in mid-July 1848, a committee had been formed to collect subscriptions, and the banks of Brocklehurst & Co. and the Liverpool & Manchester were nominated as receivers for the funds.

The foundation stone was laid in May 1849 with an original estimate of £2,500; the builder, Mr Blackshaw, had completed the excellent work in 'Halle Fields' facing towards the town.

The land, owned by the Macclesfield Free Grammar School, had been let to the Corporation at a small rent and by a quirk of fate neighboured what was at that point in time the defunct 'Great Attraction' – Mr Frost's camera obscura.

The building was a single storey and of a plain Elizabethan style with land in front on which it was intended to create a fountain. There were different entrances for males and females, one from Davenport Street and the other from James Street. Just inside each was an office where officers could take money and issue tickets. Having purchased their tickets, the men were able to use the waiting room on the left side, and the women on the opposite side.

The left-hand passage led to the north wing, where the men's swimming bath was situated. It was 37.5 feet by 18 feet, and 3 to 5 feet deep with stepladders provided and an iron rail for support. The bath was lined with beautiful white-glazed tiles that provided a 'clear and refreshing' appearance to the water; and on one side of this pool were twelve 'dressing boxes' i.e. cubicles. There were also exercising chains for those wanting to keep fit. Also in the north wing were three first-class baths, each with hot and cold water, three second-class ones and a small plunge bath for children. A vapour bath was provided that could be 'medicated at leisure', and a shower bath, each also having hot and cold water. This was incredible Victorian luxury for the masses. On the other side of the building, even though the women had the same number of baths, their swimming facilities were somewhat diminished.

Laundry

The reason was a provision of the most 'modern' laundry facilities. The room was partitioned, and each section had a washtub with ample hot and cold water, a jet of steam that a washerwoman could control, the use of a dolly tub and wringing apparatus.

Each boiler had a perforated slab for drawing off steam to prevent condensation. There were drying and ironing rooms, the latter with a stove for heating the irons, and a table. The drying room could dry clothes in twenty minutes and heavy blankets in forty, and everything was well lit by the glass roof. Constant cold air was filtered through so clothes were as fresh as those dried in the open air.

Subscriptions had been substantial, even from the working class, and although there were still arrears there was optimism that they would soon be paid off. Many of the wealthier residents had already given their names to the committee as annual subscribers, and John Brocklehurst MP was the first to make a donation – one of £100.

During the second week in January 1850, unexpectedly large numbers had used the new facilities. Fifty to sixty washerwomen had utilised the new tubs, so much so that it was decided more would be provided. This meant two more rooms would be fitted with additional laundry equipment. The figures for the bathers totalled 546 men and fifty-four women. One cannot help but think that while the men enjoyed their 'luxuries' the poor women or wives were busy on the opposite side of the building ploughing through the weekly wash. It is hoped that the married men had the decency to carry the laundry baskets home for their wives.

Rivalries

At this time there was great rivalry between the expanding towns in the north of England, and in June 1850 John May had to counter-attack a notice printed in the *Preston Chronicle* written by George Smith. His statement claimed that he had obtained information regarding income derived from the Macclesfield Baths and Wash Houses, totalling just £3 with expenses of £7 – in fact they were 'all but closed'.

This information had created great controversy among members of Preston Town Council and May immediately wrote to the Preston newspaper, with a copy sent to the *Macclesfield Courier*. While admitting that there were weeks when the water had been unfiltered during reconstruction

of the filter beds, from the opening of the extension on 1 January, during the following twenty-three weeks, 16,701 bathers had been admitted (an average of 726 per week) and fifty-one washes provided each week, the latter necessitating an additional laundry room. This had produced a profit of £30 for the council.

The local editor also gave his opinion, pointing out that not only had George Smith given incorrect details for Macclesfield, but also for Liverpool and Manchester. The question, which he felt was appropriate to ask, was whether or not there had been an intention 'to quash the idea' so far as Preston was concerned.

Later Civic Pride

Time evidently proved May's bath scheme to be a great success, so much so that by 1922 further additions were called for and, during the next few months, the Baths Committee meetings underlined the urgency. However, as usual, finances were causing concern.

It is amusing to read that in 1924 Mayor D. M. Catlow referred to the original baths and wash houses, which opened on New Year's Day in 1850, as primitive. He did also write that the project was 'Hampered by insufficient funds' yet had been built to the best advantage. This was certainly true, however, despite being 'primitive'; how many today could dry a heavy blanket in forty minutes or so? Catlow, of course, was promoting the addition of a new building, and civic pride was top of his agenda.

Only two alterations between the two large undertakings had taken place. First, a new 'plunge bath' opened in 1879 in place of the old private baths. This had been done according to plans produced by the borough surveyor, Jabez Wright, with the builder, George Roylance, carrying out

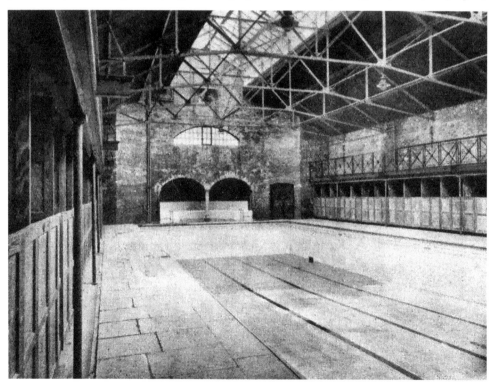

The men's new swimming pool of 1879 after further improvement in 1924. Along each side are the 'dressing boxes' which became known as cubicles.

the actual work. Second, the extension to the ladies' facilities, which were appropriately opened in 1907 by Mrs Somerville, the mayoress and daughter of John May.

The improvements suggested in 1922 were to be built on vacant land adjoining Canal Street, but the entry would still be from Davenport Street and the ladies were about to be offered a favour. Up to that time they had used 'a very small pond', which, while considered satisfactory for children, offered no scope to good swimmers. The male committee magnanimously considered that a new swimming pool, 2 yards wider and 6 inches deeper than the old one, would be the most important addition. But were the ladies impressed to discover 'that the old bath will be for the exclusive use of ladies at all times, while the men have the new one'?

The foundation stone for the enlargement was laid on 16 April 1924, and work proceeded. The male swimmers were even provided with a footbath in an alcove, which formed 'a pleasing architectural feature', and was accompanied by a dome-shaped light in the flat roof above. The ladies found themselves at the far end of the bath, no doubt in semi-darkness, but at least both ends had cold showers.

A Handsome Addition

There were six new private baths that were actually adapted for mixed use. The dressing rooms in the main hall were made from selected pitch pine and had polished gunmetal fittings, which could be folded back against the walls to suggest panelling.

The laundry was for the baths use only, having one washing machine, a water extractor and a continuous drying machine that could produce 100 clean towels per hour.

With a keynote of 'simplicity with utility' and an impression write-up of all the technicalities of the new engineering system, it was admitted that the site had not allowed for any 'striking architectural lines'. However, the extension was considered to form 'a handsome addition to the civic building', with 'luxury baths for everyday use'.

The plans had been drawn up by the architect, Peter Wright of Macclesfield, the son of Jabez Wright, the borough surveyor involved in the 1879 alterations. Assisting him was a consultant engineer, John Hargrove of Wolverhampton.

The emphasis was on the ability to provide a supply of 'clean, aerated, and sterilised water', which continuously passed out through an inch pipe near to the bottom of the bath leading to a strainer. From there, a centrifugal pump ensured that the water entered the filter plant where the natural quartz, on perforated trays inside a cylindrical steel shell, was subject to a rocking mechanism. This allowed the contaminated water to be drained off.

The list of subcontractors and suppliers was very impressive, and the building was ideally situated to serve Macclesfield for well for over 150 years.

In 1986, Macclesfield's new leisure centre, complete with modern swimming facilities, opened on the other side of town to accompany a new housing estate. Inevitably the old swimming baths were demolished, but many still recount happy childhood memories of their days when learning to swim, or just having fun splashing around in the old premises.

Outings to Capesthorne

CAPESTHORNE HALL. TERRACE AND CONSERVATORY.

Illustrations from a booklet prepared shortly after the event at Capesthorne Hall.

After the opening of Macclesfield's new swimming baths, many events took place to help defray the costs. One such event was the opening of Capesthorne Hall to the public on Wednesday and Thursday of Whitsuntide in May 1850.

Edward Davies Davenport MP of the Calveley estate near Nantwich had inherited Capesthorne on his father's death in February 1837 and, disenchanted with the 'austere classical style' of the building, had done much to alter its appearance. His travels in Italy had seen his considerable library enlarged with books of Italian classical literature – he was a great connoisseur of the arts. Something of a rebel, as the only Whig among generations of Tories, he had died in 1847 and was buried in Chapel Garden. His handsome son Arthur Henry inherited the Davenport estates but, being unmarried, was very much the eligible bachelor. It was his mother Mrs Davenport who had 'zealously superintended the arrangements' on his behalf.

Transportation

The event attracted enormous interest and, from early morning, crowds were seen making their way along the lanes and roads towards the hall. Vehicles were so crowded that many decided to walk in the hope of stopping one of the now empty vehicles, which was returning to town to pick up the next group of passengers. It was an amazing sight to see carriages of all kinds from the most impressive to the 'humblest'. Omnibuses and carts crowded the roads, and the mass continued to swell as considerable crowds poured out of Chelford station.

This station had been the import link with Manchester, and also London via Crewe, before the railways reached Macclesfield in the 1840s. It enabled hundreds to arrive more conveniently from Manchester and Stockport, being considerably nearer the hall than the two newer stations by then operating in the town. Other visitors made it by a variety of means from Sandbach, Congleton and Bollington.

Numerous marquees had been erected, and soon teams of cricketers were playing in parts of the extensive grounds. The large stretch of water was already dotted with boats and their crews, speedily rowing along, while the bands of the 3rd Dragoons and 90th Foot Soldiers enlivened the proceedings.

The number of visitors finally reached 6,000 and during the afternoon three archers appeared to entertain the crowds with their excellent skills – all of them vicars. So confident of their abilities were those passing by that they stopped and crowded around the targets, and many walked behind them as arrows headed in their direction. There were groups of dancers, a steeplechase on foot with leaps over 4-foot-high hurdles, but then a slight sound of thunder was heard. Hardly anyone had come prepared because mackintoshes and umbrellas were always a nuisance, but it was too late for regrets – down came the rain.

Downpour

In trying to escape the downpour, one of the boats on the lake got stuck in the shallows and everyone was drenched. Nor were some of those, who managed to crowd into the tents and marquees, in a better situation. Some of the marquees, heavy with rain, sagged in places and the rain poured through.

Those who had queued at 12 o'clock to go through the hall and conservatory were able to stay there, while others joined them, having paid for an entry ticket to the premises. Barns and the coaching houses were also thrown open for other unfortunates. The storm soon worsened, with flashes of lightning and deafening crashes of thunder, and continued until 6 p.m.

Those with carriages and horses were first on their way home, but hundreds of others had to trudge through the mire. The games, to have been held that afternoon, were postponed until the following day.

Day Two

On the second day of the opening of the hall and grounds, still in support of the new Macclesfield baths, everyone was expecting the arrival of even more crowds. Out of the 6,000 visitors the previous day, 1,300 had managed to view inside the hall.

Visitors began to arrive for the 10 a.m. opening, all 'elegantly dressed', and children from around the area were wearing their holiday clothes. Cricketers resumed their games and the three archers once again appeared. As the day before, the boats were soon on the lake, while dancing began in various groups.

Private parties played Blind Man's Buff, but one group of ladies was playing Cross Tick. The organised games, postponed the previous day because of the storm, began early. A large circle was formed and five stout, well-built labourers were each given a wheelbarrow and then blindfolded. They then had to turn round and dash around the circle to see who completed the race first. There was utter confusion because they could not decide in which direction they should be racing; this caused much laughter as they pushed to and fro, stumbling into one another.

Several other wheelbarrow races followed, and young Mr Davenport, the eligible bachelor, was seen surrounded by a group of ladies and enjoying the fun.

Rain Again

Suddenly down came the rain as another storm hit, unfortunately earlier than that of the previous day. Just as the storm began, a train with thirty special coaches arrived at Chelford station from Manchester. The passengers, however, remained in their seats, and eventually realising that no one was going to alight, the railway company decided it was better to return to Manchester. The storm did not clear until 6 p.m. when more sports were played – one was known as a Jingling Match.

The second day had resulted in a disappointing 1,500 visitors finally coming into the park, but 1,067 were able to go through the hall. The total receipts for the baths fund was expected to be £700. The honorary secretary, John May, had been extremely busy in organising things and Mrs Davenport was acknowledged as having very generously opened up the hall and parkland for the public.

The event led to a special publication *A Whitsuntide Ramble to Capesthorne Hall*, published by the editor of the *Macclesfield Courier* newspaper for the benefit of the baths fund. It was a little book of sixty-seven pages, but full of interest.

It described the contents of the hall and also, what was at that time, the amazing conservatory. The latter was full of 'graceful' creepers, rare plants, shrubs and bowers of varied foliage 'starred and gemmed by brilliant flowers of varied hue'. Paxton had supervised the erection of the roof

THE TOWER LODGE,
CAPESTHORNE.

Illustrations from a booklet prepared shortly after the event at Capesthorne Hall.

and, supported by slender pillars of iron, an arched framework connected them together. It had been decided that this was the place for the Capesthorne Sunday School to be held each Sunday, much to everyone's delight.

Next to it was the hothouse, which contained a stove, allowing tropical plants, including breadfruit, coffee, sugar cane, musa and other rare species to thrive. A door from the conservatory led into the family pew in the chapel.

Within the hall every treasure had been put on display. There was an Egyptian mummy and Etrurian vase, both of special interest, as archaeological digs were unearthing fascinating objects in Italy and the Middle East. Armour worn over the centuries by the Davenports was proudly displayed, and even a 'humble jug' found inside a tree. Numerous paintings and sculptures could be seen, and a lovely portrait of Arthur Henry Davenport as a child, intriguingly trying his hand at sculpture. This, and the superb bust of him by Thomas Thornycroft, which had obviously inspired the portrait, can still be seen on public display at Capesthorne.

Clear Skies

The following month, Mrs Davenport, described as 'the liberal proprietress' of Capesthorne, once more opened the park to visitors. On this occasion it was primarily for a group from Manchester arriving by train at Chelford station. The main part of the group was Mr Weston's singing school, the members of which were joined by others from the Manchester Mechanics Institute and the Athenaeum for the event.

Arrangements had been made for the coach proprietor, Mr Gledhill, to convey the visitors to and from the hall, a distance of 2 miles from the station, for which he charged 6*d* each way. Upon arrival in the grounds, everyone was greeted by a chorus of 600 to 700 children singing in the woodlands 'Now is the Month of May'. No doubt a rather inappropriate reminder for Mrs Davenport of the previous month's deluge! It was 15 June.

It is possible, of course, that the intention was for the children to have sung that particular song at the previous opening, but because of the storm had been unable to do so. Having regard for all the efforts made in rehearsing and organising the presentation, it was presumably thought that allowing them to perform on this occasion was the correct decision to make under the circumstances.

The band of the 90th Infantry again made their appearance and played five overtures, followed by waltzes and polkas.

Among the local gentry present were several from Macclesfield, including Brocklehurst family members and Christopher Shaw Roe (grandson of Charles Roe) and his wife. The entertainment drew to a close at 8 p.m. with the singing of the national anthem and those returning by train, having arrived on the 2.30 p.m. train from Manchester, were conveyed to Chelford station for the return journey on the train departing at 9 p.m.

Public Clocks Controversy

Today, many of us often do not appreciate how important church clocks were in their role as public clocks. The clock faces of Christ Church can be seen for a considerable distance, and the clock of St Michael's, now our parish church in the Market Place, was also of particular importance, and this is easily illustrated by the following complaints.

In August 1827, it was suggested by a resident that the committee for lighting and improving the town should illuminate St Michael's clock face so it could be seen at night. During the winter it was useless between 4 p.m. and 8 a.m. The suggestion was to have a rod, curving slightly downward, with a lamp and reflector on the end; this would throw light onto the clock face so it could be seen at a great distance.

Six months later, many complaints were made that the clock was twenty minutes slow. However, these complaints were nothing in comparison to the one written to the editor of the *Macclesfield Courier* on 12 March 1841 signed by 'A Macclesfield Man'. It began with 'Sir, Can you please inform us, upon what persons or body rests the responsibility of the caprices of the Old Church clock?' He continued to explain that Macclesfield was situated 2 degrees in longitude west of London, and therefore the time was eight minutes after London time. Manchester, however, was almost on the same longitude as Macclesfield and therefore should be on the same time.

St Michael and All Angels' parish clock with its one and only clock face towards the Market Place.

On returning from Manchester a few days earlier, 'our time' was fifteen minutes before that of Manchester. Although the Macclesfield inhabitants did not perhaps possess sufficient scientific knowledge to correct the time by solar, lunar or stellar observations, they could possibly check the time by means of a sundial and an almanac. However, should the atmosphere or dullness of the weather prevent such observations, he felt certain that there had to be a way to check the time daily with Manchester or Crewe. He conclude his letter in the hope that 'someone will hit upon some scheme for settling our place on the map, and not allow us to oscillate, as it were, between Decametre Forest and the Dogger Bank'.

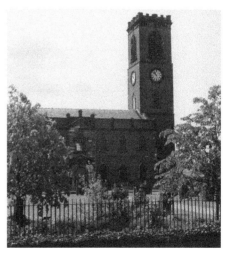

Christ Church allowing sight of two of its four clock faces, which are more practical for its role as a public clock.

Greenwich

As if in answer to the above request, in 1851 Professor George B. Airy, mathematician and Astronomer Royal, established prime meridian at Greenwich. He wrote to the committee of Gresham College in London during the following January, stating that he wanted to send by electric telegraph every two hours, the precise time at Greenwich to three places in London, one of which was the Royal Exchange.

It was of great importance that London watchmakers should know the 'true time' as they paid £200 each year to send a messenger daily to Greenwich Observatory to report it. After a short debate the Gresham Committee declined the idea, but Airy was determined.

At the request of Professor Airy, and with the consent of the South Eastern Railway, arrangements were made to place the Greenwich Observatory on the same electric telegraph cable. This allowed for instantaneous astronomical observations in all part of the country at the same time, and also, by means of a submarine telegraph, on nearly all parts of the Continent.

It had two advantages: to establish the longitude of different places and to regulate national time by the uniform standard of Greenwich. This was certainly a welcomed move, especially after the railways came to Macclesfield, but it did not help one particular passenger who complained that he had missed his train by three minutes, and all due to St Michael's clock. Still, the saga was to continue for some considerable time.

Controversy

On Friday 9 August 1856, the General Purposes Committee of the town council met to discuss the only matter that had been drawn to their attention, 'the inconvenience which the public sustained by the stopping of the church clock'. It was considered by some as not the place for such a discussion, but others asked whether or not funds were available to rectify the situation.

Councillor Jackson suggested that it would be better to have a column with four clock faces set up in the Market Place. They did have the power to do this, but had best leave it until the next meeting. The Old Church clock was inconvenient and, for those leaving by train, it was sometimes too fast and at other times too slow. It had cost just a few shillings to place the town hall clock outside the building instead of inside.

John Parrott, town clerk, said that the matter had to be dealt with by the Board of Health, as it had the power to set up clocks. It was pointed out, however, that a clause was embodied in the Macclesfield Improvement Act in relation to clocks, as set out in the General Town Improvement Act. It did relate to theirs and not to others.

The discussion continued, revealing that the minister had approached a committee member to obtain lighting for the new clock face by gaslight, and also for two extra bells to be added (the former reminiscent of the 1827 suggestion). Councillor Rathbone thought the present eight bells quite sufficient and preferred money spent on the clock; he had already contributed towards the work on the clock, and now it had stopped. When the discussion resumed, it was stated that Manchester Corporation had allowed a grant of £1,000 for their infirmary clock, and Lyme Regis £25. Surely Macclesfield could provide £10 per annum to the churchwardens for theirs.

Councillor Bullock brought up the question of the fire bell in the steeple, as orders had been given not to ring the bells, but what would happen if there was a fire? The Board of Health should place one in the town hall; it was not an expense because the person whose property was on fire paid for it to be rung.

John Parrot had found nothing in the legislation that related to bells, and the churchwardens had agreed to ring the only remaining bell with a rope attached to it!

Finally, in November 1859, there was a rapid increase in the number of complaints. This time it was not striking the hours as usual, a problem from the need to clean and regulate it, 'an expense the Wardens have no funds to defray'. It was then discovered that the town council had undertaken to pay the cost of keeping the public clock in order on the abolition of church rates; and to this day public clocks are maintained by the council.

Macclesfield Watchmakers

An interesting watch once found its way back into a jeweller's shop in Macclesfield. Its equally interesting story begins some 200 years ago.

The Pidducks

In 1810, a son was born to a William and Elizabeth Pidduck in Shropshire; named after his father, he was followed two years later by another son, Henry. The family moved to Hanley in Staffordshire, where they established a business. From the evidence available at present they seem to have originated from the Midlands where many Dissenting families had small but important metal, jewellery and fancy ornamental workshops in the eighteenth century, often using gold and silver.

The watch *c.* 1900, which inspired the article.

Both sons married, and Henry was apparently the one who started the jewellery business 'Henry Pidduck & Sons', which was to become a premier establishment in the centre of that town. This would later become a limited company.

One brother, William, had a son called William Bruce Pidduck, born 1843, who also entered the business, probably as an apprentice to his uncle. This young man seems to have been the one who enhanced the business potential by becoming a working jeweller, and, when around thirty years of age in 1873, he was sent to Manchester to open a shop at No. 24 St Anne's Square.

However, information supplied by a correspondent, David Perkin, rightly points out that, in his Manchester Directory of 1869, the firm of Henry Pidduck is shown at that address as watchmaker and goldsmith. By coincidence, the previous occupier was Elizabeth Orme, a surname with historical connections in Macclesfield. She was a silk mercer and milliner, which implies that she had a workshop there and sold wholesale, although she lived in Cheadle, Cheshire.

The Pidduck premises, shown as occupied by a watchmaker and goldsmith, again suggest a workshop, where possibly a family member was producing the watch movements and working in precious metals. The skilled workman could have been apprenticed in Manchester, and then established a workshop for the firm. From there the watch movements would have been sent to the large jewellery shop in Hanley, to be fitted into the watch cases made by the working jewellers.

During the same period there was a Joseph Pidduck recorded at No. 12 Spring Gardens in Manchester. This was the uncle of William Bruce Pidduck and he was a salesman, then known as a commission agent. Towards the end of his life he settled in Cheadle, Cheshire with other family members.

Interestingly, an Isaac Simmons, gold and silversmith, watch and electroplate manufacturer, had been in business at Nos 7–9 St Anne's Square. It could be a coincidence, but as his business ceased the Pidducks seem to have taken the opportunity to open their own premises in the square. It would have been an ideal opportunity to purchase the stock of Simmons.

William, although a working jeweller, would have learnt the retail side of the trade in Hanley. When he arrived in Manchester, the business then additionally became a shop where jewellery, clocks, watches, and presumably other items, were sold, but must have retained the workshop in which the goldsmith worked alongside the watchmaker(s). By that time William would have been more than capable of managing the retail side of the business.

An entry in the Manchester Directory of 1876 shows Henry Pidduck & Sons as goldsmiths, jewellers and watchmakers. A further entry for William Bruce Pidduck, followed by the business name, gives his residence as No. 14 Seymour Street, Cheetham Hill.

Having established the retail part of the Manchester premises, he returned to Hanley as a 'Master jeweller', who employed four men and a boy. In the mid-1880s, he took over a tailor's shop at No. 8 Mill Street, Macclesfield, and brought with him two of the young men from Hanley: Joshua Brookes and Henry D. Edwards. The trade continued in Manchester, and the one in Macclesfield was enlarged by adding an optic department to the jewellery business alongside the watch and clock-making activities.

Advertising

On 28 October 1893, a large front-page advertisement in the local newspaper by William B. Pidduck, watch and clockmaker of No. 8 Mill Street, stated that since the sale of the first watch in 1841, they had become well known in Cheshire, Derbyshire and Lancashire, and were 'going in many foreign countries'. William had an order from a customer in mid-Russia who had worn one of his watches for twenty years and who was now ordering 'five watches of various descriptions for friends'.

Apart from the guaranteed gold and silver watches, there was also a large stock of cheap grade sound watches at remarkably low prices – apparently not what he had expected to sell when first opening the Macclesfield premises.

Just before Christmas, a further large advertisement announced that a large stock of standard gold wedding rings and watches would be on sale at the Christmas fair in Fawkner's bazaar on Great King Street. For the next six months, Pidduck sold off his stock and advertised for the last time on 23 June 1894. The following week, Edwards and Brookes purchased the old established business at No. 8 Mill Street. The business, which had seemed extremely impressive, had perhaps grown a little too large for William Pidduck to control; it was fortunate that two of his employees had decided to branch out on their own.

Edwards & Brookes

The Macclesfield watch that inspired the story is, as illustrated, an Edwards and Brookes watch. They were employed by Pidduck in Hanley and, having taken over the shop in Macclesfield when William left in 1894, Joshua Brookes, a former jewellery assistant in Hanley, became head of the watch department and lived on the premises with his family. Henry Edwards lived on Newton Street with his family and was in charge of the gold department.

Their first advertisement in January 1895 advised people that all those who 'valued their eyes' should wear Edwards & Brookes 'Pure Royal Crystal and Pebble Spectacles and Eyeglasses' and that they had the largest stock in Cheshire. Their advertisement the following May was meant to impress, stating that they were 'Specialists in soundly made reliable watches' that were dust and damp proof, and their 'extra strong real English Silver Lever' ones, with crystal face, chronometer balance, jewelled actions and highly polished finish were selling at £3 10s (£3.50p) – said to be ideal for 'Farmers' Wear'.

They stocked new oak and inlaid brass chime and gong clocks, and even took on contracts for private and public clocks, promising that they would be kept in repair. An added novelty was a 'Gent's Albert Purse' of sterling silver to hold bank notes, sovereigns and half sovereigns.

A GENUINE SALE

Of Gem set Jewellery Diamond, Rings, Gold and Silver Watches, Clocks. Plate in solid Silver and Electro=Plate
(of a Reliable Quality)

At a Real Reduction of 20 per cent. 4/= in the £.

To clear surplus regular Stock, NOT trashy unreliable goods procured specially for a make-believe Sale.

A grand chance to get BARGAINS in valuable Gold Watches, Diamond Rings, Clock Sets, Tea Sets,, etc., etc.

EDWARDS & BROOKES,
8 MILL STREET, MACCLESFIELD.

Edwardian sale advertisement.

Their second advertisement was a simple affair on 9 November 1895, stating that they dealt in 'Modern and Antique Sterling Silver Plate'. Progress had been made by June of the following year in the retail department when they announced that they sold a considerable variety of beautiful silver and gold objects and watches, including 'crumb scoops, grape scissors and sardine boxes'. The price of silver was stated as 3s 10d (19p).

The partnership continued until at least the First World War, but by 1923 Henry Deakin Edwards, by then sixty-nine years of age, was operating alone as a watch maker, still at No. 8 Mill Street. He then presumably either retired or died not long afterwards. What happened to Joshua Brookes is at present unknown; he was born a year before his partner Henry. In 1923, there was a Frederick William Brookes in business as a watch maker at No. 12 Roe Street, who was still there until the mid-1950s. He was not the son of Joshua Brookes but was possibly a close relative.

Although Pidduck had returned to Hanley, by the 1890s he was again in Manchester and also Southport. A further move from the Manchester premises and then those at Hanley left the business, trading in Southport.

The watch, brought to prominence by Don Massey, could have been made by Edwards & Brookes in its entirety or only partially – nevertheless it is an interesting timepiece.

The Railway

On 4 March 1844, a public meeting was held in the town hall of Macclesfield to petition Parliament for a branch railway from the Manchester to Birmingham line.

Stockport had wanted just one terminus, but they were provided with two. The railway company, however, decided one was sufficient for Macclesfield, but it was to be in an inconvenient place, Beech Bridge. If the town's residents objected, the railway company insinuated that they could abandon the line altogether.

The Corporation ignored the threat, and the meeting was called to get a proper convenient terminal. The original proposal had been made in 1824, but it had taken several years of meetings, agreements from landlords for purchases of land, and many other problems. Several plans had been produced because of the difficulties of the terrain around the town. At one point the company planned to lay the line to run directly in front of Adlington Hall and, of course, there had been strong objections.

In 1840, Sir Edward Stracey, an eminent magistrate, owned the Beech House estate with its several farms. He had been unhappy by the way the railway company was to 'cut up' his land, but now he was happy to consent to new proposals.

It was important for the station to be nearer the centre of town, and the Earl of Derby insisted it be near the town hall. The councillors, however, agreed that it was not the centre with regard to traffic and manufactures, and wanted it in a field in Cockshut Lane (now Hibel Road). The worry was coal deliveries, as the town consumed 35,000 tons each year and at least 80,000 tons of merchandise. From Beech Bridge, two steep hills would have to be negotiated to get supplies to most of the mills.

The petition was sent to the House of Lords, because if it had not been for them, Macclesfield 'would never have stood a chance with the railway'. Two weeks later, a House of Commons committee sanctioned the Macclesfield claim for a station on Cockshut Lane. Instead of being carried by an open cutting at Beech Bridge, and then along Lower Eyes Field, it would go under Beech Lane.

Beech Bridge today over the River Bollin. To the left of the photograph, the first small railway station was provided for the town's link by train to Manchester.

Expense, as always, was the issue with the Manchester and Birmingham Railway, but it was hoped to complete the stretch from Stockport to Poynton collieries by Christmas. The collieries were important for deliveries to Stockport and all of the surrounding area, including Macclesfield.

From Poynton to Beech Bridge, which would be a temporary station only, another fifteen months would be needed. The final and difficult part, digging out the tunnel to Cockshut Lane, would take a further three months.

Official Opening

On 30 January 1845, there was a special meeting in the offices of the railway company in London Road, Manchester, to prepare a bill to extend the railway from Beech Bridge. It was delayed until 30 March so that several other railway projects could be included. Parliamentary bills were extremely expensive to prepare and submit. Also included was the authorisation for the purchase of the Manchester and Birmingham railway by the London and Manchester Railway.

On Monday 24 November, at last the official opening of the Macclesfield branch railway took place at the Beech Bridge station. It seemed to be 'an unofficial holiday' for Macclesfield, as people crowded down Beech Lane and along the Beech Bridge embankment. A special train was organised to leave at 12 o'clock. But, true to form, as future experiences would reflect, it was half an hour late. Waiting were the mayor, and the two borough MPs: John Brocklehurst, who had worked so hard to bring the railway to the town, and Thomas Grimsditch, an attorney. The latter had of recent years opposed the scheme, but realising for once he had to overcome his obstinate self, he had finally relented. Some of the railway directors from the local area were present, while other railway officials and the chairman arrived on the train. Also present was 'Spencer's Old Macclesfield Brass Band', which had entertained the crowd while awaiting its arrival. People had taken up every possible position for a better view, and the numbers astonished the directors. No doubt they were wondering why most were not at work, which might have cost some part of the day's pay.

The most difficult section of the project had been laying the stretch of line between Adlington and Macclesfield. The tunnel was 270 yards long (around 250 metres) and there was much sand in the area. Fortunately it did not cause any slides for the contractors, except at Tytherington where the gradient had to be reduced. The stations along the line had been constructed from timber boxes on platforms, all therefore 'movable' until a regular service could be established.

The train soon left with the band on board in an open carriage, still playing with great aplomb, much to the delight of the crowd. Shortly they passed Prestbury, considered the best view on the line with its lovely vista of the church and village. There was only one stop at Poynton to allow one of the directors to alight. From there a small branch line had been completed to the collieries. Created by Lord Vernon, it was about one and a quarter miles long, and sanctioned by Act of Parliament.

Only four stations had been completed along the main branch line, so the train was able to travel more quickly than when the regular service was underway. There was some delay at Cheadle due to a train, travelling to Manchester on the main line, having made a stop there. The special train followed this and arrived at London Road in thirty-eight minutes. The journey had been smooth, except for one small central section, which proved 'a little bumpy'.

There were around 180 passengers on board who, after spending an hour in the town, were joined by several more to make the return journey. The Manchester directors of the railway company also came on board with the chairman, because a celebratory dinner was organised for them at the Macclesfield town hall. A stop at Stockport saw even more passengers crowd in, and in the exact time of thirty-eight minutes it arrived back at Beech Bridge. The crowd had not dispersed, and some 'strangers' on board were surprised at the size of the town.

Soon a procession made its way up Beech Lane, led by the band. The mayor and special guests enjoyed a 'sumptuous meal'; the supply of champagne and other wines of great character was said to be considerable. Four singers and a pianist had been engaged to perform during the meal. Speeches followed, and John Brocklehurst's was poignant and entertaining, proving himself the professional speechmaker as always.

The temporary Beech Bridge railway station was to remain operative for quite some time. First the tunnel beneath Beech Lane had to be completed to – no, not Cockshut Lane – Hibel Road. Presumably the new name would sound more impressive.

Councillor Hibel must have been highly delighted, considering all his efforts and arduous years in trying to carry out road repairs. Contrary instructions from the police, and the criticisms from the Finance Committee when reminding him of a limited budget, had seen him involved in many heated arguments; but, despite all, he had achieved much and many were his supporters.

Hibel Road Station

On 5 February 1848, the newly amalgamated London & North Western Railway invited tenders for construction of the Macclesfield tunnel. The permanent Hibel Road station, however, had not even come under consideration and it was almost three years after the original railway opening of November 1845. Finance and other difficulties had caused delays, but by October 1848 they were finalised, and the station plans received railway company approval with the sanction to proceed.

It was not until the New Year in 1849 that the Macclesfield commissioners of police were made aware of it. They immediately sought an interview with two railway company directors, no doubt prompted by Thomas Grimsditch, solicitor, as one of their commissioners. They argued that the plan did not include a suitable area to set down luggage when unloaded from carriages. The suggestion of carriages waiting on either side of Hibel Road meant that luggage would have to be carried through the booking offices, and Hibel Road blocked. This was most inconvenient and had to be reconsidered.

The directors were asked to visit the site, but before and after their visit they insisted that the plans could not be altered as the work had been contracted out three months before. The commissioners also saw from the plans that Hibel Road was to be raised by 2 feet, but this could only be done with the consent of the town's authorities.

The committee then asked the surveyors Cawley and Firth to produce a plan, which they presented to the railway directors the following Saturday as requested. Richard Wright, chairman

This later railway bridge at the bottom of Buxton Road replaced the earlier bridge, widened in connection with the development of the station on Waters Green. Courtesy of the Ollier Studio.

of the committee, said it had already been pointed out by them to the railway company engineer that a formal plan was not necessary, and that copies of any resolutions made by the town hall committee should be dealt with by the chairman of the railway board.

John Brocklehurst believed that the company would have power to raise the level of the road above 2 feet, and that the engineer considered a rise of 3 feet or more necessary. The town clerk read out the clause and stated that it was a matter for the commissioners of police. If they could not agree then the Board of Trade was the authority to make the final decision. John Brocklehurst persisted in pressing the point that it was the duty of both the police commissioners and the Corporation to ensure that it was not a nuisance to the town. He was also concerned that the railway company considered Hibel Road as a mere roadside station. Although it was part of the Old Buxton Road turnpike trust, the trustees could do nothing to help within a half mile of the parish church. Also, the bridge at the bottom of Buxton Road was to be only 18 feet wide, but needed to be 25 feet. This could be done by exchanging girders, so the bridge at the bottom of Brunswick Hill was narrower.

After all the arguments and negotiations, finally, on 8 October 1849, the London & North Western Railway transferred their passenger business to the new Hibel Road station.

To London

After the grand opening of the temporary Beech Lane railway station in November 1845, the Direct London & Manchester Railway had asked for a public meeting. In response, on 19 January 1846, 200 people had gathered in the town hall with Mayor George Wright as chairman. He understood two or more projects were in the process of being put forward for a direct line through to Macclesfield from London.

The North Staffordshire Railway and several others had raised hopes over the years, and everyone was growing weary of the whole process. The first suggestion of a branch railway line to the town had been proposed on 3 July 1824, and in January 1825 railways in general were being promoted. It was stated that altogether nine different projects and plans had been produced. For one reason or another all had failed, and the mayor commented that he had received information suggesting that the North Staffordshire Railway was not likely to come through the town, so he was now impartial.

A resolution was made to support a direct line, and John Brocklehurst MP said 'no one in the meeting at present had a greater interest in the London and Birmingham railway than himself'. The Birmingham Railway only wished to act on the principle of direct lines, which was something Sir Robert Peel supported. It was wiser, therefore, for the Midland Counties and London & Birmingham companies to act together instead of getting into parliamentary contest with other companies.

The North Staffordshire Railway was stung into action, and early in March 1846 the police commissioners met to discuss the plan for the track to cross several roads i.e. Snow Hill in Sutton, Cuckstool Pit Hill and the Chapel-en-le-Frith road. The law clerk prepared a petition for the alterations, and was asked who had engaged him. He would not say who, only that it was a solicitor; the plan had 'appeared in a parcel' which he had adopted.

On 2 May 1846, the railway company requested their own public meeting. They had been before a committee in the House of Commons and explained that their project had begun ten years earlier. It had been a 'constant struggle' on behalf of the different towns and districts, and had failed for various reasons. They read out fourteen advantages for the manufacturing districts of Birmingham, the Potteries, Macclesfield, Stockport, etc. Now there were three projects before Parliament to carry out the project, and they were there to answer any queries which had risen with their proposals.

The first Macclesfield councillor to address the meeting said that at one time the Moss area had caused great problems; science, however 'had won the day' and all fears were dispelled.

The mayor asked Thomas Brodrick, solicitor and silk manufacturer, to speak. He was associated with every possible railway proposal that had been put forward for the town. He had

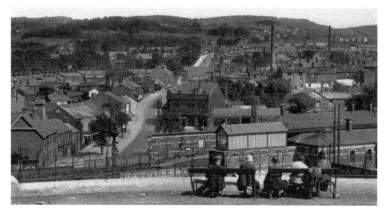

View *c.* 1930 from the Francis Dicken Brocklehurst Memorial Park (now known locally as Sparrow Park) overlooking the Waters Green central station, which, due to considerable tunnelling, became Macclesfield's only railway station from the early 1960s for trains between Manchester and London. Courtesy of the Ollier Studio.

attended every debate and committee in Parliament and answered questions. He was a director of the North Staffordshire Company and they were not connected to any other company. They had 'quietly and steadily' pursued their own course.

It was unanimously agreed to support the company, in the hope that the bill would pass through Parliament in the next session, which it did.

On 5 May 1849, the North Staffordshire Railway announced that the line through Macclesfield would open on the 18 June. The railway station had been constructed on Waters Green with the demolition of many old buildings.

Advantages

After the North Staffordshire Railway bill had been sanctioned by parliament, an enterprising tenant farmer placed an advertisement in the *Macclesfield Courier* in February 1847. It was addressed to railway contractors and timber merchants etc. and gave notice of an auction on the 18th of the month.

With the considerable amount of railway construction that was taking place in and around Macclesfield in the 1840s, it is easy to forget the thousands of men, horses and numerous supplies required for the different projects. There were 2,000 larch trees in lots of fifty lying at Hawkslee Farm, Wincle, Cheshire, where the sale would take place. The farm was around 3 miles from Bosley Wharf on the Macclesfield canal, and 3.5 miles from the railway at North Rode.

The timber was of thirty-six years growth and well adapted for railway purposes, such as permanent sleepers – it was clear of knots, clean and seasoned. The tenant, Thomas Riley, would show the lots and further information could be obtained from John Broadhurst, timber valuer of Poynton. Although not stated, larch wood was actually better than oak for the purpose. It seasoned in a short time, was known not to split or rot, was not liable to shrinkage, and resisted water. It was a hard wood that did not cause nails to rust as oak did, and therefore was considered an even better choice for the building of ships.

On Tuesday 1 November 1848, an important sale of railway horses took place by auction at the Bull's Head Inn in the Market Place, Macclesfield. This was as a consequence of the North Staffordshire Railway being nearly completed in the neighbourhood of Macclesfield. The auctioneer J. Twills had received his instructions from the owners Thomas Brassey & Co. to sell sixteen horses, described as 'very superior and powerful'.

The former Bull's Head Inn, Market Place, where the first auction of railway horses took place.

This was followed by a further auction sale on 28 August 1849 at the Bate Hall Yard. This time there was a 'great quantity' of excellent horses, harnesses and other equipment, belonging to a Thomas Moseley, to be auctioned because the North Staffordshire line to Macclesfield was now complete. The auctioneer on this occasion was T. Wood, who dominated the local auction scene in various inns around the centre of town. By a strange quirk of fate, the landlord of the Bate Hall had died only four days earlier, but his widow, Mrs Moseley, said she intended to carry on the 'posting business in all its branches' and presumably also the auctions.

Before the completion of the railway line to Macclesfield, the North Staffordshire Railway had announced, in October 1848, that it had opened two more sections of the line, both from Stoke. One was to Crewe and the other to Congleton. A booking office had been opened in the Macclesfield Arms Hotel and coaches left Macclesfield for Congleton station every morning at 8.30 a.m. and 11 a.m., except on Sundays. Further details were given for Burslem and Stoke. The prices quoted covered first, second and third class, and the journey from Crewe to Derby took two and a half to three hours; from there the train to London took approximately another five and a half hours.

Thomas Brodrick, as councillor and magistrate of Macclesfield, had been invited to the opening as a director. He had learnt that although 3,000 men had been at work between Congleton and Crewe, not a single instance of a 'gross crime' had been brought to court within the two years they had been employed. In fact, the police superintendent had told him that the number of disorders for that period had actually gone down.

Insurance

The rapidly expanding railway network of the 1840s, which saw 'Railway Mania' at its height, provided everyone with opportunities they could never have imagined; but if everyone thought it would be safer than travelling by road, they would soon realise that there was also plenty of opportunity for accidents.

Along with everything else, insurance companies were also increasing. At first London took the lead, with agents in various places in the provinces. Soon rail travel provided excellent scope for yet another to be established. On 7 September 1850, the Railway Passengers Assurance Co., which had been empowered by a special Act of Parliament one year earlier, published its first report. During the year, thirty-seven people had made claims, and details of the thirty that had been settled were set out.

Letterhead reproduced by kind permission of Aviva.

Frequent travellers could purchase periodical tickets to insure £1,000 for one month at the price of 5s (25p); three months, six months and twelve months were respectively 10s, 16s or 20s. These gave the option of travelling in any class on any railway 'in the Kingdom'. They could be purchased at most stations or from the company offices in Old Broad Street, London.

Claims

Below are some examples of some of the claims accepted and the payments awarded.

A holder of a periodical ticket fell off the platform in Preston: award £7 6s.

A Macclesfield passenger, also holder of a periodical ticket, was travelling to Manchester on 31 December 1849 when he had been 'thrown onto a gentleman sitting opposite'. He received a blow to his face from which he was 'incapable of attending to his business for a few days'. At his request the company paid 5 guineas to Manchester Infirmary. The claimant was actually a medical man, but no name was given.

Three further claims all involved mail trains. One occurred in a tunnel of the Leeds and Bradford Railway; another was the result of a train from Newcastle to Manchester coming off the line near Victoria Bridge; and the third involved a government officer and his wife travelling from Durham at 4.30 p.m. when their train hit an engine in a sidings, which was due to the points not being set properly.

Claims listed as Nos 12–17 all related to an excursion train that left Macclesfield on 3 July with passengers also from Leek. It was on its way to Liverpool but when it arrived there it went through the buffers and ploughed into the station wall. The reason given was that the weight of the train had overpowered the brakes as it entered the station.

At the time, a rumour spread that many had been killed, and there was some panic in town until an urgent message arrived to quell most fears. All were from Macclesfield except two; one was mother-in-law to a Macclesfield man, accompanied by his wife. They were all in second class and paid £2 each; all had been bruised, but not too badly. A young lady from Leek, who was a third-class passenger, hurt her face and also received £2; while a man and his wife, both silk workers, were recovering from shock and awarded 5 guineas. Another passenger was so badly shaken that he could not attend his business for several days, and received £6. The most severely hurt was a woman travelling second class; she injured her spine and neck and was still 'confined to her room', yet to be assessed.

Most of the cases did not include medical expenses, which were paid direct to the medical officer of the company. He acted promptly in visiting the injured as soon as he learned of the accident. It was hoped that by highlighting these cases, people would see the sense in adding just a small additional cost to their journey. It would help create a fund for the relief of suffering 'from time to time'.

Railway Outings

Cockfighting scene. The sport was prohibited by law in 1849.

In June 1850, the preparations for celebrating the Barnaby holidays in Macclesfield had been extended, and were announced to be more general than previously. Reference was made to many celebrations of the past when Barnaby was seen as a time for bull-baiting, cockfighting and the 'brutal exhibition' of the prize ring, all taking place on the outskirts of the town. That had all changed, now it was a time for tea meetings, anniversaries, Sunday school and other society excursions. The Female Friendly societies took the opportunity to celebrate their anniversaries and walked around the town in procession.

What had begun in a small way as one or two works excursions had grown with great rapidity. The first was recalled eight or nine years before, when George Oldham had treated a limited number of his employees to an outing in Buxton. This had actually taken place at the Wakes weekend in September, but the following year many other employers took up the idea.

Several Sunday schools organised walks that included a picnic and afterwards many games and amusements took place when everyone joined in the fun. From this, various day schools became involved, seizing the opportunity of organised canal excursions after its grand opening on 9 November 1831. So popular was this that it became difficult to make adequate arrangements for all those who wanted to take part.

The Railway

The Macclesfield branch railway was the next step in widening everyone's horizons, and the opening of the North Staffordshire line in 1849 had increased the opportunities beyond recognition. It had created a desire for railway excursions all year round, especially by Sunday school scholars.

The Macclesfield Sunday School (now the Heritage Centre) on Roe Street went by train to Stockport for their Barnaby trip. They visited the large Sunday school there, had refreshments,

and then walked around the town. Having formed a procession, they returned to the station for the journey back home.

The Christ Church schools, comprised of scholars, teachers and visitors numbering over 500, were given permission by Thomas Legh Esq. to visit Lyme Park. For this excursion it was more convenient to travel by canal. The party crowded onto five boats 'with music and banners', and on arrival marched up to Lyme Hall. Revd Peter Legh greeted them on behalf of his brother and allowed complete access to those wanting to see the various 'magnificent apartments'. Refreshments were served on the lawn beneath the house to the scholars and afterwards they formed groups to play games. The Independent Brass Band enlivened the outing, which everyone thoroughly enjoyed, and a distribution of buns on the way home completed a perfect day.

However, within a week of the opening of the Waters Green station by the North Staffordshire Railway, the Christ Church contingent did take advantage of the new railway line for their Barnaby outing. They had obtained permission from the Duke of Sutherland, via his agent, to visit Trentham Gardens in Staffordshire. Many were also looking forward to seeing 'new country'. This time the number was nearer 800, and a special train of seventeen carriages was needed. The railway company gave them a reduced rate, and at 10 a.m. their journey began by passing through some beautiful scenery.

The Harcastle Tunnel proved to be rather 'disagreeable' because of the sulphurous fumes; these they had to endure for some time due to the length of the tunnel. Once through, the scenery soon changed as the 'furnaces' came into view. However, potters and their families crowded to their doors and windows along the line, to catch a glimpse of the 'little strangers'.

In just 1 hour 15 minutes, the train arrived at Trentham station. Once again there was a distribution of the ubiquitous buns, which were eaten immediately – doubtless a well-thought-out strategy to get rid of the taste of sulphur. Now they were ready to fall in line and march off to the gardens; soon the boys were playing cricket, while the girls went off to play games of their own.

At 1 o'clock, they each had a pie and some milk, and then dispersed in different directions. Everywhere people were having picnics under the trees. Some children and some of the visitors made their way to the monument, from where there was a good view of Stone village and the Potteries. There was also an excellent view of Trentham Hall, described as 'the ducal residence'. On this occasion, however, there was no opportunity to view the inside of the house, but a pleasant alternative was soon adopted. About forty of the more senior members of the party decided to have dinner at the Trentham Hotel, before returning to join the others.

At 5 o'clock, each child again received a pie and glass of milk, but it had been a tiring day for some of the younger ones, who began to show 'symptoms of fatigue'. This gave a chance for a few older pupils, accompanied by teachers and visitors, to see the conservatory and enjoy a leisurely walk around the beautiful flower beds.

Barnaby, 1850

The Monday and Tuesday mornings of the Barnaby week in late June of 1850 had witnessed incredible scenes at the railway station, as school after school began to arrive for their day out. At that time the facilities of the Hibel Road station were used for all passengers; the platform for the North Staffordshire Railway was well below and was eventually enlarged when a proper central station was created in 1872.

The stationmaster, Mr Platt, and his assistants 'worked magnificently', filling carriages without the least confusion. The special trains were of considerable length in order to accommodate all the excited pupils, teachers and friends. The one that arrived for the Macclesfield Sunday school was made up of sixty-nine carriages and was actually 0.5 miles long. This train was also shared with the pupils and friends of Fence School in Hurdsfield, and in all was estimated to be carrying at least 500 passengers. Taking into account the length of the line and the small platform, many would have had to climb on board from the track. Another train to Derby had twenty-three carriages, while the one en route to Sudeley was made up of twenty-nine.

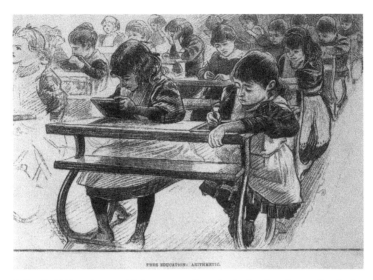

School children busy with lessons and no doubt hoping for a school trip.
Illustrated London News 1891.

Apart from the trips, the fair took place as usual on the Saturday, mostly on Waters Green close by the lower station, and it was well attended. A great quantity of all kinds of stock were sold at fair prices, but the horses sold above the average usually paid. In fact, it was considered to be the best show there had been for a number of years.

The amusements were more numerous than in previous years, with the famous George Wombwell's menagerie and 'Mr Bellamy's celebrated exhibition of Paragon Models' being the greatest attractions. Cheap trips from neighbouring towns had been offered by the railway, and the town received a large influx of visitors.

Rudyard Lake

In the early 1850s, the area was experiencing some remarkably fine days in the month of April, so a fête and regatta were planned for Rudyard Lake. The preparations had taken a long time, and it was decided that the event would take place on Easter Monday in 1851.

The lake was the great reservoir for the Trent and Mersey Canal, and considered to be 'well-adapted' for aquatic sports, being over 2 miles long and 0.25 miles wide. Its popularity had grown, particularly for picnic parties, since the North Staffordshire Railway passed through the district. This had attracted many walkers from Macclesfield and around the area because of the fine views from the wooded heights on the western side of the lake. The day arrived and proved to be ideal. The sun was shining brilliantly but with just sufficient cloud to prevent the heat from becoming 'oppressive', yet promising no rain.

Because of the popularity of the lake, the railway company had not only built a fine railway station, but also a hotel. The largest room had a bay window providing a superb view of the lake, the railway and the surrounding countryside.

In the early afternoon, an excursion train arrived, carrying crowds of people from what had now grown into the important Lancashire town of Manchester. It had been so full that no one else could have climbed on board after its original departure, and it even carried a fine military brass band. The band was that of the 28th Regiment, which at the time was stationed in that town.

The racing boats of the Manchester and Salford Regatta Club were secured along the roofs of the carriages, which must have presented quite a sight for those passing by. Just behind it was another train of eighteen carriages crammed with people from Macclesfield, and throughout the

Rudyard Lake still attracts many visitors.

day cheap day return trains arrived at intervals. With the addition of those from Manchester, Stockport and Macclesfield, others arrived from Stoke, the Potteries (i.e. the other pottery towns), Leek, and the Midland districts. Altogether an estimated 10,000 visitors were said to have arrived during the day.

Large tents and marquees provided refreshments and were conveniently spaced out in several fields around the banks of the lake, although many had brought large picnic hampers with them, 'loaded with food'. On the Monday, the newly built railway hotel was to be opened by Mr Ultivero of Congleton, who would provide refreshments said 'to suit everyone's taste and expense'.

As the hours went by, the banks at the southern end of the lake attracted the most people, avidly listening to the 28th military band as it floated by on the water. Apart from the military band, steamers cruised up and down filled to capacity, and the excitement was considerable as crowds waited for the competitions to begin.

In addition to the aquatic sports, others were taking place. In one field, a group of archers had gathered, mainly from Stalybridge. In another, there was a group of rifle-shooting members; while in a third, a maypole had been set up. The Macclesfield Mechanics Institute had also organised several other rural sports. At one o'clock there was a military salute, which signalled the start of the aquatic sports. These were under the supervision of the Manchester and Salford Regatta Club.

There were around sixteen boats, chiefly four oar gigs, with a few skiffs on the lake. During the afternoon five races took place, each consisting of several heats. Each one covered 1 mile there and back, and the results were later printed in all the local papers. There was a prize of £6 10s (£6.50) for youths under twenty-one years. The military personnel also had their own race, which a prize of £3 10s, and the skiffs competed for their prize of £6.

While the races were progressing, a quartet floated along the lake playing a variety of pieces, including Handel's 'Water Music'.

The archery competition lasted from 2 p.m. to 6 p.m. and attracted numerous competitors. First prizes were awarded for the best scores with forty-eight arrows, followed by second and third prizes.

Walks had been laid out, and many took advantage of these through the woods to enjoy a view that was not spoilt by the smoke from factories.

The day was a resounding success with hundreds of workers enjoying themselves, and 'not one single case of intoxication was observed'. Just after 6 o'clock, the first departing engine blew its whistle and soon all the trains were gone, with much praise for the directors of the North Staffordshire Railway.

With the main railway link gone, today a small station and mini-railway, run by enthusiasts, serves in providing an interesting ride alongside part of the lake.

Enterprises

By the 1850s, with the coming of the railways to Macclesfield, not only were people taking pleasure trips further afield, but the connections were important in other ways. For example, Manchester musicians and dance teachers, who usually came to the town once a week to teach, found it was far more convenient. They were accommodated either in one or two of the local private schools, or in other convenient premises. Surgeon dentists regularly appeared, whereas previously it was the local surgeon in his surgery who had carried out extractions. They also advertised in the *Macclesfield Courier* for people to visit their surgeries in Manchester, offering painless extractions and the latest designs in false teeth.

An enterprising medical partnership of Liverpool soon took their opportunity to advertise:

> For the convenience of those Persons who are not able to attend their Liverpool establishment, one of the Firm may be consulted at Park Street, opposite St. George's Street in Macclesfield, for a limited period.

At that time there were houses on both sides of Park Street. This was Messrs Lewis & Co. of No. 44 Nelson Street in Liverpool, situated two doors from Great George Square, near to Revd Dr Raffle's chapel. They were members of the Royal College of Surgeons in London and could be consulted from 9 a.m. until 9 p.m. every day. Early closing was on Sundays, when the hours were from 9 a.m. until 2 p.m.

They had just published a treatise on diseases, and 'in cases of secrecy' people were advised to consult the publication 'on every stage and symptom of Disease, in its mild and most alarming forms'; and, to encourage sales of their own concocted Lewis's Eradicative Pills, (priced at 2s 9d; 4s 6d; and a very expensive 11s per box – the latter price equal to a week's wage for a supervisor in a silk mill) those purchasing were given a little booklet.

It described all the different stages of 'deplorable and often fatal diseases', as well as the effects of taking mercury. It also provided some rays of hope in assuring everyone of 'plain and practical directions for the effectual and speedy cure with ease, secrecy, and safety'. The pills were claimed to be well known throughout Europe and America, and were the most effective and certain cure ever discovered at any stage of the disorder. There was also available Lewis's Cordial Balm of Rakasiri for debilitation, and hot off the press, *The Control of Passions*, said to be a true guide to health and long life. In the words of the famous Indian love song, 'Where are they now, where are they now?'

Postal Services

There have been various routes and methods used for the delivery of post to Macclesfield over previous centuries. It was not until the late eighteenth century that a member of the Pickford family obtained a Royal Mail posting station in the town, on what is now King Edward Street. This was for postal deliveries sent between London and Manchester.

When the Pickfords withdrew early in the nineteenth century, normal deliveries came either by coach or by horse post to the Angel Inn in the Market Place. They were passed to the post office on Mill Street, close to the Market Place, but this routine was to change.

By July 1827 several townsmen took action because of the delay with postal deliveries by the Western Mail. The Macclesfield post was left by the coachman at Monk's Heath on his way through to Manchester, and from there it was sent by horse post to the town via Wilmslow.

A communal letter was sent to the Postmaster General requesting that the post be sent by the Birmingham mail, which passed through Macclesfield and Stockport on its way to Manchester; this would cut out Wilmslow and make earlier deliveries possible. By this time the railways were beginning to link the expanding provincial towns with London; the authorities at last agreed to send the post on the North Staffordshire Railway line, and at no extra charge from what it was then costing.

With the coming of the railway line via Crewe to Manchester, the post for Macclesfield was dropped off at Chelford station along with passengers. A coach was sent to deliver and collect both passengers and post twice daily. The inconvenience was due to the fact that because of Macclesfield's geological situation – between boggy peat moss and sandy terrain – the initial engineering problems and expense would take time to resolve.

On 11 September 1846, the post office moved from Mill Street to 'more commodious' premises on Chestergate, which was considered important for customers. There was more room for transactions to take place in the money order department, and it was much more suitable for the arrival and despatch of mail. However, residents on the south side of the town soon expressed their opinions that it was less convenient for them, but, in the words of the newspaper editor, 'some arrangement could surely be made'.

A delightful photograph from the revived Spring Bank Holiday Carnival in Macclesfield of 1971 featuring the winning G.P.O. float "Postmen Through the Ages".

During the last two decades the town had experienced a doubling of the population, but the postal services had not kept pace. In January 1850, the town clerk compiled a letter of complaint from the council to the Postmaster General; again, late deliveries were highlighted, this time due to insufficient letter carriers. This was sent to the town's two MPs in London to enable them to take the matter further.

It was John Brocklehurst MP who took the complaint to the Post Office authorities but it had 'little effect'. Councillor Brodrick said the present

method was too uncertain and they must stress this; only recently a man in charge of the mail had got drunk and left the mail unattended. Another councillor instantly stated, 'With thousands of pounds in it at the time'. However, soon there was a change of secretary, and John Brocklehurst reported that there was 'a more reasonable attitude'.

Regulations

The next complaint, via the editor of the *Macclesfield Courier*, was from the local postmaster, James Sargent, who asked people to state the nearest town when sending letters to a hall or park. For instance, it was not sufficient to put 'Thomas Birtles, Birtles Hall', because, unless 'Congleton' was added, it would not be delivered. The clerks who were in charge of the railway travel post offices had no time to sit down and consult a map.

In August 1850, a report by commissioners, in respect of provincial post offices, was made known. They decided that a Sunday delivery service should be resumed, but with restrictions. There was to be only one delivery, which must not interfere with church services. It was to be made either by letter carrier (postman) or at the window of the local post office. In the principal Scottish towns, Sunday deliveries were only made at the post offices.

As far as possible the post offices were to close at 10 a.m. for the day. If the post arrived by 8 p.m. the previous evening (Saturday), which often happened in rural areas, then it could be delivered that night. If people objected to a Sunday post, they had to write a letter to the local postmaster to be excluded from deliveries.

The withdrawal of 'useless mail' would still continue on Sunday; how this was judged is tantalisingly left out of the instructions. Unfortunately the surveyors of Sunday postal services had advised the Postmaster General that some ideas were impracticable.

After 1 June 1850, postmasters were compelled to fix stamps displaying the fee charged to each registered letter. In all other cases, however, they were 'strictly prohibited' from affixing stamps to letters for the public.

Just over eighteen months later, further instructions arrived: sub-postmasters in rural districts were to be known as 'receivers', and the general accounting system for unpaid post was to be simplified. This would be done by compulsory prepayment of postage stamps in the provinces. Already, the year 1851 had seen over £800,000 collected from postage stamps, which was predicted to rapidly increase and reduced the expenses on crossroad mails passing throughout the country.

Overseas Mail

At this time there was a move to obtain postal communications between all nations by means of the lowest uniform charge on letters and printed matters transmitted by sea. This was not only important nationally, but also to certain residents of Macclesfield whose relatives were in the employ of the East India Company and carrying out valuable administrative work in medicine, surveying and governance in the Middle East and India.

This shortly resulted in the publication of a complex list of charges on books, packages and the like in February 1852, but surprisingly only highlighted postage to and from Ceylon – a possible clearing post for onward transmission to Indian and Chinese ports.

By July 1856 there had been progress when it was announced that the *6d* rate had been extended to the whole of the British Colonies and possessions, with the exception of the Cape of Good Hope, Natal and the Ionian Islands. It was also to be extended to Belgium, the African Gold Coast, Guatamala, the Danish West Indies, Egypt and China.

It is known that overland mail arrived via Alexandria before the cutting of the Suez Canal, having been transported across the Arabian Sea, the Red Sea and over the desert to Alexandria, from there it was loaded on board certain packet steamships for despatch to England. These sailings, despite all the difficulties they encountered, kept as much as possible to a schedule, and were always eagerly awaited at each stage en route.

Burmese letter carriers. *Illustrated London News,* 1891.

A post station in the desert.

Annexed to Queen Victoria's Indian Empire in 1886, the hill country on the border of 'the province of Burmah' (today part of Myanmar and bordering Bangladesh) was administered by many English officers at lonely outposts. In the settled areas, members of the Chin tribes, loyal to the British establishment and employees of the Post Office, slowly but surely made their way along highland and forest pathways to deliver mail.

There was no need for a police or military escort as the flag, carried by the first mail bearer, having the words 'Post Office' clearly printed on it, was regarded with great respect. It was impossible to reach these mini-outposts by express train, 'or even by a red mail-cart with a smart driver'. Instead letters and newspapers were packed into baskets and carried by the quietly plodding sturdy men from one stockaded group of huts to another.

It was by these means that Victorian residents of Macclesfield were able to keep in contact with loved ones, and also learn of a world full of fascinating stories, objects, animals and fauna, not only from letters and later dairies, but also from English newspaper reports and collections, which continued to fill our national museums, libraries, and zoological and botanical gardens.

The First Building Society in Macclesfield

The only mention of the first building society in Macclesfield is an advertisement in the local newspaper on 3 March 1827. It was an auction notice, addressed to 'Builders and Brick Makers', to take place on the premises occupied by the Provident Building Society. These were situated in 'Harbour Haye Street', Hurdsfield, shown on Cawley's plan from 1838 as Arbour Way Street; today Arbourhay is the southern remnant, but now of recent development.

For sale were 200,000 good bricks, 350 yards of wood covers, a quantity of wheeling planks, several wheelbarrows, a coal screen, an assortment of brickmakers' tools and many other items.

At that time the land was part of the Fence House estate, owned by the Smyth family and occupied by Edward Smyth, whose father, Thomas, had been mayor of Liverpool and a partner of Charles Roe & Co.

In 1785, Thomas Smyth gave permission for a small cotton mill to be built on Hurdsfield Road, but he died in 1824. The mill, mortgaged and occupied by different individuals for years, was finally in possession of the Brocklehursts by 1820, and converted to silk winding – not, as later recorded, in 1745.

The doorway on the left of this photograph is No.11 Arbourhay Street at one time occupied by the Beaconsfield Conservative Club. The arched doorways are typical of the period 1820s and 1830s, following the Napoleonic Wars. The houses now demolished, were possibly the ones built with the money borrowed from the Provident Building Society. Courtesy of Nancy Brocklehurst.

It seems that shortly after his father's death, the eldest son, William Smyth, gave permission to a group of tenants to build their own houses. At some point, No. 11 became the Beaconsfield Conservative Club, evidently named after Benjamin Disraeli (1804–81). He first became prime minister in 1867, but after a second period in office was created Earl of Beaconsfield in 1876, allowing him to retire from the Commons to the House of Lords.

Origins

Enquiries to the Building Societies Association provided some useful information from a book entitled *The Building Society Movement* by E. J. Clearly (1965). Official records are only extant from 1919, and prior to that they have been discovered in more local sources. However, a useful fact sheet, also forwarded by the archivist Mr Rex, provides further valuable background information for the existence of the one in Macclesfield.

Some building societies developed from earlier friendly societies in the late eighteenth century, although the movement had begun in the late seventeenth century when friendly societies made their début in various English towns as a form of security. A century later their number increased rapidly, and it was within the more forward-looking ones that the nascent building societies began to appear. The first known society is recorded in Birmingham in 1775; by 1792 another formed in Manchester, but with the intervention of the Napoleonic Wars further progress was somewhat stinted.

The objective was to enable a group of people to own their own houses, and at this early period the movement was surprisingly confined to the Midlands and the North of England. Rules were drawn up and strictly adhered to, and the secretary of each had a very responsible job, for building societies were not formally recognised in law.

Some societies organised the building work themselves, which evidently the Macclesfield one did, although by 1820 this had become less common. This type usually ceased when the work was done, and is probably the reason why, apart from the advertisement, the Provident in Macclesfield had not previously been recorded. The houses were either auctioned within the group of investors, who had contributed weekly to the fund, or allocated by drawing straws. Some societies simply advanced money to individuals, much like of recent times, enabling them to purchase their house or build one – these were the ones with the capability and financial support to carry the movement forward.

The first formal recognition of building society rights had occurred in 1812, when a test case involving payment of arrears was heard in court. Until then these societies had been operating under the Friendly Societies Act of 1793. The court ruled in favour of the society, and such was the encouragements of this judgement that by 1825 over 250 building societies had sprung into existence. This is, of course, around the time when the Provident Building Society of Macclesfield was operating.

Finally, in 1832, the Great Reform Act, with its further authoritative regulations, resulted in a rapid growth of the industry.

Terrible Storm in Hurdsfield

On 9 August 1856, the week's disastrous storm was given a vivid report. On the preceding day (a Friday) a two-hour torrential downpour accompanied by thunder, which began at 12 noon, produced 2 inches of rain. Lightning struck Bond Street, and an unfortunate man was also struck by lightning close by the Shakespeare Tavern on Buxton Road. He was carried into a neighbouring house and was luckily revived.

In Rainow, the house of Revd G. Harrison was hit when the family were away. The servants were quickly aware of a strong sulphurous smell, which was followed by a volume of smoke rapidly exiting through the doorway of the dining room. As the smoke began to clear, the domestic animals reacted strangely; this persuaded the servants to inspect a cupboard – it was the place where lamps and bundles of wicks were stored. Seeing the door open and flames projecting through, the alarm was quickly raised by one female servant who rushed to a nearby factory for help.

The fire was quickly quenched, and the passage of the lightening through the house discovered. It had descended the chimney into the overhead bedroom, splitting the mantelshelf, two stone supports and the brass fender. A small hole, where it had struck the cupboard and forked across the room, betrayed its exit below.

Worse was yet to follow as the torrential rain poured down and collected in Ruloe Hollow (today the site of the reservoir) before the huge volume forced its ever-swelling mass of water down the hill.

Toll Bar Disaster

Hurdsfield Road. The toll gate crossed the road just in front of the first car on the left of the photo, to the toll house then on the right, the latter was demolished when the row of houses was extended.

Just above the canal bridge, a river tore down from 'Cliff-lane Road' taking with it hundreds of tons of large stones and rubbish, the result of destroying the road surface. Large curbstones were 'swept away like feathers'.

As it roared down through the toll bar above the canal bridge, the water rose rapidly in the toll house on the left-hand side of its flow, and the keeper, Thompson, rushed out to get help for his wife and children. In a panic, his wife, with her baby in her arms and elder child close behind, followed in the hope of reaching a neighbour's house. Joseph Malbon saw them through his window and rushed out to help by taking hold of the baby, but the strength of the current washed all four of them away.

Mrs Thompson was quickly rescued, but Maldon, still holding the baby and the elder child, were carried a further 50 yards before he was forced to let go of the infant. Still they were swept onward, and a Mrs Warren was able to catch the small bundle, but Malbon and the elder child were subjected to injury by being buffeted against the stones and debris. Both were eventually rescued and medical attention was quickly given. Malbon remained bedridden for a long period, but the child recovered well; little hope was expressed for the recovery of the baby.

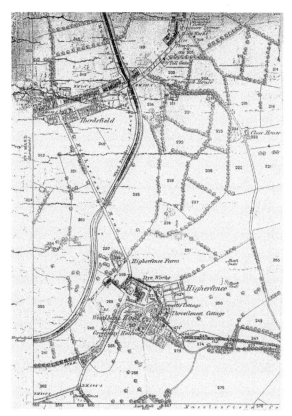

OS map of Hurdsfield 1874 (surveyed 1871) of the area devastated by the flood. The toll house No. 201 is near the top of the map, slightly right of centre. The Adshead dye works Nos 270 & 271 are clearly shown in Higherfence towards the bottom of the map. The Brocklehurst works were lower down Hurdsfield Road below Higher Fence Road.

Commercial Damage

On the other side of Hurdsfield, nearer to Buxton Road, the dye works of 'Messrs William Adshead' sustained considerable damage due to the overflow of the company pond, essential for supplying water to the works. The dye houses, engine house and machine rooms were all flooded to a depth of 4–5 feet, and the large coppers were dislodged from their positions.

The pool, situated in an upper field behind the works, received its water from the catchment area of Buxton Road and, as a consequence of the freak storm, filled rapidly. As the water poured down through the gate at the bottom of the field, taking the course of least resistance, it was channelled between two walls. Soon a considerable part of the lower wall gave way, allowing the flood to ruin cottage gardens by tearing up trees, bushes, plants and vegetables. With the pressure increasing, doors burst open and terrified occupants saw furniture and belongings disappear as they drifted out on the tide. With great difficulty all the families were rescued, including a baby floating in a cradle.

The dye works was the next target, where the concern was to save as much silk as possible from the dye house. With the yard flooded to an

inconvenient depth, it was quickly decided to hoist a boat over the wall, though this was a difficult task. As one of the workmen was retrieving the silk from the hydro-extractor room, the increased force of the water closed the door, threatening to drown the man as it rose quickly within. Another employee, realising the danger, reacted quickly and with considerable 'alacrity' forced open the door, allowing a volume of water to escape. Both men and all the silk were saved.

Aftermath

Unfortunately, as the water receded, a 'thick earthy deposit' was left in the engine room, and the fear was that the engine and lustring machines would be badly damaged. (Lustring was a closely woven lightweight silk with the weft threads doubled or trebled. In order to attain a high gloss finish, the silk was heated and stretched, presumably in the dye works after the dyeing process had been completed.) Ironically the waterwheel was destroyed, together with a quantity of chemicals and dyes.

The next dye house to suffer damage was that of the Brocklehurst family further down Hurdsfield Road. Again, considerable damage was caused due to a culvert becoming blocked by rubble from a collapsing wall.

Surrounding streets adjoining Hurdsfield Road were deluged with water, mud and debris. One householder at Daybrook reported that the water flowed through his house from one side and out through a window on the other side for over one hour, acting as a conduit. Those residents in Harbour Haye Street (now Arbourhay Street), who had built their houses on the south side of Brocklehurst's first mill by using the facilities of the Provident Building Society during the 1820s, must have been particularly devastated.

The one consolation was that it happened in daylight, for it would have been far worse in the dark, and it had been local. Surprisingly no comparison was made with the freak storm of January 1839 in Sutton, when the embankment of the Wood's factory pool had collapsed and caused devastation in the Mill Green area of the town.

Treacle Town

On arriving in Macclesfield many years ago, it was interesting to learn that Congleton was known as 'Bear Town' and Macclesfield as 'Treacle Town'. The Congleton story pointed to an early origin; the town's performing bear had died and in order to buy a new one, the town's Bible was sold. Often there is some truth in myths, but with time they become embellished and distorted, yet are a 'good yarn' to tell. With regard to the Macclesfield story, curiosity sought an answer. All that seemed to be known was that a barrel of treacle had fallen off the back of a cart or wagon and smashed, spilling its sticky contents onto the street. Almost immediately people rushed out of doors with pots and other convenient vessels in order to scoop up some of the sticky mass.

No one could say when or where this incident happened, although the suggestion was on Mill Street. Apart from modern speculations in newspapers, so far nothing has surfaced as a definite fact since the *Macclesfield Courier* newspaper began life in 1811. This seems to indicate that the saga had taken place before that year.

Strange to relate, on the Enclosure Map of Macclesfield, dated 1804 – the result of a survey from 1796 – Pickford Street appears as Sugar Street and Sunderland Street as Pickford Street. On many property deeds of that period no mention is made of Sugar Street, but in a deed of 1816 it is clearly the Pickford Street of today that is referred to.

Joseph Pickford of Royton in Lancashire, a cotton manufacturer whose family was formerly of Macclesfield, owned and leased out a substantial area of land in the southern part of the town until the late eighteenth century (and some of the ground rents were retained by the family until well into the nineteenth century). His father's second marriage in the mid-eighteenth century was to a Miss Elizabeth Sunderland of Croydon, whose relative Richard Townley later assisted with a large loan – hence the street names adopted in that area. There are also, of course, George Street and Charlotte Street, which show true patriotism to George III and his wife Queen Charlotte, indicative of streets that were also laid out in the late eighteenth century.

Often names have been copied from London, where in the City there is a Bread Street and Milk Street, the latter also in Manchester, but no Sugar Street. There were plenty of Sugar Loaf names in London, and a Sugar Loaf Walk still exists, reminiscent of the Elizabethan passion for sugary delicacies, and also the later influx of sugar bakers from the Continent. They came particularly from Denmark, settled around the Tower of London from the late seventeenth century onwards, and even had a Danish church close by.

So, why does Sugar Street appear on the Macclesfield Enclosure Map of 1804 when there is no indication of any sugar baker being in that area? Someone must have thought that the Corporation had sanctioned such a name, yet no mention is made in the Corporation minutes.

A treacle jar *c.* 1840 or possibly a little earlier. Courtesy of the owner.

A letter from an interested party suggested that the story was surely a myth, but another letter from the late Derek Ford, long remembered for his days in the auction rooms of Brocklehurst's on King Edward Street, said that he had been told employers in the Macclesfield silk mills bought barrels of treacle so that their employees could dip in jugs and spread it on bread at break times. Perhaps the latter is true, but it does seem that a fuller explanation is necessary as to how Pickford Street could possibly have been shown as Sugar Street on the Enclosure Map published in 1804.

A Sticky End

Pickford Street enters Mill Street at the steepest point of both their ascents. Could it be that the old story of a barrel of treacle falling off a cart or wagon had occurred at that point, then rolled part way down Pickford Street, smashing in the process and spilling out its contents?

The street at that time would have been cobbled, and anything of a syrupy constituency would have lodged between the cobbles, taking time to clear, and meanwhile turning into sugary granules.

The next question to consider is what would have been meant by the generic name of 'treacle'. This refers to any syrup made from the process of refining sugar cane i.e. black or brown treacle and golden syrup. It was also the common name in earlier centuries for a medicine 'Theriaca Andromachi' made into a conserve or paste by the addition of syrup or honey, which made the concoction palatable.

Sugar was made with the use of machines called sugar mills. Each had three rollers, with the middle one armed with a cog full of sharp teeth, and all having iron plates. The rollers were rotated literally with the use of horse power, usually two, and the sugar canes fed through. These were from 8 to 10 feet in length, having been cut just above the roots and then trimmed of all leaves. The rollers squeezed out all the juice, which was caught in a vessel beneath the machine and allowed to immediately drain through into the first boiler. After a gentle boiling it was released into a second boiler where the heat was increased. The excessive bubbling created scum on the surface, which was ladled off at intervals with a large spoon-shaped utensil perforated with small holes. At this stage it was strained through a cloth, and the residue remaining on the material was fermented with water to create a 'sort of wine'; this seems to suggest a liqueur. The liquid, by then considered 'clean', was poured into a third boiler and reduced to a sugary consistency over a hot fire, but had to be continuously stirred and any scum removed.

The most difficult and dangerous part was to prevent the liquid from boiling over the sides of the vessel. This was done by scooping up a ladle of the liquid and letting it run back into the mass gradually, while at the same time adding a small piece of butter or fat.

Fruit juice, or anything acidic, was avoided at all costs because it had the effect of preventing the sugary substance from granulating. When of sufficient density it was scooped into conical earthenware vessels. These had a large opening at the top, and a small one at the bottom, but the latter was sealed with a wooden plug.

After twenty-four hours they were neatly arranged in the sugarhouses, and each in turn had its plug removed. During the next forty days, liquid, known as molasses, drained out and was collected into an earthenware receptacle that had been placed beneath each conical vessel. A thin clay paste was then poured in at the top, making a cover some 2–3 inches in depth. As the water from this drained through, it created more molasses, and when the clay had dried out and set quite solid, the contents were pushed out; the clay layer removed, and the sugar cut into lumps. These dirty-looking brown pieces were placed in hogsheads or casts and sold as brown sugar. When considered desirable, further processes converted this into white sugar lumps.

All the molasses, which had been drained off, were again boiled up to reduce them further into a sticky mass, and this was sold in casks as molasses or treacle. If it was one of these casks which fell off the wagon in Macclesfield, it was probably destined for the making of spirits in the public houses, and being a market town there were certainly sufficient landlords, particularly on Mill Street, to create a large demand for the molasses.

Upper Pickford Street, mid-1990s leading into Mill Street, just visible on the right of the photo.

Lower Pickford Street, mid-1990s. For a brief period in the late eighteenth century, this street was known as Sugar Street.

Perplexing Licensing Act

In 1828, an Act of Parliament called 'The Licensing Act' was passed in order to grant licences to inns and alehouses etc. to enable them to sell excisable liquor on their premises, in particular beer, in the hope that it would combat the menace of gin drinking. Licences were issued once a year, and in Macclesfield, being a borough, the magistrates met to consider which to grant. Previously a Justice of the Peace had granted them. Two years later, an 1830 Act was passed to enable a licence to be obtained from the Excise Office but, having not been thought through properly, its failings were quickly realised.

Throughout the country it encouraged the opening of many new and small businesses, in particularly beerhouses. This, of course, meant that the problem of intoxication from gin became that from beer, as evidenced by many incidents in Macclesfield. Initially, however, it resulted in a very interesting case.

Two characters called John Crossley and David Whiston, while drinking in a beerhouse called the Lord Hill Tavern somewhere on the lower part of Park Lane, discovered that the proprietor, John Shufflebotham, was serving after hours. Under the supposed idea from the act that anyone reporting the misdemeanour was entitled to a share of the penalty, they reported the matter to the police. They were brought before the magistrates, one of whom was the mayor, and another, one of the Macclesfield surgeons, Dickinson.

Mr Grimsditch, who lived on Jordangate, was the defending solicitor, and being a somewhat Dickensian, colourful character, loved an argument or debate. He managed to get David Whiston

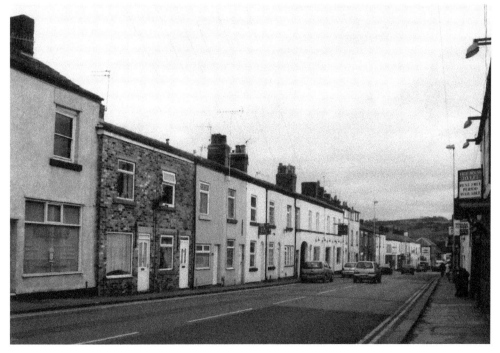

Lower Park Lane. Apart from modern replacements such as windows and doors, the properties remain very much as they were in the first half of the nineteenth century.

to admit that it was he who had bought a pint of beer at 11 p.m. when the act stated 10 p.m. for last orders. This, of course, proved that Whiston had been drinking illegally.

Having succeeded in one point, Grimsditch was also able to get Whiston to admit that he was hoping to share part of the penalty with John Crossley. This should have been declared beforehand. A self-satisfied Grimsditch then argued that their testimony could not be accepted, and the case should be dismissed.

The magistrates, although agreeing in part, did consider the evidence admissible. Dickinson said the 22nd clause of the Act allowed magistrates to refuse the informer any share of the penalty, to which the town clerk agreed. Grimsditch then argued that at that time his client was not subject to the law because he was not licensed under the retail beer act, but had opened his house under the permission and regulations of the Board of Excise. This allowed for a licence to be granted after ten days' notice.

Mr Stephenson, the excise clerk, then gave evidence that Shufflebotham was now fully licensed. He was registered on 29 November 1830 and the licence was dated that day and could expire on 31 November 1831. He had paid the 2 guineas fee at that time, and the licence was given to him.

Grimsditch agreed that the money had not been paid at the time of the offence, and that the Board of Excise could permit the sale of beer for an unlimited period without a licence, but the town clerk did not agree. Dickinson said that he would be 'the last person on earth to attempt to abridge the power or authority of the Magistry; but on looking at the clause alluded to, he must confess he felt inclined to favour the conclusion which Mr Grimsditch had arrived at.'

Still the magistrates were unable to reach an agreement, and, after a short private meeting, the packed courtroom audience was told that some points under the act remained unclear, and therefore they felt that a temporary postponement was necessary until the following Monday.

An interesting footnote from the newspaper editor read:

> We understand that Mr Stephenson was in error stating the licence of the defendant had the date of entry entered on it [i.e. 29th November] when in fact it was found to be the 6th December 1830 – the day of the court hearing and also the date on which the money was paid for the licence.

In the event, the Board of Excise had already found out the problem, resulting in Mr Shufflebotham receiving instructions just a few hours after the case was adjourned; the regulation was to be abolished. In future no one could sell beer unless they already had a licence under the provision of the act. Under the circumstances, the case was closed with the comment that it was 'a most blundering piece of legislation'.

The Smale Tragedy

A Mysterious House

Some time ago, a London schoolteacher sent a pen-and-ink design drawn by her great-uncle McDonald Gill (1884–1947), an architect, artist and designer of the Art and Craft Movement. He was the younger brother of the more famous Eric Gill. Her research at that time had uncovered some interesting details of his work, and she was anxious to trace the property, which is the main focus of the drawing.

The lovely pen-and-ink design, reproduced here, clearly shows the arms of the Old Macclesfield Guildhall, and a vignette of Macclesfield town in the top right-hand corner. The arms on the top left are described as 'Crest – Unicorn on Chinese shoes ermine'. A quick search revealed that it related to the important silk family of Smale.

Next, the house needed to be identified; additional information given by the writer was that the mural would have been commissioned for display on a wall panel. The exact size of the frame, usually in mahogany and fixed to the wall panel, is written along the top border: 4 feet 3.25 inches wide by 2 feet 3.75 inches high. When painted the mural would be done either as a separate picture, and then screwed onto the panel to fit exactly in the frame, or it would be painted directly onto the plaster wall.

Mysteries call out to be solved, and with curiosity aroused, particularly as the design was so much like a Lutyens house (Edwin Landseer Lutyens, 1869–1944), considered 'the greatest British Architect', certainly of the twentieth century, determination to find the property increased.

Between the two arms, devices, curving across the top of the drawing, are a waterway with two sailing boats in obvious view. It could not be the River Bollin, therefore it had to be the Macclesfield Canal.

There is a particularly fine painting by Constable entitled *A Boat Passing a Lock*, which shows a boy negotiating a canal lock, while his boat, with an orange sail only partially hoisted, waits at the lock gates. Today it is a novel idea to think of a sailing boat on a canal, but then it was a logical idea to use wind power whenever possible.

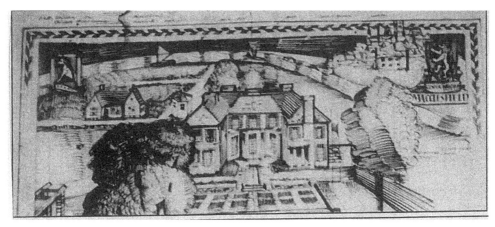

McDonald Gill's pen-and-ink design. Courtesy of Caroline Walker.

As the canal was curved, the place that immediately sprang to mind was Sutton, and there stood the house. The rear had been in part altered from the original design, with the addition of two garages, but it certainly projected the style of Lutyens.

With so many questions needing to be answered, permission was obtained from the owner to visit and take photos, hoping that the painting was still in existence. In the meantime, with more research a ledger was found, and my correspondent reported that the architect was in fact Milne from whom her great-uncle had received a fee of £7 7s for the design.

There were two Milnes: the father, William Oswald Milne, who was a pupil of Sir A. W. Blomfield, the architect used for the final two years (1898–1900) of the great restoration of Macclesfield's parish church of St Michael and All Angels; and the son, Oswald Partridge Milne who, for a period, actually worked for Edwin Lutyens. It is hardly surprising that Milne, more than likely the son, was chosen by the important silk manufacturer Josiah Bradley Smale, to build him a fine house using only the best materials and workmen. When completed, the house was originally known as Lyme Green House; it is now Pendlebury Manor Care Home. This discovery, however, was just the start of an intriguing and tragic story.

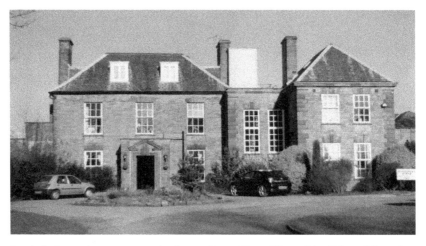

South-facing main entrance to the former Lyme Green House (Pendlebury Manor).

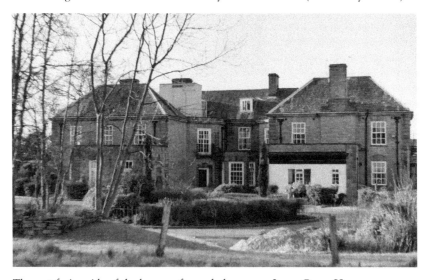

The east-facing side of the house – formerly known as Lyme Green House.

J. B. Smale

Josiah Bradley Smale had already done well for himself when he built his grand residence at Lyme Green in Sutton. He was president of the Silk Protection Association and head of the largest silk manufacturing business in Macclesfield, having control of ten silk mills. He took a particular interest in the welfare of his employees, and if they fell ill, or the work became too great a strain, he immediately took steps to offer assistance and ease the situation.

He was described as 'active, energetic and alert', somewhat brusque in manner, which concealed his 'generous, shy and tender' nature. When young he had been a keen church worker and weaver, and having acquired a fortune became a philanthropist in his later years. He was also a keen sportsman, a football fanatic and was in fact president of the Macclesfield Football Club.

Traditionally the family considered themselves Huguenots, and were certainly practising Protestants, later Dissenters. First recorded in 1551, Robert Smale, later joined by Thomas, was farming at Pott Shrigley. With the opening of the Dissenting Chapel on Back Street (now the King Edward Street Chapel), situated on the northern boundary of Macclesfield Borough at that time, the family joined the congregation. They were soon involved in the silk trade and in 1771 a Josiah Smale is recorded as a silk twister on Back Street (now King Edward Street).

By 1850 John Smale, eldest of four surviving brothers, had established the family silk concern, which would significantly grow. From his prolific family of seven sons and three daughters, the eldest son, Josiah Bradley Smale was trained to take over; this he did in 1900 when his father retired. It was Josiah's business acumen and expertise that saw a considerable expansion take place.

His father died on 2 April 1910 and Josiah inherited a small farm at Lyme Green built of grey stone, with stables, outbuildings and a shippon. In 1912, he set to work and, described as his 'labour of love', commissioned his fine house from Milne on the site of the farm, while retaining the stables and outbuildings. The following year the building work was completed and, on 10 November, McDonald Gill visited Milne in his office on Chancery Lane. There he accepted the task of creating a fine mural depicting the house at Lyme Green to be set over the fireplace in the Smoke Room.

Fireplace in the original smoke room; the space created for Gill's design is today part-filled by a mountain scene.

Gill was due to travel to Macclesfield on Thursday 20 November, but instead had to change the visit to the following Tuesday, the 25th. He left Euston on the 7 a.m. train, and apparently returned to London that day. At that period Gill was kept extremely busy by Milne; one of the commissions undertaken was similar to that at Sutton, it was for a mural at Llanwern Park in Wales, unfortunately the property is now demolished.

Gill must have come to some agreement with Smale, and sketched a quick idea for the painting, then completed the drawing on his return to London. He had obviously taken into account the position of the canal, but used artistic licence. The nearby toll house is clearly visible, which suggests the view of the house is from the south side, when actually it is from the east.

However, before this final embellishment for the Smoke Room could be accomplished, the headlines read 'Macclesfield's Great Loss – The Death of Mr J. Bradley Smale'.

Great Problems

The news of Josiah Bradley Smale's death on 27 December 1913, aged only forty-nine years, reverberated around Macclesfield like a giant shockwave. The inquest revealed that the previous Saturday he had watched the football match at the Moss Rose with his brother Charles and son Philip. He had been sitting down during the game, which Macclesfield had easily won, so he was not excited in anyway.

It was a bitterly cold day, but, being a great athlete he was enjoying the vigorous walk home when his son complained about the cold. Josiah chided him, though not aggressively, and when they reached the house, having removed his hat and coat, he went into his smoke room.

Charles went to the toilet and heard a thud; then Philip called out. The latter had followed his father into the smoke room, and once more Josiah started to chivvy him about feeling the cold, then he suddenly fell backwards, hitting his head 'slightly' on the table. Despite all efforts by his uncle to loosen his father's clothes, Philip realised his father had died. When called, Dr Proudfoot confirmed that the post-mortem had revealed a heart attack, although everyone had agreed how healthy and athletic Josiah had been.

The funeral was impressive. Literally thousands of people lined the route along London Road to Christ Church, where Josiah had been a Sunday school teacher when young. The black carriage with hearse, drawn by 'a fine pair of black Belgians', together with a long procession, including 238 men representing all the Smale silk mills, then passed along the crowded Prestbury Road to the cemetery.

The whole of the Corporation was in attendance, and many Union Jacks hung limply at half-mast on public buildings and mills; the wreaths of beautiful mauves and pinks, several tied with contrasting silk ribbons, totalled seventy-three and created a magnificent display. Eulogies followed, expounding Josiah's considerable charity works and more than generous donations, but his demise signalled the start of many problems.

Probate was granted to his widow, Elsie Beatrice Smale with a request to his brother Henry to be executor and ensure all his estate went to his wife – it grossed just over £36,500 – but Henry refused. By 1 August 1914, a case, 'Smale versus Smale', began in the Chancery court in London, which continued until the fifth session – an appeal on 8 July 1915. By this the judge ordered the sale of all Josiah's property, and his widow was forced out of her home.

The local newspaper is utterly silent about the case, and at present, despite sterling efforts on the part of Gill's relative to trace it among the hundreds of court cases in the Public Record Office, no further details are known, but obviously all was not well. Great arguments arose about the business among the family, and it was finally floated as a public company.

The start of the First World War did not help matters, as a large proportion of Macclesfield woven silk was dyed in Germany. At that time thousands of pounds worth of silk was with the well-known firm of Boschars & Co., dyers of 'Crefeld' (Krefeld near Dusseldorf). The comment was 'this is one of the penalties of depending on the foreigner'.

Also, the Customs and Inland Revenue Act (1879) prohibited exportation of certain items that could be used in warfare. These included 'Silk cloth, silk braid, silk thread, suitable for

cartridges, silk nails' etc. The secretary of the Macclesfield Silk Trade Employers Association wrote to the War Office as a literal interpretation would destroy the trade, especially when the greatest proportion of spun silk yarn was for export to America, France, India, Canada and other British Colonies. Government advisors 'saw the light' and advised the shipping companies not to delay the exports. Meanwhile, young Philip Smale had been recruited into the army in France.

Smale Auction

Josiah's widow, Elsie, due to the sudden death of her husband, was, within nine months of his death, living in a house called 'The Hut' in Sutton. The removal, having been forced on her by the judgement in the Chancery court, had perhaps inspired the ironic name of her new residence. The magnificent house she had left at Lyme Green had hardly been finished and furnished, when Messrs C. W. Provis & Sons of Manchester announced the auction on the premises 24th to 26th August 1915.

The catalogue alone was a superb publication listing 700 items of finest quality, and containing beautifully produced photographs. The twenty-four sets of cream cashmere casement curtains indicate the number of rooms, including eleven bedrooms, apart from the utility rooms. Most of the bedding was new, the finest blankets were from London, edged with silk. Other items included 'A Handsome Crown Derby dinner service of 120 pieces'; Royal Worcester tea and breakfast services, a Limoges china desert service. The list seemed never ending.

Most of the furniture was mahogany. There were Axminster and Persian carpets, the best wines and spirits, silverware, cut crystal glassware, several sets of chairs, and many antique pieces attributed 'Jacobean' or 'Chippendale'.

Reflecting Josiah's passion for sport was tennis and croquet equipment, and he even had a cycle room. But his two most treasured possessions must have been his two magnificent cars, for which he had the house plans altered so that a garage could be added, which did rather spoil the look of the eastern façade.

They were both Renault Landaulettes with coachwork by Cockshoot's garage, Macclesfield. The one of 1909 was painted dark blue, picked out with orange lines, upholstered with fawn-striped cloth. The other was the 'luxurious Renault 'D' fronted' of 1912, black with orange lines, expensively fitted and again upholstered with stripes. Even the heavy eighteenth-century style entrance gates were auctioned!

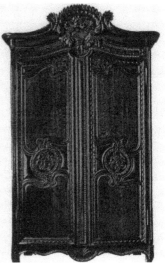

Above: One of Smale's Renault Landaulettes in the auction of 1915.

Right: An impressive mahogany wardrobe from the 1915 sale catalogue.

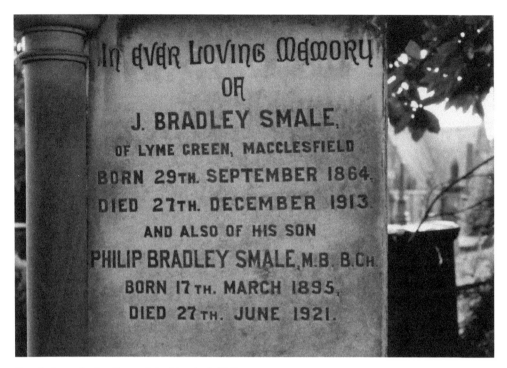

In dved Loving Memory
of
J. BRADLEY SMALE,
OF LYME GREEN, MACCLESFIELD
BORN 29TH. SEPTEMBER 1864,
DIED 27TH. DECEMBER 1913,
AND ALSO OF HIS SON
PHILIP BRADLEY SMALE, M.B. B.CH.
BORN 17TH. MARCH 1895,
DIED 27TH. JUNE 1921.

Details from the family tomb in Macclesfield Cemetery.

Life is cruel at times; in less than three months Mrs Smale learnt that her son had been badly wounded in France and was brought to Manchester for hospital treatment. When examined, with the intention of returning him to the front line, he was too weak and was sent to Hurdsfield House, one of the former Brocklehurst residences in Hurdsfield, by then a convalescent hospital.

After the war Philip was inspired to become a doctor, but having only recently passed his examinations, he died after a short illness on Sunday 27 June 1921 at 'The Hut' in Sutton. He was just twenty-seven years of age. In direct contrast to that of his father's funeral less than six years earlier, his funeral quietly took place at Macclesfield Cemetery, where he was placed in the family vault alongside his deceased parent and other family members.

Immediately after the last war, in 1945, Lyme Green Hall, as it was then known, was purchased for use as an important paraplegic settlement and proudly produced some Olympic medallists. While part remains, the main house is now a residential home for the elderly. My thanks go to the manager and staff who, with permission, escorted me around the hall pointing out the beautiful features, especially the exceptional oak panelling, and also helped with facilitating photography.

Lyme Green Settlement

Lyme Green Hall

On 4 January 1946, a Joint Cheshire Committee of the British Red Cross Society and the Order of St John of Jerusalem passed a resolution for an important trust to be created. As a consequence, on the following 12 June four people were appointed, which included the secretary to the Cheshire Branch of the British Red Cross, and Lady Elizabeth Viscount Ashbrook of Arley Hall near Northwich.

The governors were from various places in east Cheshire and numbered fourteen, equally divided between those appointed by the Red Cross and those by the Order of St John. Their remit was to establish a special settlement for armed forces personnel who had been severely wounded during the war and lost the use of their legs – they were paraplegics. The Joint Committee provided £25,000, but to cover any additional costs funds had to be raised locally, and for this a Purposes Committee was formed.

Preference had to be given to those paraplegics or their families who normally resided in the North West of England, the West Riding of Yorkshire or the three northern counties of Wales.

The next important step was to find and purchase an appropriate site for the facility. In the event it was none other than Josiah Smales's creation, Lyme Green Hall with its 5.5 acres. The deed dated 28 September 1945 confirmed that the trust had made the purchase from Hitchin, Lloyd & King Ltd. On the same day two further plots of land were bought from a Hugh Carver; one of just less than 20 acres adjoining the site, and the other on the opposite side of London Road was just over 3 acres.

The mansion was converted into a hospital with two five-bed dormitories, a physiotherapy department, gymnasium, recreation room, and a common room with library and dining room. There

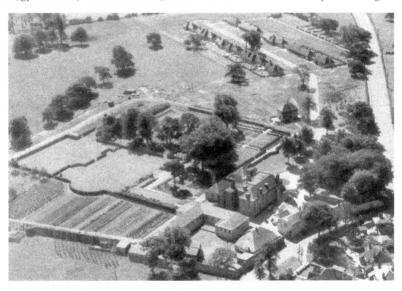

Aerial view of the Lyme Green Settlement estate.

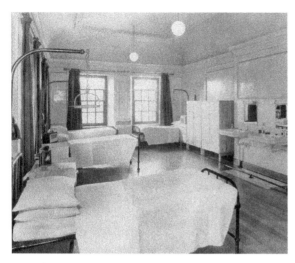

One of the dormitories in Lyme Green Hall, the house that Josiah Smale originally built as his home.

was also a six-bed clinical ward in the early years. The other rooms were for staff requirements, and a matron, sister and nurse occupied some of the upstairs rooms, other nurses were volunteers from St John's and the Red Cross.

A lift, of course, had to be installed, but great care was taken not to spoil the internal structure and panelling of the house. The hospital when completed was opened by Lord Mountbatten's wife, Lady Edwina.

Next, bungalows were built, which are well looked after today. Each was built by donations from different villages, Prestbury provided one, Bollington another and so forth; others were from organisations. These were ideal for those who were married men, for it allowed their wives to live with them.

At first there were no further grants and the paraplegics, after an intensive rehabilitation programme, were employed in workshops provided on site. There were three in all, and the men became very skilled at their jobs and were paid wages. One was the Watch and Clock repair shop, the second the Boot and Shoe, and the third the Carpentry shop.

For the first few years the carpenters made bedside cabinets, pegs and clothes maidens, then a change in policy saw a progression to doors, windows, and picnic tables, which were made from lighter woods. Each year the men were taken to the Cheshire Show where they could proudly show off their skills.

These workshops finally closed eighteen years ago, as the older armed forces residents had gradually been replaced by civilian residents. At the time of writing there were only two survivors from the former paraplegics. One contracted polio when he was in the Royal Air Force; the other 'Paddy' Moran, a casualty from the Korean War, has the most wonderful story to tell.

Today with extra grants, those paraplegics from the Iraq and Afghan wars are accommodated in their own homes, which are adapted for their use.

Paraplegics

By one of those remarkable quirks of fate, the success of the Lyme Green Settlement in Sutton actually began in 1899, in what was then Upper Silesia. There Ludwig Guttmann was born on 3 July into a Jewish farming family.

Through hard work his father Bernhard had become a prosperous businessman who ensured that his son had a good education, which included learning Latin and Greek. At that time the region belonged to Prussia, and Bernhard fought in the First World War as a loyal German; also a cousin won the Iron Cross for rescuing a wounded commander under a hail of bullets.

Meanwhile Ludwig, not happy at school, quickly grasped the opportunity to join the National Emergency Services. His ambition to become a doctor saw him accepted in the Accident Hospital for Coalmines. There he assisted a surgeon and learnt a great deal, as the hospital of 800 beds became an auxiliary unit for many war wounded.

Soon he experienced his first severe case of a spinal injury – a young but strong collier. While staff pulled the patient's arms and legs, a surgeon forced back the bones with his fist. The collier, then encased in plaster, was put into a bed and was screened off from the rest of the ward.

The verdict was the same as for all the paraplegics who preceded him – he would die within six weeks, which he did, totally emaciated.

Astonished at this waste of life, Ludwig, after excellent training, a German university education and the practicalities taught by the best in Germany, became a neurosurgeon. Needless to say by 1935, with a Nazi government in power, things began to change. The outcome was that Ludwig, his wife and two children were lucky to escape via Paris to England in 1939. Because of his considerable reputation, and a couple of decent German officers 'looking the other way', he was allowed to bring a few crates of belongings.

To do justice to his story would take chapters, but his belief 'that in order to prevent spinal injuries from becoming merely an accommodation of doomed cripples, the practice of certain basic arrangements was absolutely indispensable…' took him to Stoke Mandeville hospital south-east of Aylesbury, Buckinghamshire, in 1943. There he worked tirelessly, leaving one patient to wonder when the doctor ate or slept. He was the first ever to rescue men, women and children from what he called 'the human scrapheap' and return them 'to a life worth living, as useful and respected citizens in the community'. His belief in sporting activities became the main centre of focus in his crusade.

Paddy

A decade later during the Korean War, now almost forgotten in England but not in America, a young soldier stepped on a mine and was severely injured by flying shrapnel. His name, T. K. Moran from County Wexford, southern Ireland, known to everyone as 'Paddy'. Rushed by helicopter to an American field hospital, which he describes with much humour as a perfect example of that in the T.V. series *M.A.S.H.*, he was treated for two weeks then flown to Japan. In contrast, the American hospital in Tokyo 'was like a 5 star hotel'.

Given ten years to live, Paddy was repatriated, but the flight home took ten seemingly long days, as paraplegics were only allowed to fly four hours each day. New patients with spinal injuries must be turned every two hours to prevent bedsores. As Paddy was on a special stretcher, it meant two hours on his back and two on his stomach. The latter were the worst because his face was accommodated through a hole in the canvas, and the only thing visible was the floor, particularly boring during each flight.

After six or seven weeks in a military hospital near Oxford he arrived at Stoke Mandeville for a year under Dr Guttmann's care, more aptly termed 'regime'. Strict discipline ruled, but the forces patients were used to this. 'Mind over matter' was essential. Archery built up shoulder and upper back muscles, table tennis ensured movement to and fro in wheelchairs, and they were taught how to cope. After one year he was returned to southern Ireland; but unknown to him his final destination would be the Lyme Green Settlement at Sutton, and his life was about to completely change, though he did not know it.

In 1953, Paddy Moran arrived at the Lyme Green Settlement in Sutton. His transfer from southern Ireland had been arranged by the Red Cross, which considered it to be the most appropriate place for him. In doing so, the society paid the fee of £24, this allowed him to become a British citizen so that the move could be made.

Routine

Any new entrant at Lyme Green was first placed in the hall (now Pendlebury Manor), which was still being used as the hospital. This was a reciprocal arrangement to see if the patient was suited to the environment. Dr Guttmann's methods, as practised at Stoke Mandeville, were definitely in vogue, and Paddy stayed.

The twenty-nine bungalows were occupied by married couples and at that time, as elsewhere in an England still recovering from the Second World War, things were very primitive. With no

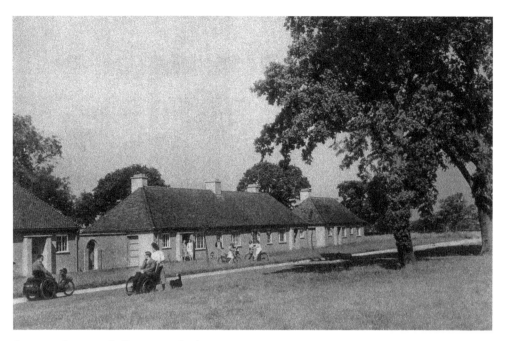

A group of cottages built post-war in the 1950s.

carpets on the floors, severe winters and a boiler that caused great problems, rooms were very cold at times.

After the first three months Paddy, as a single man, shared a large dormitory with five others. It was well fitted out with equipment and washbasins, allowing plenty of freedom for movement. They had to earn their living by working in one of the three workshops on site, otherwise there was no income. Their day work was hard and wages small, but Paddy continued his enthusiasm for sport that he had acquired at Stoke Mandeville.

To encourage sport, although the workshops closed at 4 p.m. those in the basketball team were allowed to finish one hour sooner. Two teams were formed, one for those who could walk a little, and the other for those confined to wheelchairs. About one hour was suggested for practice time, but often it was 5 or 6 o'clock before they finished practising.

At that period there was an excellent market garden looked after by three gardeners, so with good fresh vegetables and the extra exercise, the Sutton paraplegics built up a strong and formidable basketball team.

In 1954, the first international game against Holland took place at Stoke Mandeville. The basketball team was predominantly made up from the Lyme Green team, and Paddy proudly stated, 'Of course, we beat Holland!' This was the start of a movement that grew quickly into the Commonwealth Paraplegic Games.

With little money to spend, their social lives were somewhat restricted. To gain a late pass to a local public house they had to get dressed in two minutes. Paddy, in his inimitable amusing manner, pointed out it wasn't much of an incentive, because with little money they could only buy the odd drink – perhaps as well with wheelchairs to negotiate.

However, a small evening convoy of wheelchairs with their lively occupants was a regular sight on its way to the Golden Lion in Moss Lane. There Paddy met a remarkable girl called Mary, a friend of the landlord's daughter. Both girls attended Macclesfield High School, but with time she married the good-looking athlete with his Irish charm, and devoted her life to him. They were soon entitled to a bungalow, but with rent etc. to pay Mary went out to work. For twenty years she worked in the office of the *Macclesfield Express* in town, until a move to Stockport proved too inconvenient. She then completed another twenty years with Macclesfield Borough Council.

Olympics

During those early years, Paddy quickly built up his sporting skills, and was soon chosen to represent England. Each member of the Lyme Green basketball team competed in another discipline, but Paddy competed in all of them.

In September 1960, together with two other colleagues, he proudly led out their contingent to represent England in the Paralympics in Rome. The paraplegics had finally achieved their ambition to take part in the greatest sporting event in the world.

Following this first Paralympic event, the 'Lyme Green Team' became internationally known, so much so that people would refer to them by their name and not by 'the England Team'.

There seems little doubt that Josiah Smale would have heartily approved of the use for which his mansion and grounds had been adapted, especially as he himself had been such an enthusiastic athlete.

The basketball team became national champions for twenty-one years, and many of the Lyme Green sportsmen represented Great Britain all over the world, both in the Commonwealth Games and the Olympics.

The most difficult part in those early days was the logistics of flying them around before jet aircraft came into service. The long trips, especially to Australia and New Zealand, were the most difficult. With more than 100 disabled people in wheelchairs, plus special equipment for medical care, and spare parts 'for just about everything', it was a colossal task.

Practising archery.

The large wheels from the chairs were removed and labelled, so they could be attached correctly at the end of the journey. This meant everyone from the captain, crew, doctors, nurses, helpers, to anyone else who could, carried a spanner.

Flights to other countries included Belgium, Holland, Sweden, Switzerland, Italy, France, Germany, Japan, Israel and Kenya. They were treated like royalty wherever they went, particularly in Australia. Israel proved interesting, and provided more female paraplegic athletes than any other nation. In Kenya they actually trained the African athletes, and in Paddy's words, 'Too well, because at the next meeting they beat us'.

Paddy's greatest triumph was in 1961 when he was top athlete. He won everything and was presented with five cups for basketball, javelin, archery, discus and shot-put; as a result he met Queen Juliana of the Netherlands.

Practising throwing the javelin.

A proud Paddy Moran with his medals, taken by the author in May 2010.

End of an Era

By 1976 the hospital facilities at Lyme Green had become redundant and, as a financial consequence, the hall with its 5 acres of land were put up for sale. The settlement remained to occupy the southern part of the grounds, while the hall became a nursing home. It was first run by Doctors Harte and Wadge, and then Dr Varley of Park Green. Next it accommodated 'wayward children', an idea which simply did not work alongside a paraplegic community. Clumber House followed and then Pendlebury Manor, both residences for the elderly.

In 1982, Paddy became a governor of the trust, but a change in policy during 1997 saw the governors become trustees instead. It had always been under the auspices of the joint committee of the British Red Cross and the Order of St John, but in 2006 it was decided to end the charity, however pension arrangements caused complications and it had to continue.

Over the years many functions at Lyme Green have raised money, and the small community centre is at present let as a nursery, with older residents occupying the cottages. The grounds are still well maintained, although the allotments are long gone, but the fresh vegetables are sorely missed by the few long-term residents able to remember them.

Paddy was seventy-eight years of age at the time of writing the original article in 2010, but it is with great regret that confirmation of his death in December 2013 can now be recorded. Not only were these wonderful athletes representing Great Britain, but their exceptional performances ensured that the name of Macclesfield became well known wherever they competed in the world.

My sincere thanks go to Paddy's widow, Mary, for allowing reproduction of the photographs from the Moran collection.

South Park Bandstand

The Opening of South Park

At the end of the First World War, Alderman William Frost, a prominent silk manufacturer, alarmed at a proposed housing development in the Park Lane area, decided to take action. West Park was located in the north-west area of the town, and Victoria Park in the east. But while the streets in the Park Street and lower Park Lane areas of the town were crowded with families, they had no such amenity close by for them.

Alderman Frost began a series of land purchases, and conveyed a large area of land to the Corporation in 1919. Further purchases of plots saw a final conveyance on 31 March 1922; in all a total of 45 acres, larger than the total acreage of the other two parks. (See *Past Times of Macclesfield: Volume III*, pp. 8–11 for full details).

This was an incredible gift to the town, which was greatly acknowledged at the opening ceremony on Wednesday 16 August 1922, when Alderman Frost unlocked the gates to the park entrance on South Park Road with a gold key. He gave a lengthy speech, expressing his sentiments admirably. He had lived and worked in that part of the town all his life, where the streets had rows of small cottages with few modern conveniences. In summer, women sat outside their doors unable to get into the country and take their children to enjoy outings. Boys often appeared before the Watch Committee; some were fined for playing in the streets, all complaining they had nowhere to play. His gift was a memorial to his wife and son, as many knew his wife and how important this had been to her.

He was delighted that the council had begun to develop the park 'to make it a thing of beauty', and concluded 'Parks and open spaces are of value in enabling us to develop our lives on sure and rational lines.' With three cheers from the considerable crowd, the foundation stone was laid and the National Anthem played.

View of the bandstand across Ryle's Pool.

Brass Band Era

As this was the era of a resurgence of brass bands after the war, the band of the Scouts and Church Lads Brigade and the Macclesfield Town Band had accompanied the procession from the Town Hall, via Park Green and Park Lane. At this time there was no bandstand; the borough surveyor had produced plans for five intended tennis courts, two bowling greens, paths, drainage, huts, pavilion, toilets but little else as money was scarce. The estimate total of £6,039 could be halved by a grant from the Unemployment Grants Committee, but the remainder would have to be borrowed and spread over several years. It was only possible to prepare two of the tennis courts and one bowling green for the opening, with tournaments arranged and a marquee for refreshments.

During 1923 the pavilion was built, the second bowling green laid out, the tennis courts at some point became hard courts instead of grass, and two children's play areas were organised near Wood's Pool, but still no mention of a bandstand. However, by January 1924 tenders for bands to play in all the parks during the summer were called for, and a park keeper and two patrolmen for security purposes were already employed.

There was also an exciting event in August of that year when a wireless demonstration took place in South Park on a Wednesday evening when the band was not playing.

It is not until 17 June 1925 that the committee minutes finally acknowledge a bandstand, when the park keeper was instructed to stop children from playing on the bandstand steps in South Park. Later evidence refers to this as a 'temporary' affair, and evidently not a very substantial structure. It stood close to where the present one stands, but simply on the grass of a lawn.

Progress

Over the next decade the pavilion received its tea rooms, overlooking the bandstand area; the park in turn accommodated the 'Crowning of the Silk Queen'; huts were built and in February 1937 the South Park Bowling Club provided a 39-foot-long shelter, open-fronted and glass-covered. The estimated cost was £96–98, and they worked hard collecting contributions from members. They declared it to be a daytime shelter for bowlers when raining, and a sheltered corner where 'old folks, and those who have been sick' could enjoy the sunshine, (The entire opposite for what it is now used for!) and this was their contribution towards celebrating the coronation of George VI and Queen Elizabeth. However, an even more important contribution was about to be made.

The Mayor

On 9 November 1936, Councillor G. J. Challinor had become mayor of Macclesfield, and although he had only been a councillor for six years, he was considered well suited to the task in hand – to guide the town through the coronation year.

He had attended St Andrews junior school and then evening classes, which gave him the chance to work with the silk firm of P. Davenport Ltd (fancy trimmers) for twenty-five years. By 1920 he was in partnership with a W. E. Holmes on Windmill Street, and together with his wife, the three were directors of the company. He was keen on sport, being vice-chair of many organisations, and even president of the very enthusiastic 'Macclesfield Budgerigar Club'. He was also a member, as many were at that time, of a Freemason's Lodge.

In his inaugural speech, Mayor Challinor said that he and his wife already had plans in mind for the coronation year, but gave no details. At this time the country was well aware of the problems brought about by the liaison of Edward VII with Mrs Simpson, and Macclesfield Corporation, while having sent their declaration of loyalty to the king, like everywhere else, seemed to be operating in 'low gear'. The situation had a dreadful effect on the nation, so on 20 November Challinor and his wife made an announcement.

The mayor lived at 'Glenside', on Ryles Park Road, and from the rear of the house there is an unimpeded view of the bandstand area of South Park. This he referred to, saying that daily they saw the present stand and considered a modern structure, compared with those in other parks, a necessity. They were willing to donate the money, which would relieve the coronation subcommittee of one of its difficulties, and he hoped it would be ready in time for the coronation celebrations in May.

The New Bandstand

By this period, the list of bands playing each month in South Park, from May to August, was surprising. Not only did Macclesfield now have its Town Silver Band, Salvation Army Band, Scouts etc. but another band had also made its name. Formed in 1908, the Bethel Silver Band had risen to great prominence over the years. It practised in the Bethel schoolroom in Windmill Square, and so great

An early partnership advertisement.

was the attendance and enthusiasm that it had a junior band in addition to the senior one. In January 1937, it was the first local band to be given an audition in the Manchester studios of the BBC.

Previous seasons had programmes that included not only the Macclesfield group, but bands from Stalybridge, Gorton & Openshaw, Hyde Borough, another from Openshaw only, and the 7th Battalion Cheshire Regiment – all of which were either silver or prize bands. Little wonder that the mayor wanted a respectable structure in which they could play.

In just one week, having accepted Challinor's generous offer, the Parks Committee and officials met with him and suggested visits to other towns with a view to deciding on the shape and design for South Park.

Abdication

Less than two weeks later, on Friday 11 December, the *Macclesfield Courier* carried the abdication announcement of Edward VII on its front page. The worry for the town was that it would affect the silk trade, as everyone had been preparing items for the coronation, which could result in considerable losses.

But despite the trade worries, a new enthusiasm was abroad, and on 18 December the borough surveyor submitted a draft scheme to the council meeting. He proposed a new layout between the pavilion and lake, incorporating the position of the new bandstand. Paths would be created lined with flowerbeds, with an asphalt arena around the stand for dancing. A decision was also taken to visit Colwyn Bay within the next few days.

The mayor, town clerk, borough surveyor and chairman of the parks committee, made a visit to Colwyn Bay on 30 December, where they met their counterparts (apart from the surveyor) of the local council. They were very impressed with the bandstand at Eiras Park. It was octagonal in shape, a fine modern structure of reinforced concrete, with columns at the 'corners' and a concrete dome. The sides were of glass, but folded back at right angles, allowing adjustment to protect the band from prevailing winds.

Boating Lake, Eirias Park, Colwyn Bay. W.500.

Postcard in possession of the author. The Eirias bandstand was demolished some years ago.

The committee were delighted with the design and agreed to adopt it, with a wooden roof 'to form a round box' and electric lights fitted into the interior for use on dark evenings.

Decision

The Macclesfield Corporation meeting of 6 January 1937 reflected the considerable sense of relief felt everywhere, that at last the problem of the succession to the throne had been resolved. Now, with the utmost enthusiasm, the newspaper recorded one of the shortest council meetings on record, which resulted in a considerable amount of business being completed in just twenty-five minutes. The long wrangles and drawn-out debates of the past were forgotten, and there was agreement to everything.

The mayor, town clerk, borough surveyor and chairman of the Parks Committee, having made the visit to Colwyn Bay on 30 December made their report, confirming that they were very impressed with the bandstand at Eiras Park. They therefore recommended that, with the consent of the Colwyn Bay Council, a similar bandstand should be erected in South Park. It was also agreed that the estimate of £500 for the borough surveyor's plan regarding the layout of the site close by the temporary bandstand, should be made available. The estimate for the proposed bandstand stood at just over £1,200, which the mayor promised he would pay. The plans were sanctioned and went ahead.

The Grand Opening

On Wednesday 13 May 1937, almost 3,000 people crowded around the new bandstand to see the mayor and mayoress, Mr and Mrs Challinor, present the new structure 'of beautiful appearance' to the town.

The deputy mayor told the crowd that shortly after Councillor Challinor's election as mayor, he wanted to provide a new bandstand for the town 'not only to commemorate his year in office, but also to mark the Coronation year of our beloved King and Queen, King George VI and Queen Elizabeth … it will give South Park a much needed bandstand'. He referred to the fact that the estimate had considerably exceeded the £1,200, but the mayor and mayoress together had

The only poor photograph available of the 'Grand Opening' in South Park. Reproduced with help from the Ollier Studio.

met all the costs. Both the townspeople and the Corporation owed a great debt of gratitude to them for their more than generous gift.

In reply the mayor thanked his deputy for his kind words, and said the borough surveyor and the contractors, Messrs Cooper Bros., deserved much praise for their efforts. He also thanked the representative of the contractors, Mr McQuilter, who was present, for the fact they had used local labour as much as possible.

The mayoress was handed a golden key and said they had felt for many years, 'the need of a real and substantial bandstand in the South Park, one that would be worthy in every respect of the town' and continued, 'We have given this bandstand to mark not only our love for Macclesfield, but our gratitude for the friendship and kindness we have always received from the townspeople'. Having concluded her speech, she unlocked the door to open up the bandstand, and the Macclesfield Silver Band played a fine selection.

Restoration

Almost as soon as the South Park bandstand had enjoyed its official and poignant opening ceremony, Britain was again at war. The post-war years have taken their toll on the structure, and the question of restoration has, from time to time, been considered. On each occasion efforts have been made to find out the details of its construction but have only progressed a little way, until now.

With the full story at last revealed, and many remembering memories from their younger days and expressing support for restoration work, the Cheshire East Council has now appreciated the significance of this once fine structure.

Brass Band Season 2010

The brass band concerts in the newly 'spruced up' bandstand have proved to be a great success, and it is probably because of family connections that I have taken a keen interest.

Brass band concert in South Park during the summer of 2010. The audience was well prepared for sunshine or rain.

In the 1880s, Grandfather James and his brother Abraham, otherwise known as 'Jim and Abe', were members of the renowned Brighouse & Raistrick Brass band. Grandfather played the tenor horn, cornet and euphonium. Band members regularly played at the Oddfellows Hall in Brighouse for weekend dances, and there he met Edith, who became my grandmother. It was therefore particularly pleasing to see youth bands playing once more in South Park in Macclesfield, and the enthusiasm with which they play. It is thanks to their conductor and organiser, Louise Renshaw, that events on Sunday afternoons during the summer months of 2010 were such a success.

The first was the senior band of Macclesfield Brass, and the following week it was the turn of the King Edward Music Society. The third performance was a chance to see youth in action, which included a delightful performance by the Prestbury school choir, all juniors.

The fourth band from Poynton represented the Vernon Building Society, and again was another stirring performance. Finally it was a real treat to see the Macclesfield Youth and Junior Brass Bands in excellent form in the final summer concert.

Louise, connected with youth bands for over twenty-five years, originated in Poynton. Feeling that Macclesfield ought once more to have a town centre band, she took up the challenge, and in September 2005 founded the present band. This resulted in a total of 110 children from various schools throughout Macclesfield becoming involved in Macclesfield Brass. This is a considerable achievement, and was initially done mostly by contacting schools in the area, and then by word of mouth.

With no experience necessary, instruments provided if required and a small payment each week, it has given great encouragement to many. The ages of the youth band vary from twelve to eighteen and the juniors from nine to ten, but children have been welcomed from the age of seven years upwards. They are from various schools, quite a mixed and interesting group and co-operate well.

Louise projected such enthusiasm that adult sessions became established at Ashgrove School on Wednesday evenings, and the result was the formation of the Moss Rose Community Band.

In relation to the new railings of the bandstand, which are not as elegant looking as the old ones were, one of the senior stewards commented that he was full of approval and considered that they would stand up to the rigours of today better than those of yesteryear. Being something of a sentimentalist and much preferring the old style, having considered his comment I reluctantly had to agree.

The Old Snuff Shop

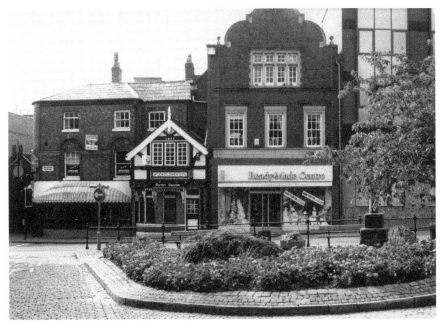

Market Place, 1990s, when the shop of Chester Twemlow was a tobacconist of many years standing.

What must be the tiniest shop in Macclesfield, situated on the western side of the Market Place and close to the Grosvenor Centre indoor market, has attracted much interest for over 100 years.

In 1904, an architect and antiquarian Walter Aston, when writing about some of the unusual discoveries in Macclesfield, referred to a 'tiny building' in the Market Place known as 'the old snuff shop', which had been part-demolished some seven years earlier in 1897. This had revealed a medieval wall with a framework of oak beams filled with wattle and daub. In the wall was a window divided in two by a central mullion, with the two openings arched and cusped, said to be fourteenth century. The tracery and framework were oak, but the window openings had been filled in with wattle and daub.

When the adjoining corner premises were rebuilt, the south side of which indicated the beginning of Stanley Street, the remainder of a wall was demolished for extension purposes, and human remains were discovered. Exactly what happened to the latter is not mentioned; only Aston's comment remains, 'showing that internments had taken place in what must have been the inside of the building'. This curious deduction suggests that the remains were from more than one person, and therefore begs the question as to whether or not there had been an ancient burial ground in that area that was subsequently built over.

Apparently there was a tradition among the Roman Catholics of the area to regard this site as the original 'Priest's House', because it faced east, overlooking the original Queen Eleanor chapel (now the parish church of St Michael and All Angels), and had what was considered to be the oratory window.

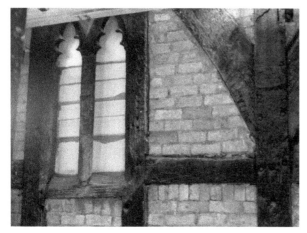

Above and below: The features mentioned by Aston revealed during the 1998 restoration work.

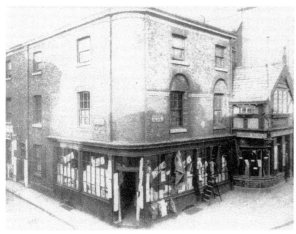

Edwardian photo of the London Tailors premises on the corner of Stanley Street and Market Place, which extended into the tiny shop.

Aston also recorded that the remaining oak frame and window had been carefully preserved in situ. These were, however, completely plastered over, so there was only Aston's record to rely on.

In May 1998, refurbishment of the tiny shop was once more underway, and having seen Aston's details it was time to hurry to the premises and explain what I had read. Unsure of whether or not the features were still there, and if so would they be concealed yet again, permission was given for photographs. A wait of two or three weeks amazingly revealed virtually all of the recorded features. The missing element seemed to be the wattle and daub, apparently replaced by bricks.

The intention was to leave on view what was possible, for it was to become the working premises of a small jewellery shop. Samples from the timbers were taken for radio carbon analysis, but the Cheshire Archaeological Service report is still awaited.

Following my article of June 1998 'A Window Into the Past is Thrown Open', Mr A. Rowbotham kindly forwarded an Edwardian photograph from his collection showing that it was the London tailors who had taken the premises and extended through to the tiny building. Later alterations resulted in 'the old snuff shop', being once more divided off when it became Chester Twemlow's tobacconist shop. This it remained until 1998, as shown on the photograph taken at that time, just after the anticipated refurbishment.

With a separate enlargement of the jewellery business taking place close by on the south side of the Market Place, it will be interesting to see what the next chapter brings for the tiny shop with regard to its curious history.

A Brief History of Macclesfield Libraries

From earliest times, the written word has had a profound influence and because of this has either been treasured or destroyed. Ancient libraries contained scrolls, and the word itself is supposed to have come from *liber*, the inner bark of a tree, which the Romans acknowledged as having been used in the production of early writings.

The Early Years

The earliest reference to a library in connection with Macclesfield, albeit a personal one, is that of John de Macclesfield who created his mini-castle in Mill Street between the years 1391–93 during the reign of Richard II. His will, dated 23 March 1421, mentions Higden's book entitled *Polychronican,* which was a history of the world from its creation to 1327.

Ranulf Higden was a monk of St Werburgh's Abbey, Chester, and his first shorter version was copied several times then added to by others, and was one of the earliest books to be printed by Caxton. In 1352, Higden enlarged his copy, but only two other versions of this are known, one of these being the one owned by John de Macclesfield; this had been lent to the Abbott of St Werburgh's on 5 August 1416. So precious was the book that John had included it in his will, evidently to make sure that everyone knew where is was, adding 'and all my other books and goods be sold by my executors…'

The first, which could be called a public library, had been provided by one of the Downes family of the nearby hamlet of Pott Shrigley. Geoffrey Downes, a fellow of Queen's College, Cambridge, whose will is dated 20 June 1492, had organised a lending library for those attending the chapel of Pott Shrigley. Anyone wishing to borrow a book was allowed thirteen weeks to read it, but had to make a pledge to keep it safe. Although the books were few in number, and mostly religious, one is intriguing – it was a Wyclif or Lollard Bible.

John Wyclif (*c.* 1330–84), an Oxford don and philosopher, was one of the first 'outsiders' to be labelled Lollard. He had been engaged by Henry III's government to find ways of combating papal demands that levied high taxes on the clergy. Soon, however, he went further, challenging the authority of the pope and priests and demanding that the Bible be printed in the 'mother tongue', i.e. English for the English, so many could read it for themselves. The Church, however, stood firm believing that without guidance many would misinterpret the true meaning of the then Latin text. Later in life Wyclif oversaw the printing of the first Bible in English.

Wyclif inspired a certain John Huss in Bohemia also to rebel against papal dictates; his followers were known as Hussites. In 1382, Richard II, who had succeeded his grandfather Henry III, married Anne of Bohemia, daughter of the Holy Roman Emperor. This creates something of an enigma, because circumstantial evidence suggests that some of Anne's retinue were Hussites who joined the Lollards on arriving in England.

Evidently the Pott Shrigley Bible was in English, which would suggest that many people in the congregation could read, but early religious books were usually beautifully illustrated, so perhaps those who could not read could interpret its message from the superbly coloured pictures. It was possibly also considered an encouragement to foster a desire to learn to read what was written on the pages, and also to stimulate parents in providing some form of education for their children. The local priest no doubt read out loud to members of the congregation, or used the Bible to teach some of the children to interpret certain parts of the text.

The Eighteenth and Nineteenth Centuries

At present the canvas is blank until about 1770, when the first of the 'modern' libraries in Macclesfield made its appearance. It was housed in a Georgian property on Parsonage (Park) Green and was by subscription. This, by its nature, provided facilities for the educated gentlemen of the town and their families, particularly those in the business community. The building is still extant, but is now home to a partnership of solicitors.

On 1 March 1811, it was announced that the library had moved to No. 7 Back Street (now King Edward Street) next to the post office, where books would be supplied as usual from 10 a.m. to 1 p.m. and from 6 p.m. to 8 p.m.; the subscription was 2 guineas each year.

The library had an excellent collection of books, which had gradually increased over forty years, and the librarian was recorded as Mrs Martin, who, it was stated, would be on duty. The president was a Mr W. Broadhurst.

As modes of travel increased, a rapidly expanding population saw an increased demand for newspapers, so an additional facility appeared, the Park Green News Rooms, which were well flourishing by the 1830s, and apparently still connected with the old building, which became a gentleman's club.

By 1835 the London papers arrived at 9 a.m. on the day following publication; evening papers arrived the next day. The daily papers were advertised as *The Times* and *Morning Post*; the evening papers, *The Standard* and *Globe*. There was a variety of weekly editions: *The Macclesfield Courier and Herald*; both Manchester papers, *The Guardian* and *The Times*; there was also *The Leeds Mercury*, *Spectator*, and not forgetting *John Bull*. Pamphlets and magazines were also available. One advantage was that with the advent of more newspapers *The Macclesfield Courier* began to report more local news and less of that from elsewhere.

The Useful Knowledge Society was finally established also in 1835, to encourage further education. At last John Brocklehurst MP, banker and silk manufacturer, saw his vision taking shape, for education was his great passion. Soon a vast library of hundreds of books on all sorts of subjects was established, but once again it was only available to those who supported or joined its classes by paying a subscription.

In January 1837, the Angel Inn in the Market Place was host to the Annual General Meeting of the subscription library when W. Welsh was elected librarian. In the intervening years the annual subscription had increased from two to three guineas and was set to rise again to 4 and a half guineas. The reason was that new premises on Park Green were by then available, and a large reading room had been 'fitted up'.

Thomas Grimsditch, a Macclesfield solicitor and future Tory MP, wrote to the editor of the local newspaper on 15 June 1839 setting out the reason, with particular regard to education, why a public library was an absolute necessity for the town. However, it took a further decade for legislation to be passed enabling corporations to levy a rate for library buildings; the Act was finally passed in 1850. This was on the assumption by the government that private individuals would donate books.

A further five years produced a wider ranging Act, but as always the population of Macclesfield was reluctant to see a rate increase, and assumed that the town was well endowed with facilities for those who were interested. Even after a meeting chaired by the then mayor, Henry Brocklehurst in 1861, the answer was still a resounding 'No!'

The Public Library

Finally David Chadwick MP, one of the two liberal members for the town, paid for the building himself, also on Park Green, where it would remain until 1994. It was designed by the local architect A. J. Stevens and opened on 27 May 1876 with the usual fanfare for such occasions. In due course its interior was considerably altered and enlarged, and, as shown in 1914, the facility for reading newspapers was now part of the service.

The Library Committee met in March of that year and noted the new books purchased and those donated. The question of a further provision of a newspaper stand in the men's reading room was referred to a subcommittee, and the borough surveyor was asked to submit a cost. The committee also decided (and here one must assume that it was an all male committee) that the reading room and ladies' reading room should be closed Easter Monday. The men's reading room, however, could stay open until 8 p.m. if the chairman was able to arrange for a responsible man to look after the place!

The final move to the impressive renovated bank premises on Jordangate did, of course, take place in 1994, yet still modern facilities continue to outgrow the building. Now alongside books, DVDs, newspapers and photocopying machines, are representatives of the ever-increasing computer age. One can only guess at the reactions and surprises John de Macclesfield, Geoffrey Downes, John Brocklehurst, David Chadwick and all the rest would have if they were to return now.

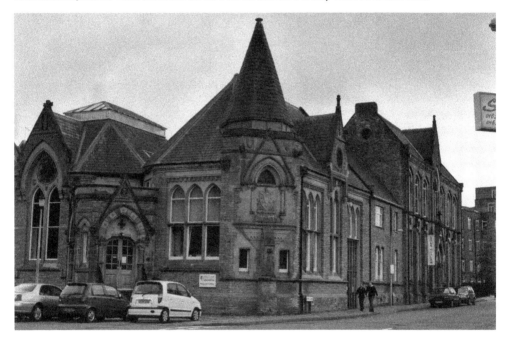

Above: The former Chadwick public library on Park Green.

Right: The present public library at the top of Jordangate, as seen from the Market Place. Surveyor's plan showing the position of the mine.

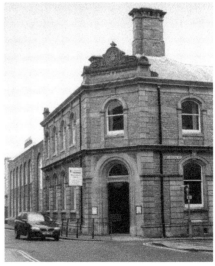

Mottram St Andrew Mining

In the eighteenth century, Mottram St Andrew, known simply as Mottram Andrew, was the scene of a copper mining speculation. Resident there for a period was Harry Lankford, brother-in-law of Charles Roe of Macclesfield, the famous silk entrepreneur who, by 1756, had become involved in the copper trade. At that time, close by the parish boundary of Mottram Andrew, Charles Roe's men were busy reworking the copper mines on Alderley Edge.

Until recently it has always been assumed that the mineral veins of Alderley continued uninterrupted into Mottram St Andrew, but it is now known that a geological fault runs between the two.

In the eighteenth century, the three parishes of Mottram Andrew, Over Alderley and Nether Alderley contained several halls, many existing today as farmhouses. It has not been possible to discover in which hall Harry Lankford lived, but at that time the choice is limited and does suggest it was Mottram Old Hall.

The present mines of Mottram, near the Kirkleyditch quarry, lie contiguous with what were boundary lines of eighteenth-century estates, and one of them is definitely on land originally part of the Mottram Estate. It was often quarrying that uncovered minerals near the surface and caused speculations in mining, and this seems to have happened at Mottram.

Evidence suggests that Harry's father, Samuel Lankford, mayor of Macclesfield in 1753–54 and partner of son-in-law Charles Roe in the original silk spinning mill in the town, seeing Charles's success at Alderley, decided to speculate, leaving son Harry resident on the Mottram site. A letter dated 20 March 1760, from a Derbyshire man to his partner, infers a business arrangement to be made with Samuel Lankford. They had interests in the smelt works at Denby, and also copper rolling mills in Derby. Samuel was very ill and could not keep their appointment, so Harry had written to tell them that as soon as his father was better he would go into Derbyshire 'to Settle the Affaire'.

As the Derbyshire partnership had no interests in silk, Samuel must have found some lead and copper on site in which they were interested. They had been mining the Duke of Devonshire's mine at Ecton Hill in Staffordshire, but their lease was due to expire in October 1760, and the duke had made it clear that he intended to mine the ore himself. This meant a desperate search for another source of copper to keep their smelters burning and their mills rolling. It was an expensive business, and Charles, already committed to Coniston mine in the Lake District and Alderley Edge, had no doubt wisely chosen to leave well alone.

Samuel Lankford must have been seriously ill because he died a month later. Harry's priority was his marriage a few months later, and he moved to Fence House in Macclesfield. This is now the site of the King's School for Girls on Fence Avenue. He remained committed to the silk trade, but unfortunately he, together with his brother, was forced out of business in 1774 by creditors.

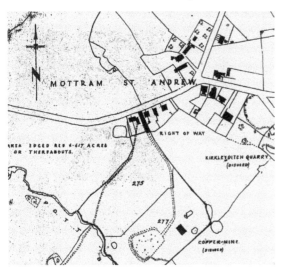

Share certificate. Courtesy of Mr Tunstall.

Nineteenth-Century Mining

According to an article by G. Warrington (reprinted from the *Journal of the Chester Archaeological Society,* Vol. 64, 1981) entitled 'The Copper Mines of Alderley Edge and Mottram St Andrew, Cheshire', the workings at Mottram were largely inaccessible and partially flooded at the time of writing his article. However, they appeared to have attracted some interest contemporaneously with those of Alderley Edge in the early nineteenth century, but it was recorded that a quantity of lead obtained had been unremunerative.

The mining on Alderley Edge proved to be sporadic, but, during a third speculation between 1857 and 1878, trials at the Mottram mine had apparently proved successful, hence the Corporation of the Mottram St Andrew Mining Co. Ltd on 24 January 1861. This had evidently encouraged investors, such as Mr Charles Tunstall, to speculate, which in his case was not an inconsequential sum at that time.

It is thanks to a descendant of Mr Tunstall that three share certificates are still extant, one of which is illustrated. Each certificate relates to five shares purchased on 7 March 1861 for which the purchase price was £10 per share, i.e. a total investment of £150. By 14 August that year the £10,000 capital required was achieved, and by 20 August, perhaps flush with success, a further issue of 500 preference shares at £10 each was issued. Again the capital was realised, but all in vain. On 13 April 1865, the decision was taken to dissolve the company, yet it was not until 7 March 1882 that the notice appeared in the *London Gazette* and was finally accomplished on 23 January 1883.

The sale of assets had taken place by auction in 1866, which included a process works erected by a James Michell in 1860 (a partner in the Alderley mine venture) but produced little more than £643. Subsequently the works site had been leased as a brickfield in 1881, and this seems to mark the end of the Mottram St Andrews Mining Company's quest for commercial glory.

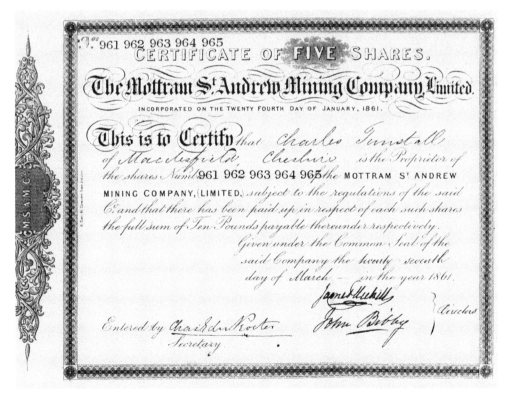

A new housing development around Old Farm Close now occupies part of the land that comprised

Scarlet Fever in Upton

Sycamore Farm adjacent to Prestbury Road.

This case is important, not just from the point of view of the disease, but because it reveals so much more information about the local area in which the outbreak took place in the late Victorian period.

In 1889, a government white paper, based on a report by Dr H. Franklin Parsons, revealed the full extent of an outbreak of scarlet fever with associated diphtheria and sore throat, which had occurred in the Macclesfield Rural and Urban Sanitary districts in connection with a particular milk supply.

On 7 February that year, the Rural Sanitary Authority had informed the Local Government Board that within the previous ten days there had been an outbreak of the disease. It was prevalent in children, as described above, together with symptoms of blood poisoning. In all the cases under review, the milk supply had come from the same farm in Upton, which not only delivered to several customers in the township, but also in the Macclesfield borough area contiguous with the Upton boundary.

On 11 February, Dr Parsons arrived with instructions, not only to target Upton, but had been granted an extension of enquiries into Macclesfield 'as far as was necessary for understanding the outbreak'. He was met by officers from the Rural Sanitary Authority and found Upton to be a small township containing forty-one houses with 228 occupants, an increase from the 1881 census figures of thirty-nine inhabited houses with 185 occupants. Situated nearest the Macclesfield boundary they were villas in which private middle-class people lived, mostly having businesses in the town. Those within the borough, just over the boundary, were of similar character and all supplied with water from the town.

The Upton sewage disposal was by cesspools or watercourses and not connected to the Macclesfield sewers. And surprisingly, overall, the infection had occurred in the more middle-class areas, whereas 'the older, lower and poorer parts of the town had almost escaped the outbreak'.

The Outbreak

Because of the rapidity with which it had begun, it was compulsory for the borough medical men to issue notice of the infectious disease under the Macclesfield Corporation Act 1882. There had been just two cases in January, but forty-five for February, thirty-two of which had arisen in the first week of that month. Upton reported none for January until the last week when ten occurred. Additionally, scattered cases were reported from the neighbouring village of Prestbury, and also Mottram St Andrew, Bosley, Chelford, Rainow, Langley and Macclesfield Forest.

The farmer, identified only as 'Mr V,' was solely engaged in selling his milk, and was assisted by his wife, adult son, two lads and a servant girl. During Dr Parsons's visit they were all well and the cattle seemed healthy, as already noted by the two local medical officers on their earlier visit.

The doctor was quick to vindicate the farmer of any wrongdoing; he found the house inside and out scrupulously clean and was impressed by the care and attention with which the business was managed. The farmer had 103 customers, of which forty-one had morning deliveries; twenty-two were evening only, while the rest were both morning and evening.

The OS map (survey 1871 pub 1874) shows the position of the farm near the top right hand corner, adjoining the road leading to Prestbury village. Just above Parkside Lunatic Asylum (bottom left) is Boughey Lane (now Victoria Road) within the Macclesfield boundary.

The round commenced in Upton and then continued into Macclesfield. The delivery times provided no significant difference in relation to the outbreak.

Dr Parsons assiduously visited every household and compiled a mass of information from which he produced charts. This enabled him to appreciate that the outbreak had actually begun with two young boys in Prestbury, who attended the school where other pupils from affected households had been present.

Farmer V had co-operated fully and stated that he supplied seventy-eight houses in Macclesfield. Parsons was able to discover that there were 386 people living in those properties, and that sixty more milk dealers supplied the rest of the town; the total population was 37,514. On average, therefore, the other milk dealers supplied twice as many houses each as farmer V, but he supplied many 'well-to-do' customers who used a large quantity of milk.

Suspect Milk?

Dr Parsons had to decide whether or not the milk was the culprit, and at this point he surmised that it was doubtful. He investigated the daily consumption in each household and found that those who drank less milk were the worst affected, then he took into consideration the ages of those affected.

The symptoms were not straightforward; in some cases the attending medical practitioner judged it to be scarlet fever, others diphtheria, diphtheritic sore throat or just sore throat. Parsons's concluded that the cause was the same but varied in appearance because of individual circumstances. Generally it seemed to be more appropriate to scarlet fever yet had presented certain peculiarities, for example:

1) Frequent vomiting and purging at the start.
2) The state of the tongue (rarely white fur or 'strawberry tongue' but covered with a thick white creamy or dirty brown coat).
3) Apart from the usual scarlet blush, in certain cases purple blotches had appeared first on hands and then feet, and only had he once observed the customary peeling of skin, and then only on the hands.
4) The slight tendency to spread by infection (scarlet fever is, of course, highly contagious, and passes easily from person to person with the slightest contact).
5) The absence of kidney problems.

The two medical officers, Somerville and Hughes, who had greatly assisted Dr Parsons with reports on their cases, considered it something other than scarlet fever, and were inclined towards 'a form of blood poisoning due to sewage mater conveyed through the medium of milk'. This idea Parsons had next to consider, and after consulting his charts began a chronological interpretation of events.

The outbreak had begun around 25 January and ceased on 2 February, with most cases recorded between 27 and 31 January. This was important for it suggested that something happened a day or so before the 25th of the month. If the cause was the milk, how had it become infected?

The Farm and Routine

The farmhouse stood alone, a little way back from the road. Until the outbreak, water was supplied from a pump in the yard, but the cattle were let out from the shippon to drink from the spring in the nearby field.

The cellar, where any leftover milk was kept overnight, was damp in the corner nearest the privy. The latter was against the wall of the building and accessible through the washhouse; it was found to be poorly ventilated resulting in a dreadful stench. The outlet under the seat was to a drain that was a conduit for liquid from the pigsties, on its way to a tank some 35 yards from the building. Once a year the tank was pumped out and the contents spread over the fields; it had last been drained in March 1888.

The well, situated 7 yards from the privy, had always been considered the provider of a good clean supply, but Parsons discovered otherwise on his visit due to contamination by sewage, and it was immediately declared redundant.

The routine was the next item to take into account. The cows were milked early morning and late afternoon six days a week by the farmer, his son and the servant girl. The son took the milk for delivery in a cart (evidently horse drawn) in a large can (this was later called a milk churn and part of a similar delivery that lasted in many areas until the 1950s). On the first part of his round the son was aided by the two lads and the girl, and then he continued alone. Each day 10 or 11 dozen quarts were sold, but because Sundays always required extra milk he sometimes bought a small additional quantity from another Upton farmer. The latter was not a milk retailer but used his milk during the week to make butter, which he sold to Macclesfield shopkeepers.

When the son returned to the farm on Sunday evenings, if any milk was left in the can it was allowed to 'stand over' and made into cream; only three customers had bought cream since the outbreak and none were or had been ill.

During delivery, on arrival at each customer's house, the son dipped a smaller can into the large can, ladled out the required quantity into the customer's vessels left in a convenient place,

or was allowed into the kitchen to do likewise. On arriving back at the farm the empty cans were scalded morning and evening with boiling water, rinsed out with cold, turned upside down and placed on a stand in the yard to dry out.

As the large can was filled, the milk passed through a clean fluffy towel considered much better than the cloths normally used, and four such towels had been bought specifically for the operation. After straining the towel was placed in hot water and washed, and every two days the four of them were boiled for four hours, rinsed, mangled, dried and placed in a particular drawer ready for use again.

The rural medical officer for health, Dr Rushton and the farmer's son wondered if, when ladling out the milk into each of the customer's containers, the drops running down the sides and dripping back into the can could have caused contamination. However, Dr Parson was quick to point out that this procedure had been carried on for such a long time, together with the rinsing of the cans, that the sudden outbreak was unlikely to have been caused by either, and they were easily remedied.

The Cows

In answering further questions with regard to the cows, Farmer V revealed that on 14 January he had bought two new cows from a respectable dealer in Macclesfield. In exchange the dealer bought two cows from the farm, which had begun 'to run dry' and get fat, and these had been sold to a butcher in Manchester. The bought cows came from a farm in Butley and one in Macclesfield Forest. These two farms were visited by Dr Parsons and nothing amiss was discovered; one cow had calves on 14 January and the other on the 20th.

Milk from a newly calved cow was called 'beasting' and was not mixed with the general stock because it was albuminous and tinged with blood on occasion; it coagulated when heated and was occasionally used for puddings and custards. After six milkings Farmer V tested the milk by boiling and, as it did not coagulate, found that it could be added to the general supply on the evening of 23 January, which accorded well with the first outbreak of the disease.

Dr Parsons examined the cow and was able to confirm that the teats were neither scabbed nor chapped, but it did have a few bare patches on its rump. Since buying the two cows the farmer had kept them in the barn and given them water from the contaminated pump, but since 31 January the Macclesfield Corporation waterworks had supplied fresh water to the farm.

Dr Parsons was no nearer solving the conundrum, and stated that, in several instances of scarlet fever or diphtheria outbreaks, the dairy supplying the milk had always been found to be 'a model one' where every effort had been made to eliminate the disease, but infectious germs could not be chemically observed. In those cases cows had been kept tied up in barns at equitable temperatures so that all the nutritious food was supposedly being used to produce high-quality milk, and not being utilised for muscular exercise or keeping up body heat.

'A cow living under these conditions may be looked upon as a milk-producing machine worked at high pressure, and hence perhaps specially susceptible to infection'.

The Grammar School

In 1888, there had been an outbreak in the Macclesfield Free Grammar School, but since then the school and master's house had been disinfected. The school recommenced after the Christmas holidays with boarders returning on 20 January and day pupils the following day. From 27 January three of the headmaster's children became ill over a four-day period, and a non-resident master succumbed on 2 February. They had all drunk the suspect milk.

It was unfortunate, so far as Dr Parsons was concerned, that the school had been blamed for the outbreak, despite the fact that precautions were immediately put in place. Those affected were moved to an empty house close by, for which the headmaster was blamed, but the doctor said that no better course could have been taken, as hospital accommodation for isolating the patients was unavailable at that time.

Action

Two years earlier, Macclesfield Corporation had erected a temporary 'Ducker' hospital on the outskirts of the town, but within borough limits. It was in use as an isolation hospital for a smallpox outbreak, and had been used for that ever since. It had two wards each containing six beds, but in January the hospital was in no fit state to receive patients, however, by the time Dr Parsons returned on 20 February it was accommodating one patient with the suspected scarlet fever infection.

The milk deliveries from Farmer V's farm had been discontinued and instead he was making cheese with it, and had agreed to do so until he knew the outcome of the Rural Sanitary Authority's meeting due on 5 March. At the time of the outbreak, the latter's officer of nuisances had died and they were awaiting a replacement. It was decided to leave the reconstruction of the farm's privy to the new appointee, and Dr Parsons was quick to consider that 'a good many matters' required the intervention of the new officer in Prestbury. He thanked all the medical officers who had greatly assisted him in both the rural and urban districts, and completed the report on 2 March.

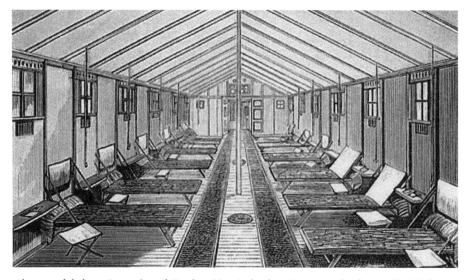

Above and below: Examples of Ducker Hospital advertisements, thanks to The Wellcome Institute.

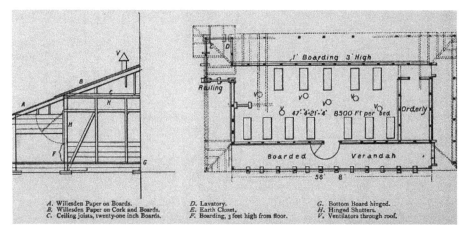

Veterinary Inspection

Meanwhile, on 7 February a visit was made by Walter Lewis M.R.C.V.S. of Crewe, to the farm in Upton. He was accompanied by Doctors Rushton and Bower and the local veterinary surgeon Mr Beard. Having been informed by Farmer V that he had bought small supplementary supplies of milk from a Mr S. W. at the Fallibroome farm until 30 November last (1888), and since from Mr J. L. of Yew Tree Farm, Upton, Mr Lewis added them to his schedule for inspection.

All fourteen cows on Farmer V's 35-acre farm were found to be in good condition and healthy; their temperatures were normal; the food was good quality, and although under analysis at the time, the drinking water seemed to be satisfactory, and the house and premises were credibly clean with good sanitary conditions.

Mr J. L.'s farm of 27 acres supported just six cows, all normal with no suspicious skin conditions. The farmer confirmed the Sunday supply to Farmer V, with the last made on 27 January. Mr S. W.'s farm was 107 acres and his shippon held twenty-two cows besides young stock, none of which showed any sign of infectious disease. He confirmed that he had last supplied Farmer V on 30 November. He had been supplying about 12 quarts daily to a Mr Fisher and also to a Mr Whittaker, with 3 quarts to a Mr Shaw, and none of them had fallen ill.

In concluding, Lewis emphasised his findings, but ended with the remark that if milk was suspect then it should be boiled before consumption to destroy any germs.

> During an experience of over 30 years among the dairy stocks of Cheshire and adjoining counties I have never seen or heard of cattle being attached with infectious scarlatina or with any disease capable of communicating scarlatina to man.

He signed his report followed by his full title, 'Chief Veterinary Inspector of Cheshire, Provincial Surgeon to the Royal Agricultural Society of England etc.' and addressed it to the chairman of the Macclesfield Sanitary Authority.

Unfortunately this was not the end of the matter, and a postscript was added by Dr Parsons on 28 March 1889, having learnt that with the resumption of deliveries of Farmer V's milk another

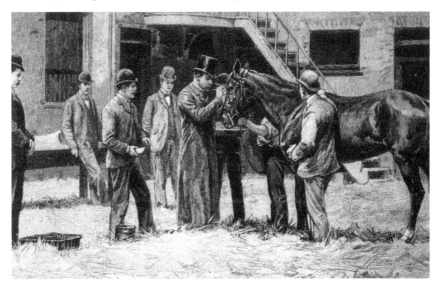

A veterinary surgeon operating on a horse's head at the Royal Veterinary College in Camden Town. It was established in 1791 as a college of learning 'the profession of veterinary surgery and medicine' and allied with the Army Veterinary Department and the Royal Agricultural Society. *Illustrated London News*, 1891.

similar outbreak had occurred. During his second visit of 25 March, all the patients appeared to be in households connected previously with the first outbreak. Also he was told by Farmer V that the milk from the suspect cow had not been added to the general supply since his last visit, but given instead to the calf. Dr Parsons found the calf to be healthy, but the cow had lost weight and one of her teats had a scab and was sticky. With that there was nothing further that he could do, but having regard for all the precautionary measures that were in place, including use of the isolation hospital, he submitted his report. The cause of the outbreak seems to have remained a mystery.

Ducker Hospitals

In the publication *Scientific America* for 26 June 1886 it was stated that the 'Society of the Red Cross in Europe has, for several years, given particular attention to the subject of portable field hospitals ... for the care, of sick and wounded soldiers'.

The statement was evidently the outcome of an ingenious idea, the inspiration of Captain Johann G. C. Doecker (1828–1904) who had devised a method of transporting and constructing portable buildings, the first of which were field hospital units. He patented his invention first in France and Germany during 1880, and received a special medal from the Empress of Germany, which materially helped its promotion throughout the rest of Europe. It was accompanied by a suggestion that its reception was greatly appreciated by engineers, architects, surgeons both civil and military, and philanthropists 'from all parts of the civilised world'.

During the following three years patents were registered in several European countries, including England in 1882, and two years later, America. The latter provided an ever-increasing market for all things portable including gazebos, building extensions, portable homes, from which the company established a base at No. 735 Broadway, New York with an office and warehouse. There was also an office in the City of London at Nos 30–31 Saint Swithin's Lane, close by the Mansion House.

The family name became anglicised as 'Ducker' and used in a more generic way when relating to temporary hospital units. They were produced in sections approximately 3 feet square (almost a square metre) some of lighter construction with the packing material intended for the flooring. They were joined together with iron hooks and studs and easily stacked for transportation, quickly erected or dismantled on site, and ideal for armies on the move. They could be extended as necessary by the addition of extra units, and each usually contained six beds.

The second type was units of much stronger construction comprising two layers of 'Doeker' material held together with wooden frames. The double layer of the walls, allowing an almost 5-inch space between, could be filled with insulating materials, while the outer walls were guaranteed waterproof and inflammable. As they were clearly of a more permanent nature, they were very popular with school authorities.

Even Dr Parsons (1846–1913), who had achieved his degree in 1870 after studying at St Mary's Hospital in London, was so interested in the subject that he subsequently wrote a book entitled *Insulation Hospitals* published by the Cambridge University Press. The title page stated that he had been at 'Sometime First Assistant Medical Officer of the Local Government Board'. His impressive medical record shows that he had accomplished many inspections and reports on epidemics throughout the country during a very busy medical career, one of which was, of course, the mysterious outbreak at Upton and the neighbouring part of Macclesfield in 1888–89.

Addendum.
The farm in question can be identified as Sycamore Farm, and the farmer as William Vernon. At the time of the outbreak of the mysterious infection he was forty-nine years of age and assisted by his wife Emma of forty-five years, together with his son, twenty-seven year old George.

My sincere thanks go to the Wellcome Institute Library for allowing photocopying of the Government white paper, and for providing illustrations for the Ducker hospital units.

The Macclesfield Eye Society

Early History

Thomas Henshaw of Bolton died in 1810, bequeathing £20,000 to establish an institution for the blind in Manchester. His will was contested by the family for twenty-six years, but finally upheld by the Court of Chancery.

In September 1834, the Board of Management of both Henshaw's Blind Institution and the Deaf and Dumb School, purchased a plot of land adjoining the Botanical Gardens in Old Trafford. Finally, in 1837 the asylum was founded, later to become Henshaw's Blind School. G. A. Hughes was governor in 1850 when he patented his Hughes Typograph, claimed to be the first typewriting machine; it won a gold medal at the Great Exhibition of 1851. In 1859, Lord Derby became the society's president, which has been continued by family members to the present day. A further two changes of name followed; from 1921 it was Henshaw's Institution for the Blind, and fifty years later Henshaw's Society for the Blind. However, a new millennium produced the name by which it is known today, Henshaw's Society for Blind People.

The expansion of the work has been phenomenal throughout the North of England, covering Manchester, Merseyside, Harrogate, Knaresborough and Newcastle. And there is no doubt that because of its early creation the Macclesfield silk family of Brocklehurst became staunch supporters of the town's own foundation for the blind.

Macclesfield

The first person in Macclesfield to become involved with the Manchester dual undertaking was the Liberal Member of Parliament for the town from 1832, John Brocklehurst. At the Annual General Meeting in Manchester of 3 April 1839 he was listed as vice president of the society, a position that he held until 1842.

Although vice president, he did not become a trustee of the blind school, but appears to have concentrated his efforts on the deaf and dumb part of the partnership. The governors were responsible for the selection of pupils, and by 6 June 1839 seventeen children had gained entry to the school at that time.

From its inception in 1834, for each of the initial six years it accepted two children from Macclesfield aged between ten to thirteen years. From then on further Macclesfield deaf and dumb pupils were accepted intermittently. This important Macclesfield connection seems to have captured the attention of John's nephew, Thomas Unett Brocklehurst, the eldest son of John's younger brother, Thomas. Both brothers were the chief partners of the family concern in the town, Messrs J. & T. Brocklehurst of Hurdsfield mills, producers of silk.

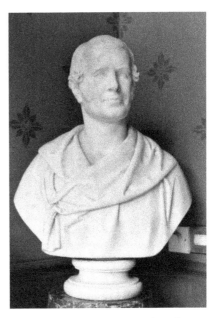

John Brocklehurst MP. Bust by Thomas Thornycroft RA exhibited at the Royal Academy 1853. Courtesy of Cheshire East Council.

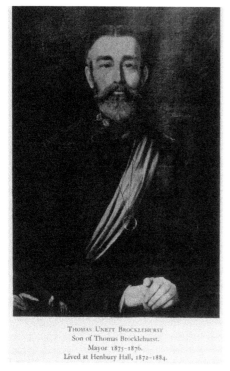

THOMAS UNETT BROCKLEHURST
Son of Thomas Brocklehurst.
Mayor 1875–1876.
Lived at Henbury Hall, 1872–1884.

Portrait of Thomas Unett Brocklehurst
whereabouts unknown.

Thomas Unett was a considerable philanthropist, and his great concern was the welfare of others. He contributed to many causes not only financially, but gave much time and effort to his projects. He served as mayor of Macclesfield from 1874 to November 1876. On 16 October 1876, he chaired the 1st Annual General Meeting of Home Teaching for the Blind, the society founded by him, but which he insisted was 'expressive of the work of a most useful and philanthropic society of Macclesfield ladies'.

When away in other towns of about the same size as Macclesfield, he noticed how they assisted their blind residents. In Hastings, as he walked along he heard singing, and, on entering a large room, found seventeen blind men busily making baskets along with their happy rendition of songs. Those in Brighton did likewise; there he learnt that the blind residents had moved to be nearer their place of work.

On his return, Thomas discovered to his surprise that there were about fifty blind residents in and around Macclesfield. He arranged a public meeting in the town hall on 21 July 1875 when G. M. Tate of the Parent Society of London (only operative from 1855) gave details of the work in the capital. Three months later a small group gathered in the mayor's parlour, and two ladies volunteered to teach blind children in their homes knitting, netting and other light occupations.

Mr Chatfield was sent from London to assist. He was a missionary who some years earlier had been chosen for work in New Zealand, but there he had become blind. During his first few months in Macclesfield he visited 1,357 blind residents in their homes to teach them to read. And the indefatigable Thomas Unett also paid many visits to some of those homes, intent on finding out what was needed, even after he had become High Sheriff of Cheshire in 1877. After his death on 19 August 1886, the presidency was taken by one of his surviving younger brothers, William Walter, who had returned to England after many years of sheep farming in Australia.

Success

Queen Victoria's Diamond Jubilee celebrations of 1896, with entertainment at the town hall, helped draw attention to the plight of the blind. This inspired Thomas Weston to contribute £50 to start an Endowment Fund, which was augmented by three further £50 donations in 1903 from the secretary Mrs Mair and two Brocklehursts. The £200 was invested in New Zealand government stock.

The ladies committee worked hard, and, apart from organising a representative in different surrounding areas who collected funds from contributors on a regular basis, they provided tea and entertainment in the large Sunday school in Roe Street for the blind residents each year.

Occasionally a young blind person of exceptional talent was recommended for a place in Henshaw's Blind School in Manchester. One such was Fred Parker in 1898, who completed his tuition in 1911 and entered his profession of piano tuning from No. 50 Peel Street, Macclesfield. In 1914, he organised a concert for funds and purchased a piano, then became tuner to all the County Council Schools in the Macclesfield and Hayfield areas, and even gave piano lessons.

Page from magazine, by kind permission of the Macclesfield Eye Society trustees.

The Moon Type

In 1913, the society had received twenty-eight volumes of Braille from the North West Union Library, but many of the older blind residents found it difficult to learn and instead chose the Moon type.

Dr William Moon (1818–94), born in Horsemonden, Kent, was totally blind by 1840, but decided 'God gave me blindness as a talent', and that without it he would never have been able to appreciate 'the wants of the Blind'. He perfected his typing system (i.e. Moon machine) in 1845 and his productions went around the world in various languages, even Chinese. As a dedicated evangelist, many of his books were portions of the Bible.

The Twentieth Century

By the time of William Walter's death in 1918, when he was succeeded by his only son, Walter Argyll Brocklehurst, the society was well established and sending cases free of charge to be treated by doctors at the Manchester Eye Hospital.

In 1920, the Ministry of Health took over the care of the blind and wanted them to be as self-supporting as possible. An inspector arrived and gave great approval for the work being done, which gave the society a grant for purchasing materials for homemakers and also teachers' salaries. The then teacher, reader and librarian, George Thornhill was sent to Henshaw's for training in chair-canning, rush seating and basket making; on his return the scheme worked well and included rugs and knitted dishcloths.

William Argyll oversaw a change in the accounting period from the year end 31 December 1920 to 31 March 1921, and the purchase of No. 15 Queen Victoria Street in 1924, which provided space for a depot where the storing and selling of work could take place. He was making great progress with the society but died suddenly in September 1926 aged only forty-six. The committee not only recorded the regret at the loss of the president, but 'also of its old and valued friend Mr George Thornhill'. He had been a visitor and teacher since 1908 and was 'beloved by all'. These two deaths marked the end of an era, and it was time for the ladies to step in.

The presidency was accepted by Mrs Isabella Edith Phillips Brocklehurst of Hare Hill, wife of Thomas Unett's nephew Lt-Col. R. W. D. Phillips Brocklehurst, sheriff of Cheshire 1914–15. In 1939, she received the CBE (Civil) for political and public services in Lancashire and Cheshire (she was

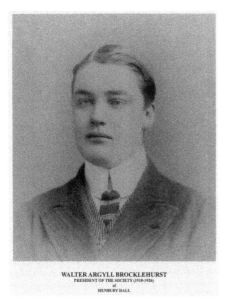

WALTER ARGYLL BROCKLEHURST
PRESIDENT OF THE SOCIETY (1918-1926)
of
HENBURY HALL

Walter Argyll Brocklehurst. Courtesy of the owner.

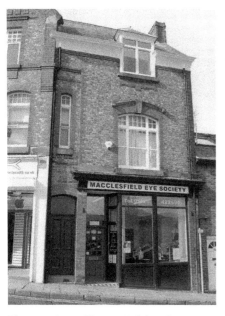

The premises still occupied by the society, originally purchased by Walter Argyll Brocklehurst 1924. Courtesy of Martin Welch.

extremely active in Manchester). As her husband had finally retired the previous year, she seems to have handed over the presidency of the Macclesfield Eye Society to Mrs Armitage of Sutton Hall.

In 1964, the workshop closed and it was the intention to also close the shop, but this remains as a small retail outlet for the sale of visual aids, and the centre of local services.

Generous Gifts

The years passed and in 1973 the British Welfare Services were integrated with Social Services, bringing to an end fifty-three years of the society's agency with Cheshire County Council. It was also the year in which the idea of a 'Talking newspaper' was put forward. With a grant of £1,000 from Cheshire County Council, the team were able to purchase cassettes and begin to establish themselves. At that time, the society, then known as the Macclesfield and District Society for the Blind, provided two upper rooms in their premises still at No. 15 Queen Victoria Street for the venture. With generous donations and a lot of hard work involving decorating etc. the following year the Macclesfield Talking Newspaper was established. The total cost, including all the necessary equipment and sufficient funds to cover the initial lighting and heating costs for the weekly production, was £3,180.

From its earliest days, the society and its members have been generously supported by donations and gifts. Initially several members of the Brocklehurst family actively supported events behind the scenes and were generous in providing personal gifts to blind members e.g. William Walter Brocklehurst, in December 1905, sent round coal and warm clothes and this was not the only occasion; parties and other entertainments were arranged in either the town hall or the large Sunday school on Roe Street.

Between the wars, gifts were generously provided by the Macclesfield Football club, Nixon & Son (coal dealers) and others. During the 1960s there was a flurry of support from other local businesses, clubs and even the staff and pupils of The King's School. Adlington Hall provided the venue for fundraising wine and cheese parties, and great support also came from different groups in the neighbouring village of Bollington.

The generosity has continued, but unfortunately, in recent times, health and safety issues have restricted outings, concerts and similar events that were once so popular with visually impaired members, yet despite this the work continues through the efforts of an exceptional group of volunteers and trustees who have kept the valuable work in progress.

Index

Also available from Amberley Publishing

DOROTHY BENTLEY SMITH

PAST TIMES OF MACCLESFIELD
VOLUME III

The third volume of a fascinating selection of local history articles written by Dorothy Bentley Smith.

978 1 4456 5821 6

Available to order direct 01453 847 800

www.amberley-books.com